INDIANA LANDMARKS

# Rescued & Restored

Hon. Randall T. Shepard
Marsh Davis
Tina Connor

Indianapolis

INDIANA LANDMARKS

Printed in the United States of America by Worzalla

ISBN 978-1-7342027-0-0

Randall Shepard, Foreword
Marsh Davis, Introduction
Tina Connor, Editor

Jacket & book designed by Evan Hale

On the cover: West Baden Springs Hotel
© French Lick Resort

*Indiana Landmarks Rescued & Restored* is dedicated to Indiana civic leader, business luminary, and historic preservation champion Sallie Rowland whose vision, determination, and financial support made this project possible.

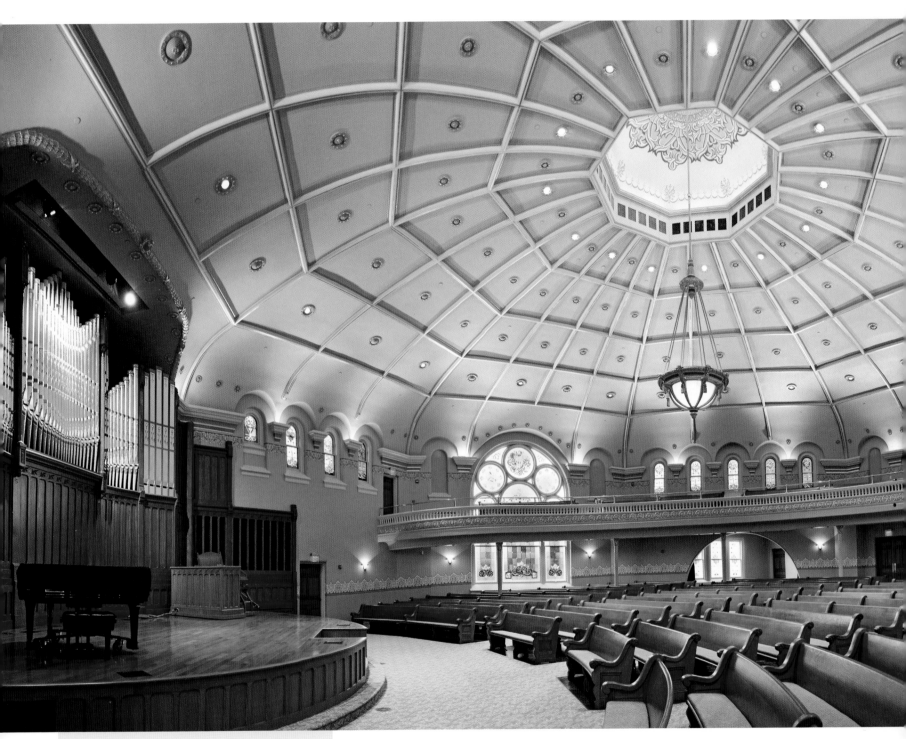

INDIANA LANDMARKS CENTER

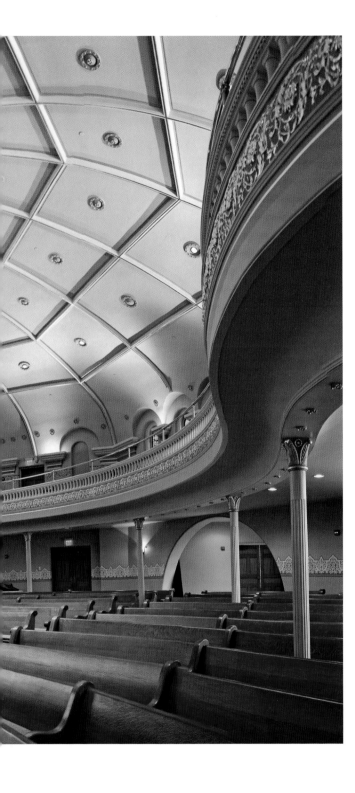

# Table of Contents

# Turning "Befores" into "Afters"

WHEN PEOPLE GATHER AROUND THE CAUSE OF HISTORIC preservation in formal settings like committee sessions and membership meetings, the agenda and the discussion necessarily cover everything from budgeting to project selection to recruiting more supporters.

These are, of course, the core of what it takes to succeed at rescuing the special structures and neighborhoods that bring us together as preservationists. Still, there's one thing that defines whether it's been an experience that makes us want to keep on campaigning.

Pictures! What does this bedraggled but elegant house look like today? What might it look like if we save it from demolition and put it to good future use?

Pictures!! What does a streetscape look like when the bulldozers punch a hole in the middle of the block? Seeing what's at risk, don't we have to plunge ahead and keep it from happening?

That part of the experience has surely been the same ever since the modern preservation movement began with the rescue of Mt. Vernon just before the Civil War. Even as the movement thereafter often focused on the homes of the famous, the caliber of the architecture and the quality of the stewardship surely mattered.

Happily, by the middle of the twentieth century, preservationists expanded their attention to the structures where regular Americans lived and worked. And we began to think about what preservation could mean to neighborhoods, beyond focusing on individual structures. How could these splendid city neighborhoods remain attractive during decades of rapid suburbanization that sometimes left cities almost hollowed out?

In time, our movement generally adjusted to the idea of preservation of "place." Though Americans increasingly moved around during their lives, didn't they still need places to live that gave them a sense of stability in a rocky era, a sense of belonging to something other than their iPads? Put another way, the preservation movement can help us live in greater harmony with each other to build a society that's more peaceful, just, and prosperous.

Indiana Landmarks has been doing exactly that for 60 years, and this volume reflects just a few of the thousands of valuable places rescued and revived by the work of career staff and tens of thousands of volunteers and contributors over these decades.

To be sure, Landmarks has continued to care about monumental architectural jewels like West Baden and French Lick and Wright's residential spot in West Lafayette, Samara.

But we have also labored to save churches like Allen Chapel in Terre Haute, the Greyhound station in Evansville, the Naval Armory in Indianapolis, and courthouses in Winamac and Winchester. There have been countless rescues in Indiana's smallest towns, like Dupont and Lyles Station.

If anything, the preservation project is not "finished." The work becomes broader and more complex. And Indiana Landmarks has helped make this state a marvel for preservationists all over America. Preservation advocates from sea to sea often turn to each other and say, "Let's call Indiana Landmarks, and ask them."

Take a loving look at these "pictures," friends, and get ready to move ahead.

by Hon. Randall T. Shepard
HONORARY CHAIRMAN, INDIANA LANDMARKS

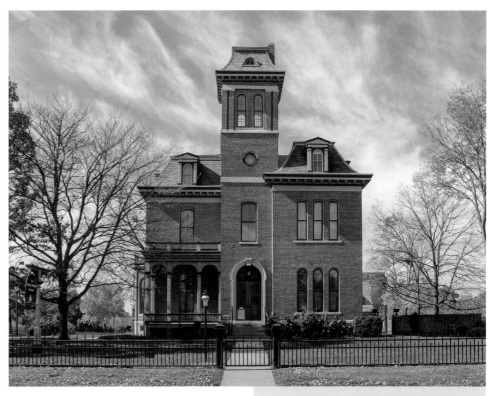

MORRIS-BUTLER HOUSE

# This Could Have Been a Really Big Book

COMMUNITY VISIONARIES AND PHILANTHROPISTS LAUNCHED Indiana Landmarks on its mission of rescuing historic places in 1960, and we've saved many along the way. Some would define our mission as "saving old buildings," but it's more than that. We prefer to state it in three components: Indiana Landmarks revitalizes communities, reconnects us to our heritage, and saves meaningful places.

This book illustrates Indiana Landmarks' three-pronged mission through an arduously winnowed list of places where we made an essential difference. With so many to choose from, selecting the entries was tough. Even harder was depicting, through brief essays, the scope of work and depth of partnerships involved in making the saves. This could have been a really big book.

But so as not to strain readers' laps and coffee tables where we hope *Rescued & Restored* lands, we offer this respectfully scaled retrospective on Indiana Landmarks' legacy.

A quick look at the places Indiana Landmarks has called home reveals how, over time, we have remained true to the tenets of our mission.

Indiana Landmarks' very first project and headquarters, the Morris-Butler House in Indianapolis's Old Northside neighborhood, illustrates how historic preservation can serve as a catalyst for revitalizing communities. Undertaken in the mid-1960s, our pioneering investment in the neighborhood helped fuel the renaissance now in full bloom in the Old Northside and other once-neglected urban neighborhoods.

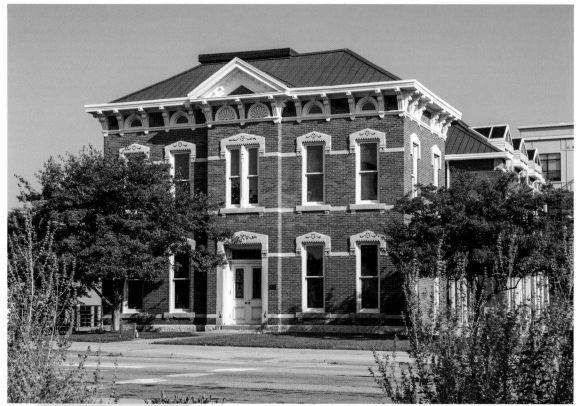

KUHN HOUSE

Moving on from the Morris-Butler House, Indiana Landmarks' next two state headquarters in Indianapolis, the Waiting Station at Crown Hill Cemetery and the Kuhn House—later named the Heritage Preservation Center and Williamson Center—are meaningful places we saved from serious neglect and imminent demolition, respectively. And both continue to enjoy sustainable uses long after we rescued them.

When Indiana Landmarks took on its current headquarters in 2010, it was a vacant, crumbling hulk in the otherwise resurgent Old Northside neighborhood. The former Central Avenue Methodist Episcopal Church is now the Indiana Landmarks Center, a place that captures all three points of our mission—including reconnection with our heritage. Historically, the building was a hub of social and cultural activity—all of which had been lost. Now rescued and restored, the Indiana Landmarks Center is fully reconnected with its surrounding community and beyond.

But Indiana Landmarks' pursuit of its mission is best expressed in our work throughout Indiana where we have joined forces with local leaders who understand the value historic places hold in their communities.

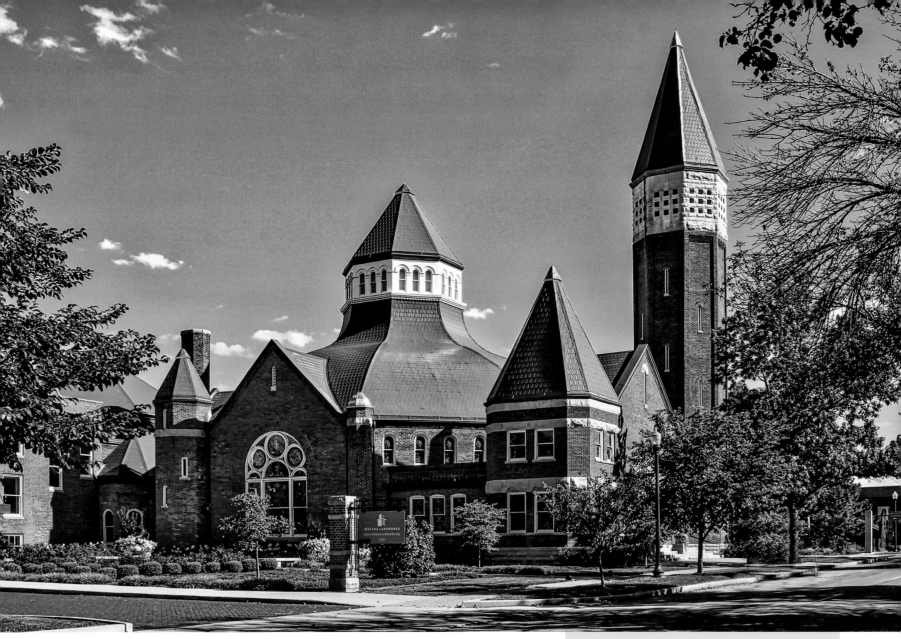

INDIANA LANDMARKS CENTER

Our work has been, and remains, a collaborative effort, aided and fueled by philanthropists, advocates, and our members at all levels. All are essential to successfully rescuing and restoring places that define and enrich our state. The pages that follow reflect a collective legacy that Indiana Landmarks has been proud to serve.

by Marsh Davis
PRESIDENT, INDIANA LANDMARKS

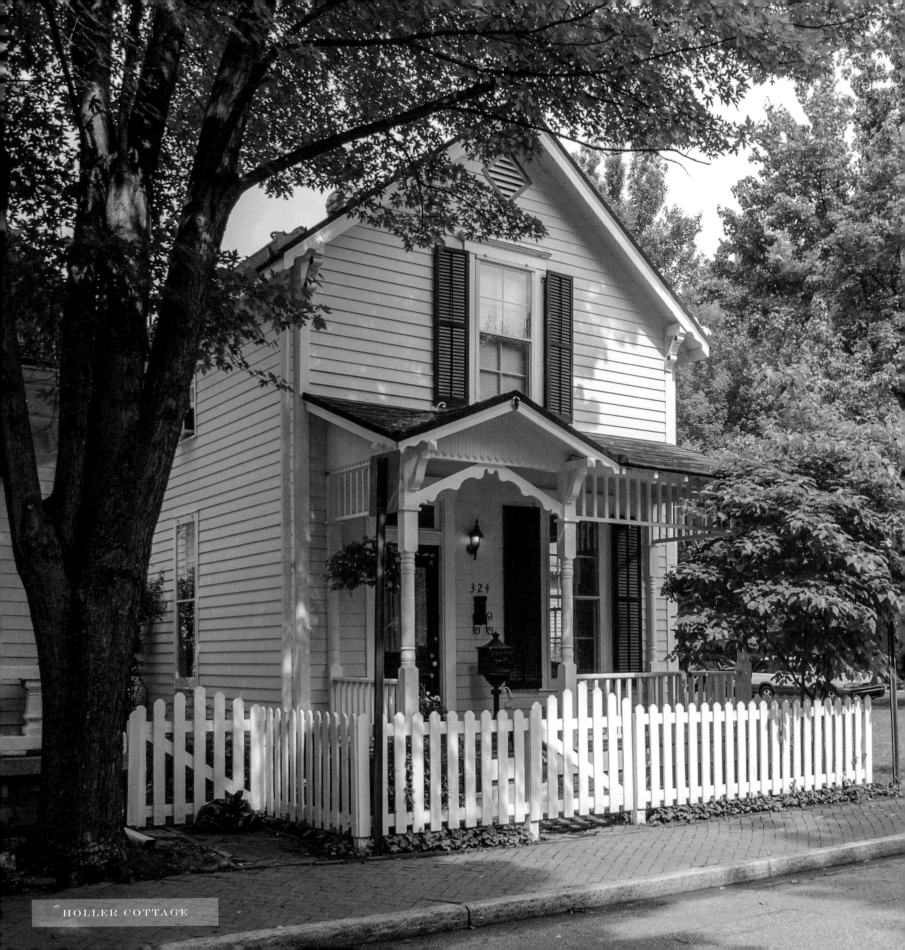

HOLLER COTTAGE

# Lockerbie Square

## INDIANAPOLIS

**E**nvision this dismal neighborhood scene: dilapidated and vacant houses bordered by broken sidewalks and trash-filled empty lots, roamed by a thriving rat population. In the heart of the area sits the James Whitcomb Riley Museum Home, a well-tended house where the Hoosier poet lived from 1893 until his death in 1916. That was Lockerbie Square in the 1960s.

Creating museums in landmark houses was the M.O. of the historic preservation movement in those days, but Indiana Landmarks pioneered a different approach to saving historic places, starting with Lockerbie Square. The model featured several key elements: treat landmarks as real estate; help create a supportive network, specifically municipal preservation commissions, local preservation nonprofit organizations, and neighborhood associations; and seek broad community participation. The approach proved successful in Lockerbie and elsewhere in the city and the state.

Indiana Landmarks lobbied the state legislature for the creation of the Indianapolis Historic Preservation Commission (IHPC) in 1967 and helped pave the way for the commission's first local landmark designation—Lockerbie Square. It provided support for the Lockerbie Square People's Club, a neighborhood association.

1

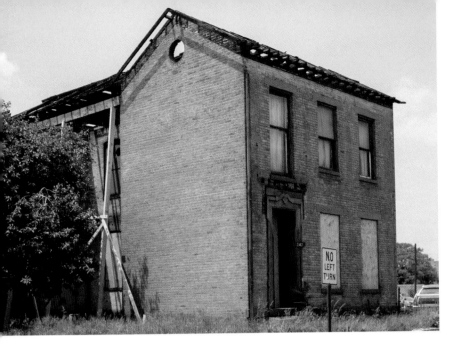

The transformations, Indiana Landmarks' institutional presence, and the partners it enlisted created confidence that the neighborhood could be an inviting place to live.

Visit Lockerbie Square today (with expanded boundaries under design oversight by IHPC) and you'll see restored structures—Italianate brick houses and story-book frame cottages—and new buildings that blend with the old, set on streets shaded by trees, including many planted during the 1976 bicentennial.

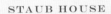

STAUB HOUSE

Indiana Landmarks also enlisted participation in the revival from the Indianapolis Garden Club, the Junior League of Indianapolis, Women in Construction, and the City.

Over a 15-year period from 1965-1980, Indiana Landmarks bought and sold 40 houses and vacant lots in the small district then bounded by New York, College, Michigan and East streets. It restored some inside and out, like the Holler Cottage and the Staub House. After restoring the Holler Cottage—the worst house on the block—Indiana Landmarks loaned it for use as the headquarters of the city's 1976 national bicentennial celebration, bringing public awareness to the area. The attention helped attract more do-it-yourself restorers to the neighborhood.

Indiana Landmarks resold other houses and lots with protective covenants that required restoration or compatible new construction within a specified period. In a few cases, it moved threatened structures from other areas to fill vacant lots. A donor gave Indiana Landmarks an 1862 house that would have been demolished and paid for its relocation from West Washington Street to Park Avenue in Lockerbie.

SCHRIBNER HOUSE

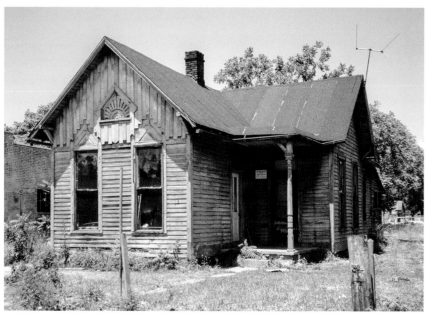

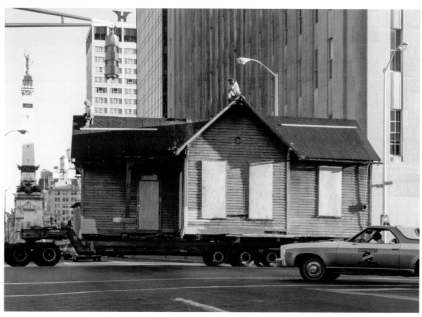

3

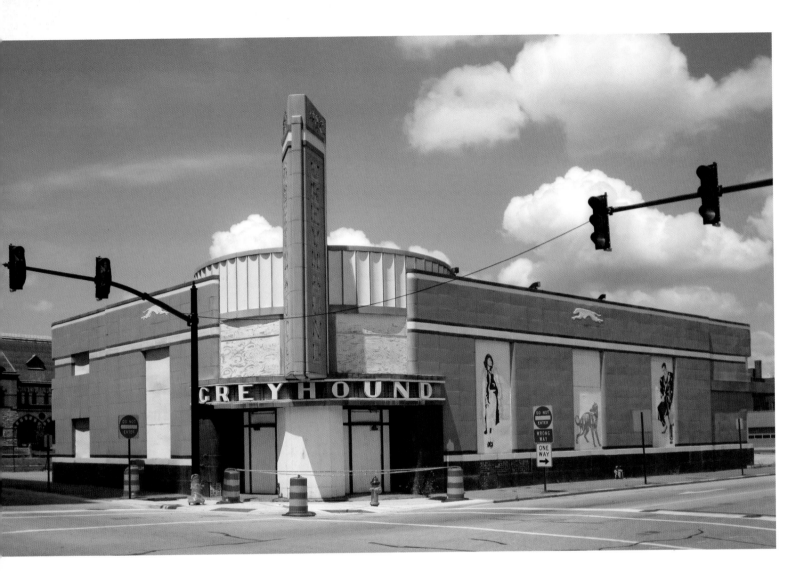

# Greyhound Station EVANSVILLE

With its speeding canine signage and streamlined Art Moderne design, the Greyhound bus station communicated speedy modern transportation when it debuted in 1939. Greyhound moved out in 2007. Six years later the City of Evansville donated the vacant building and $250,000 to Indiana Landmarks to fuel a turnaround.

Louisville architect William S. Arrasmith designed at least 50 terminals for Greyhound between 1937 and 1960, including the Evansville station with its curved corners, smooth surfaces, and parallel lines suggesting speed and movement. Arrasmith used blue enameled-steel panels to match Greyhound's buses, a color motif he used on terminals in Louisville, Bowling Green, and Fort Wayne, all now demolished.

With guidance from a local committee, Indiana Landmarks restored the terminal's exterior panels, steel sash, and glass block windows. It removed the baby blue paint covering the exterior panels to recapture the elegant original two-toned scheme.

After years in the dark, hundreds came to watch when Indiana Landmarks flipped the switch on the restored blinking neon lights that make the dog atop the vertical sign appear to run—a rarity among stations nationwide.

Determining that a restaurant would add to downtown revitalization, Indiana Landmarks recruited and renovated the interior for tenant Cunningham Restaurant Group. The firm's Bru Burger at the Greyhound opened to immediate success in 2016.

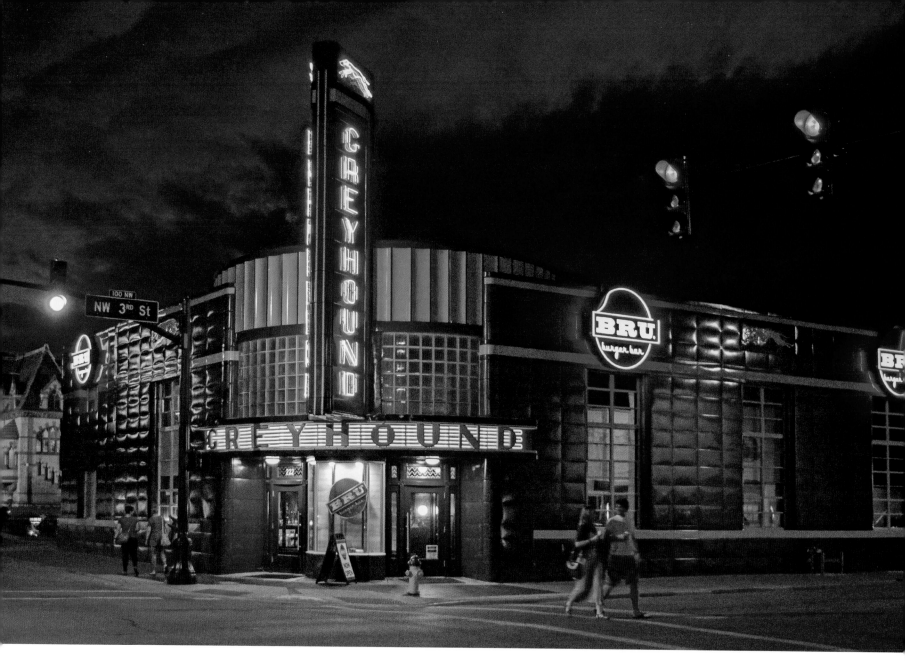

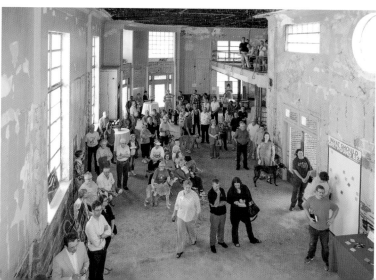

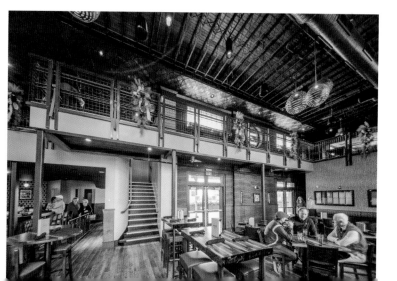

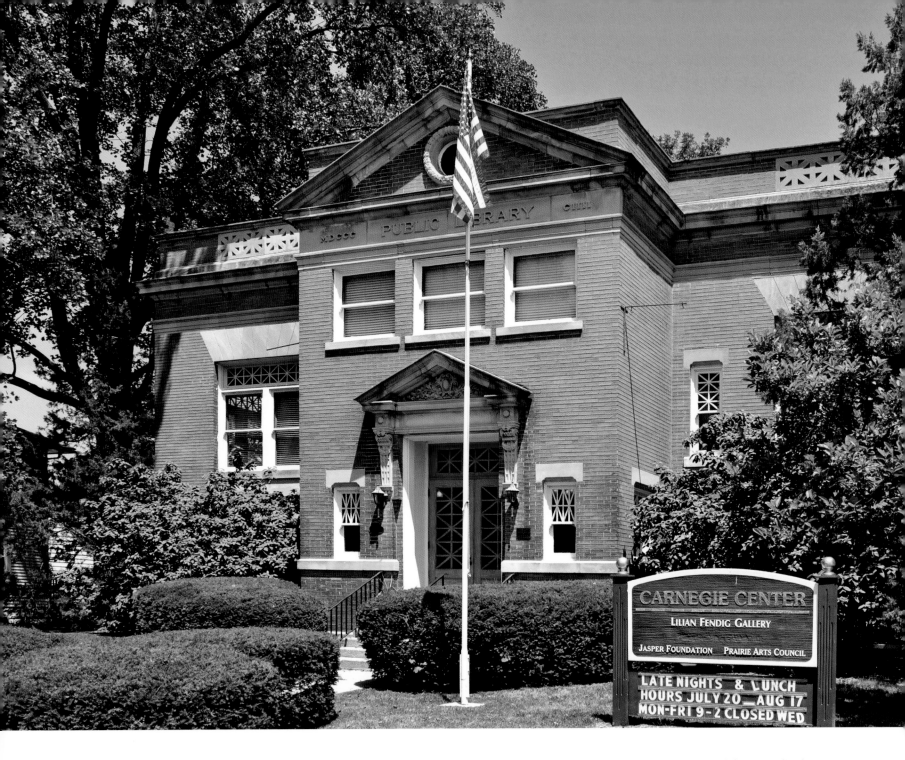

# Carnegie Library

RENSSELAER

When Andrew Carnegie immigrated from Scotland at age 13 in 1848, he worked in a factory 12 hours a day, 6 days a week. He never forgot the wealthy man who allowed him, a scruffy working-class boy, to borrow books from his personal library, helping him improve his lot in life. After he made a fortune in railroads and steel, his philanthropy included grants to build libraries throughout the U.S. and abroad.

Between 1901 and 1922, Indiana communities received 164 Carnegie grants to build libraries, more than any other state. The majority remain public libraries. Many of the rest have been adapted as town halls, history museums, restaurants, offices, and homes.

When Rensselaer replaced its Carnegie library in 1993, the Jasper Newton Foundation, Greater Rensselaer Chamber of Commerce, and Prairie Arts Council hatched a plan to reuse the 1905 building but needed help to make it work. Indiana Landmarks funded a restoration plan and won a $375,000 Lilly Endowment renovation grant before the trio took over in 1999.

The Carnegie Center includes an art gallery, a restored auditorium for community events, and offices. The groups recreated the long-missing stained-glass ceiling and wood front doors and removed banks of fluorescent tubes in favor of period light fixtures. An elevator and new restrooms make the building accessible to all. In 2019, grants helped fund restoration of the historic windows.

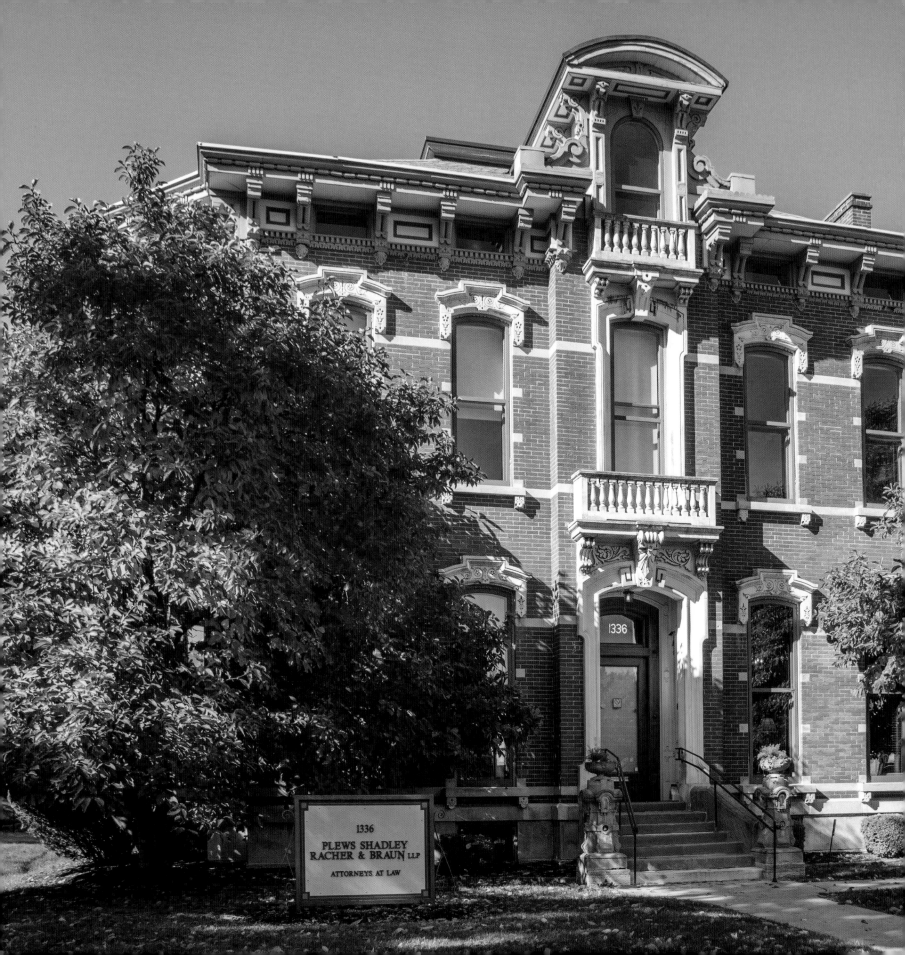

# Old Northside
## INDIANAPOLIS

I n the nineteenth century, substantial houses built in the popular Victorian styles of the day—Italianate, Second Empire, Queen Anne—lined tree-shaded streets in the capital city's grandest residential district. By the 1960s, however, fires and demolition had claimed many of the houses, leaving weed-choked vacant lots. The majority of Old Northside structures that remained suffered neglect and abandonment. Crime and vandalism intimidated people interested in renovating the houses, most of which had been broken up into apartments following World Wars I and II.

After buying and restoring the Morris-Butler House in the '60s (see page ix), Indiana Landmarks enlisted the Indianapolis Historic Preservation Commission and the Junior League of Indianapolis as partners in a three-year project that produced a master plan for the area and a historic district nomination to the National Register of Historic Places.

The partners also created a revolving fund to rescue vacant houses, starting in 1977 with the Eden-Talbott House on Delaware Street, slated to be demolished for a parking lot. Removing the gray paint revealed an elegant red brick and stone manse, drawing attention on the heavily traveled thoroughfare. Restored and sold two years later to the Federation of Music Clubs for its national headquarters, the 1871 house is now one of five Delaware Street landmarks proudly owned and occupied by Plews Shadley Racher and Braun law firm.

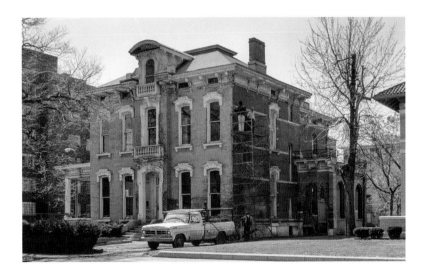

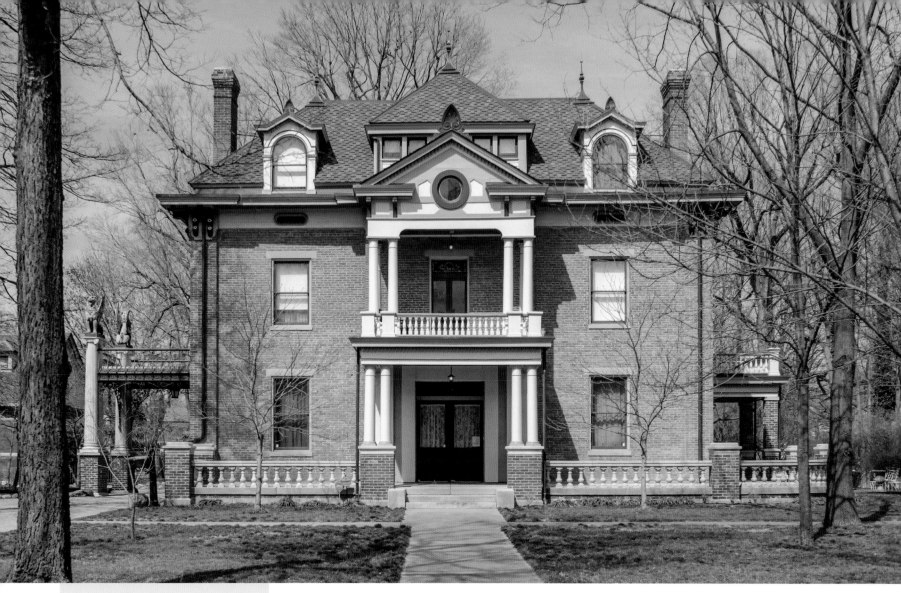

OVID BUTLER HOUSE

Proceeds from the sale of the house allowed the buy-restore-sell cycle to save other structures in the district bounded by Pennsylvania, Bellefontaine, and 16th streets and Interstate 65/70. Indiana Landmarks bought and stabilized 20 derelict places, then sold them with protective covenants to people who restored them. This approach revived the 1903 Georgian Revival-style home on Delaware Street of novelist/journalist/diplomat Meredith Nicholson, now owned by Indiana Humanities, and the massive 13th Street home of abolitionist Ovid Butler, namesake of Butler University.

Rescuing endangered properties grew less urgent after 1979 when the Old Northside Neighborhood Association formed to improve livability and recruit restorers, including many young DIYers. The same year, the Indianapolis

Historic Preservation Commission designated the Old Northside as a local historic district, offering demolition protection and design review. By the first decade of the 2000s, only a handful of unrestored properties remained in the 170-acre district, including a church Indiana Landmarks rescued in 2010 (see page xi).

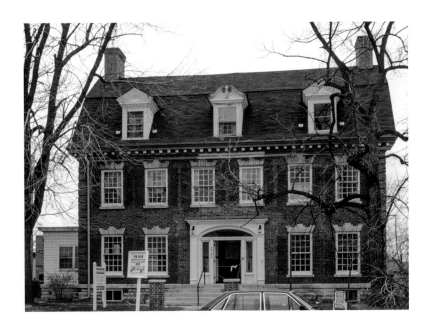

In 2017, Indiana Landmarks commissioned a study of the economic impact of historic districts in the capital city. The study verified local district designation's efficacy in revitalizing disinvested areas, documenting significantly higher property values, lower foreclosure rates, and higher job attraction and community engagement in local districts, including the Old Northside, than in the city as a whole.

MEREDITH NICHOLSON HOUSE

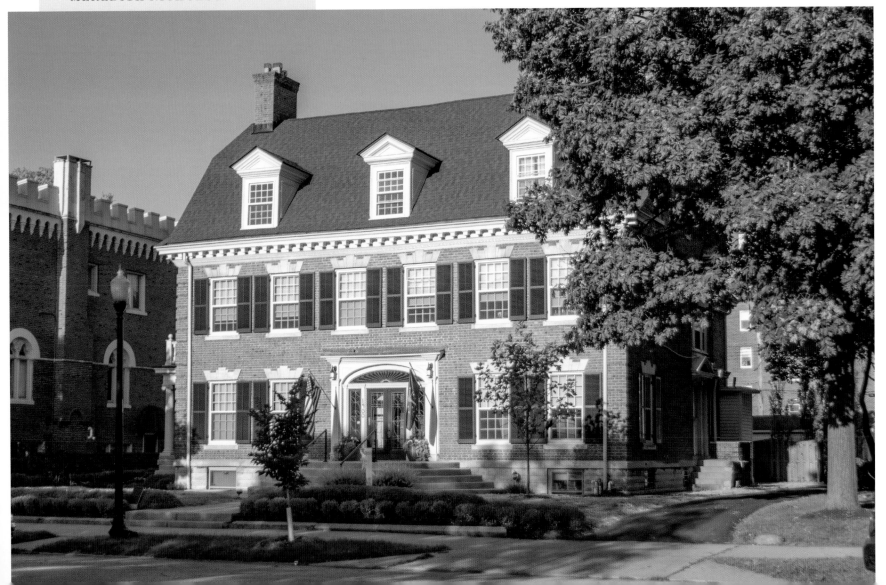

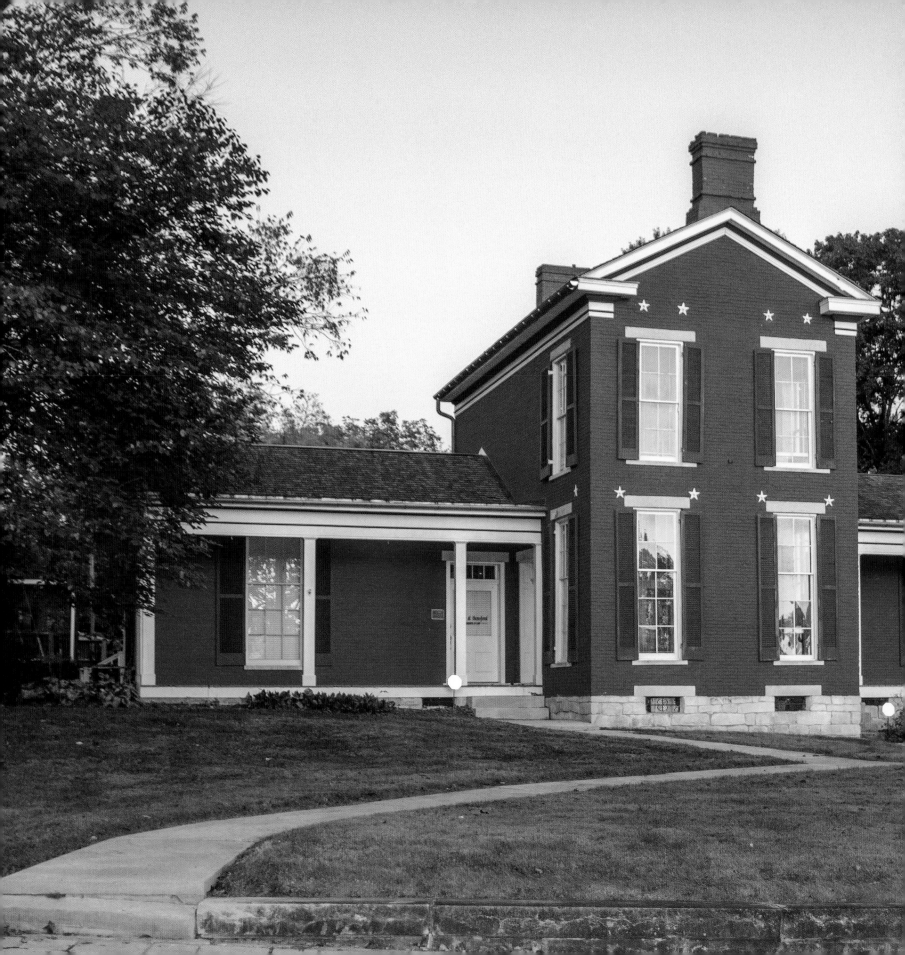

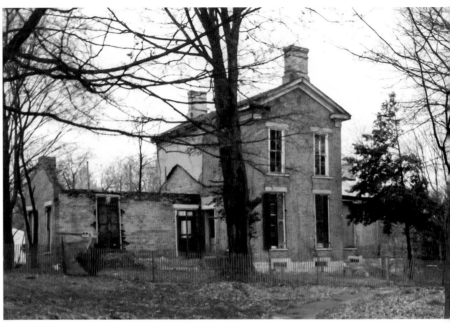

# Paris Dunning House
BLOOMINGTON

In 1978, Indiana Landmarks created a low-interest loan fund available to local preservation organizations for rescuing endangered historic buildings. Bloomington Restorations, Inc., (BRI) the fund's best customer, has borrowed nearly $900,000 to save 40 houses and churches in Monroe County.

One of the group's earliest projects—the c.1845 Paris C. Dunning House—helped establish Bloomington Restorations and historic preservation as a local force for revitalization. No bank would loan the group money because the project looked too risky.

Named for the Indiana governor who owned it in the 1860s, the hilltop house sat in the path of a proposed expansion of Third Street when BRI received the property as a gift from IU librarian Lingle Craig. BRI won local landmark status for the house and borrowed $85,000 for the restoration. The project stymied the street widening, saving 30 other houses and sparking revitalization of the Prospect Hill neighborhood.

BRI sold the restored house in 1985. Bauer and Densford, a law firm, bought the Dunning House in 1989. In 2010, a late-night jogger spotted smoke rising from the house. A sprinkler system and quick response by the Bloomington Fire Department saved the house, which Bauer and Densford re-restored to better-than-ever condition.

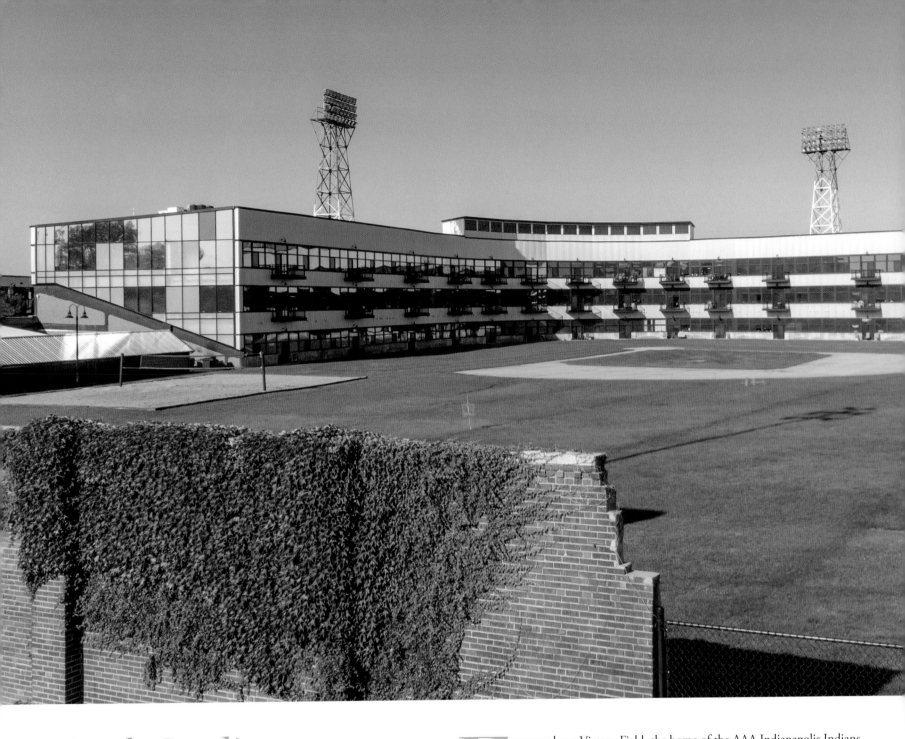

# Bush Stadium

## INDIANAPOLIS

Everyone loves Victory Field, the home of the AAA Indianapolis Indians that opened downtown in 1996. But the Indians' move left the similarly beloved Bush Stadium on West 16th Street without a purpose.

Called Perry Stadium when it opened in 1931, the Art Deco ballpark designed by Pierre and Wright hosted play by Negro League teams as well as Babe Ruth, Lou Gehrig, Ted Williams, Hank Aaron, and other greats on their way to the majors. Cubs owner Bill Veeck claimed the stadium's ivy-covered outfield walls inspired Wrigley Field's famous ivy.

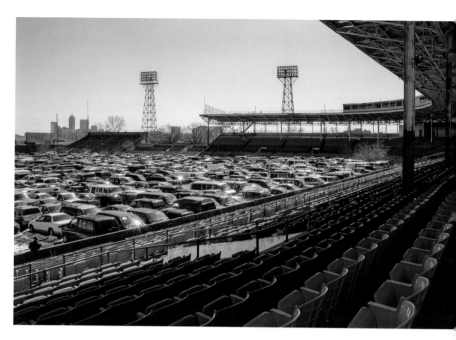

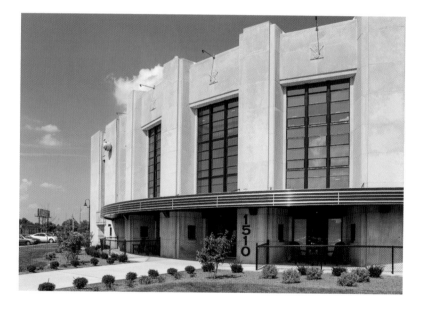

The place declined until what seemed like the final indignity—the playing field filled with carcasses of polluting cars redeemed in the government's "Cash for Clunkers" program. The city proposed demolishing the stadium for new development.

Indiana Landmarks named Bush Stadium a 10 Most Endangered site in 2008, its second stint on the list, and mounted a last-ditch effort to rescue the place, teaming with developer John Watson who proposed a radical reuse as apartments. Their against-the-odds joint pitch to a city task force won approval.

The $22 million Stadium Lofts preserves the Art Deco entrance, lighting towers, brick outfield walls, and keeps the playing field as green space. Stadium Lofts debuted in 2013 with all 138 apartments fully leased on opening day.

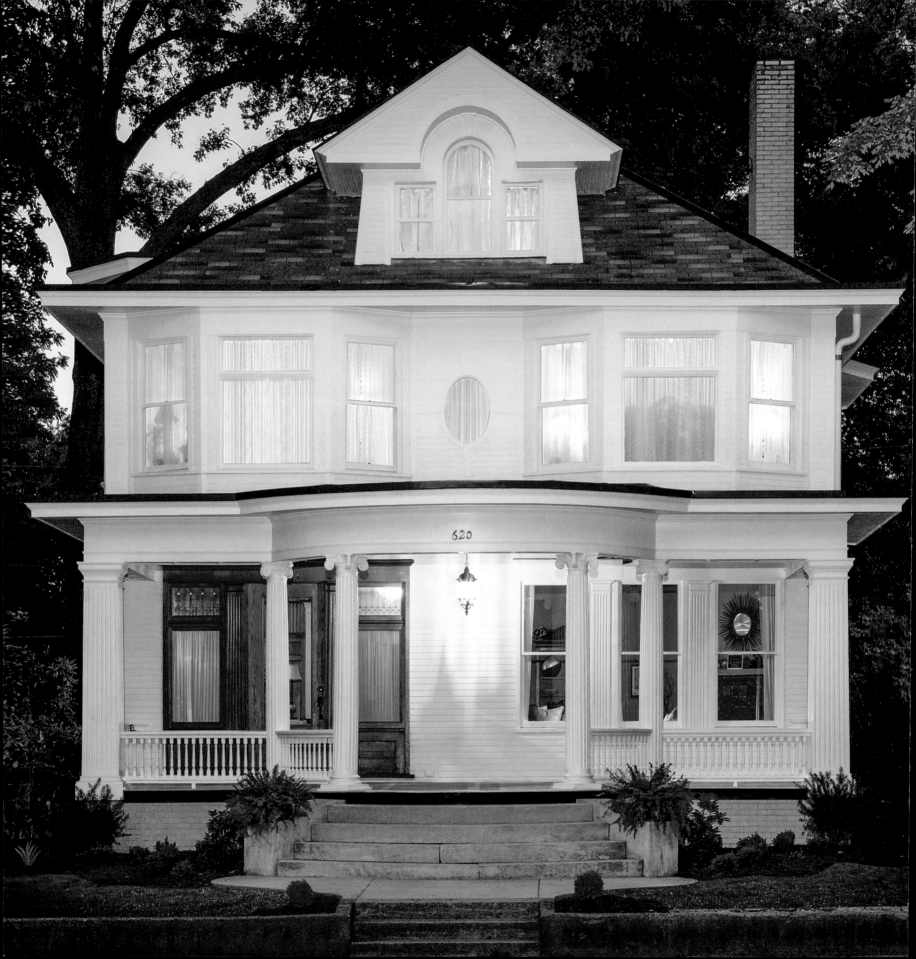

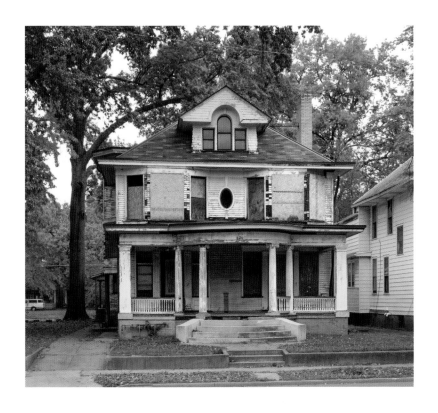

# Lautenschlaeger House EVANSVILLE

Makeovers inspire imitation, which gave then–Evansville Mayor Jonathan Weinzapfel an idea. Why not move *Evansville Living* magazine's 2010 annual Idea Home from a new house in the suburbs to an inspiring fixer-upper in an urban neighborhood that could use a boost? Magazine publishers Kristen and Todd Tucker and the Junior League of Evansville, their Idea Home partner, embraced the suggestion. Indiana Landmarks offered the perfect subject, a c.1901 Colonial Revival-style house on well-traveled Washington Avenue in a 10 Most Endangered historic district.

In addition to bringing attention to the rundown Victorian houses in the area, the transformation turned a dilapidated shell into a showcase for cost- and energy-efficient renovation and décor and displayed the benefits of rehabbing the old over building new.

The 3,500-square-foot house needed an extreme makeover. It got an accurate exterior restoration, with special attention to original details, such as the porch columns and the front door. Half of the original wood window frames were salvageable, retrofit with insulated glass. The interior, heavily altered to create apartments with little original fabric left, became an open-plan space that blended refurbished historic features and modern and recycled materials. Indiana Landmarks sold the Idea Home to architects Jody and Maya Phillips.

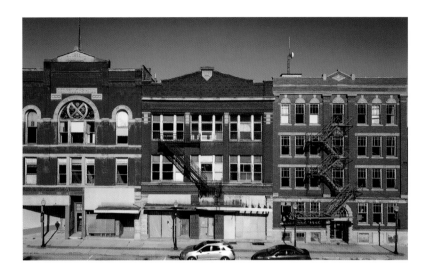

# United Brethren Block
## HUNTINGTON

The clock was ticking on a blighted block across the street from the Huntington County Courthouse. The International Order of Odd Fellows constructed the 1889 lodge hall and added the I.O.O.F Trust Building next door around 1915. The same year, the United Brethren Church built the third structure for a publishing company that produced Sunday School manuals and hymnals, eventually expanding operations into all three buildings and remaining there until 1981. After that, things went downhill.

In 2015, the local redevelopment commission took possession of the block for back taxes and announced demolition plans. Indiana Landmarks named the block to its 10 Most Endangered list and intervened, partnering with its local affiliate Huntington Alert.

The city gave the groups a year and support to assess rehab costs, plug leaking roofs, and find a developer with a viable new use. Anderson Partners took on the challenge, transforming the historic structures with assistance from the City of Huntington, the county, Indiana Regional Cities funding, the federal Historic Tax Credit, and local investors.

The $9 million restoration opened in 2020 with 37 market-rate lofts, an arts center and community kitchen, and an entrepreneurship program. Instead of a block-long weedy vacant lot in the National Register historic district, the city got a vibrant retooled landmark with apartments that appeal to young people.

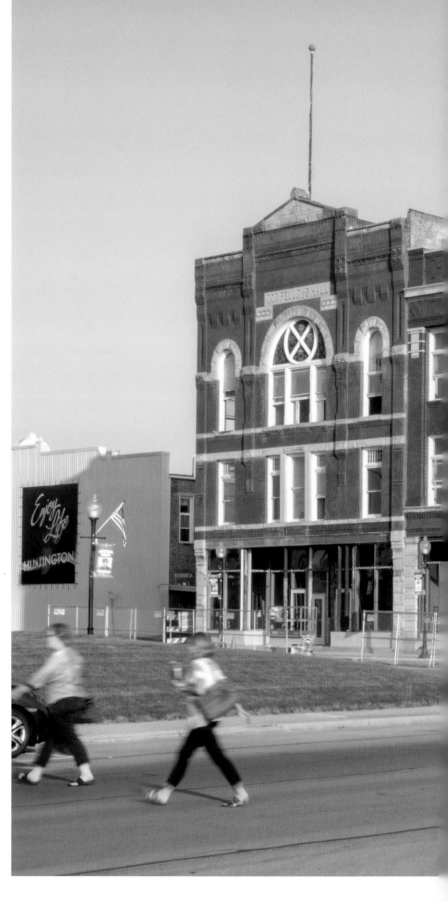

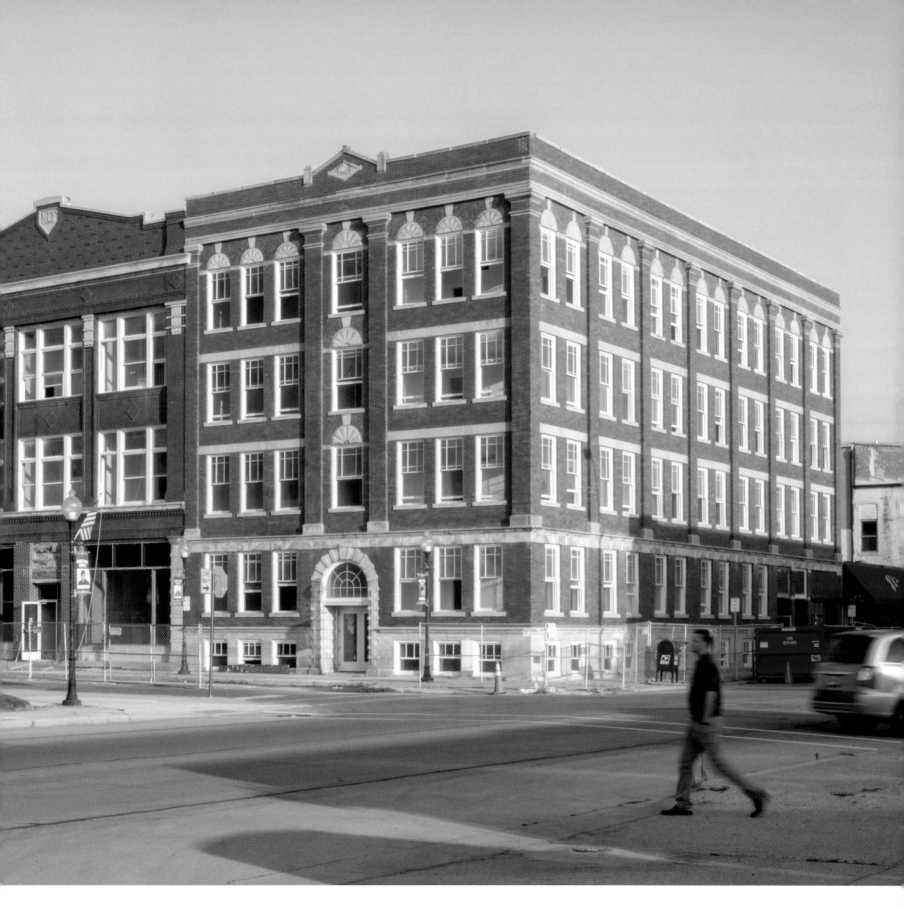

19

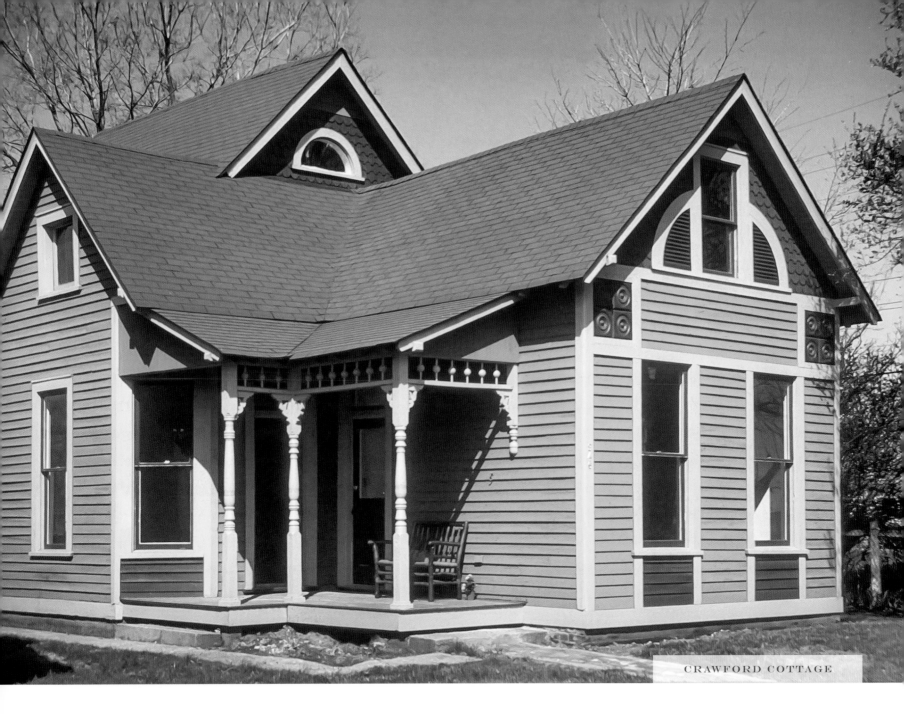

# Ransom Place

## INDIANAPOLIS

Ransom Place, the capital city's most intact nineteenth-century neighborhood associated with African Americans, needed a boost back in the 1990s. Historically, the area was home to Black doctors, civic leaders, attorneys, and other professionals who patronized a thriving commercial district along Indiana Avenue.

Today's district—roughly bounded by Paca, St. Clair, 10th and Dr. Martin Luther King Jr. streets—is a fragment of the vibrant neighborhood that

20

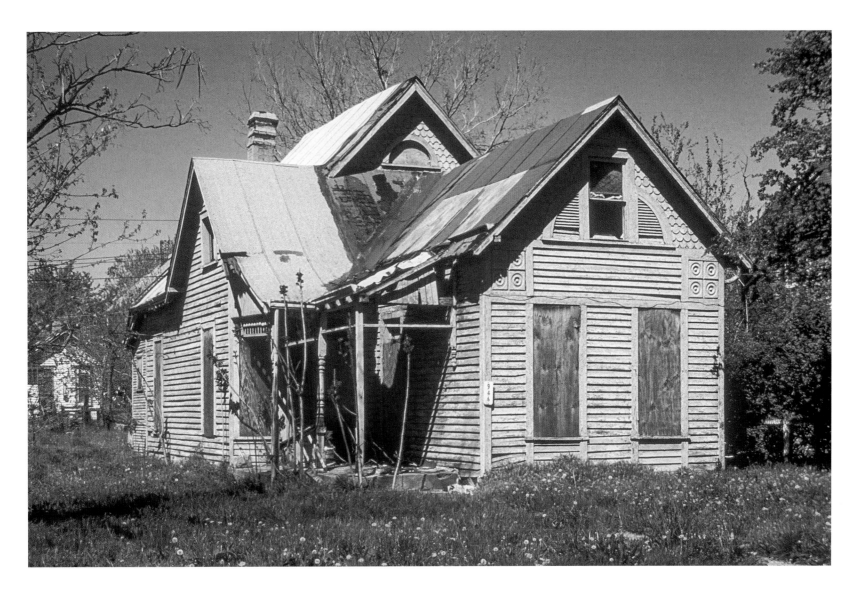

existed before the 1960s when IUPUI bought and demolished nearly 1,000 houses and commercial buildings for the downtown campus, causing rapid decline in what remained.

Indiana Landmarks helped the Ransom Place Neighborhood Association list the area in the National Register of Historic Places in 1992 and secure local conservation district status in 1998. To demonstrate the restoration potential of the neighborhood's nineteenth-century cottages, Indiana Landmarks acquired the worst house on the block in a swap with the city for

land the organization owned on the downtown canal. Indiana National Bank contributed to the renovation.

The 1880s California Street cottage hadn't seen paint in decades. Holes in the roof let in the weather, and drug paraphernalia littered the interior. After a complete renovation, Indiana Landmarks sold the house in 1994 to Theresa Crawford. She lives there still, loving the walkability to downtown attractions and the role her home played as an early revitalization catalyst in the district.

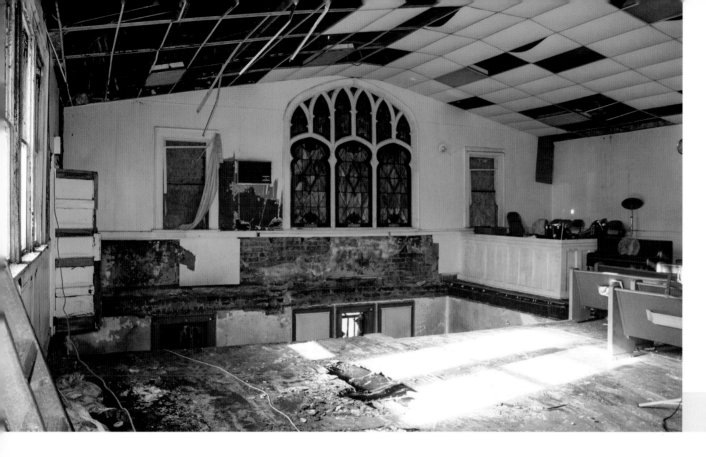

SECOND CHRISTIAN
CHURCH

By the 2000s, Ransom Place was in much better shape, although a threatened landmark at its heart depressed the value of surrounding property. Gaping holes in the roof and a cloudy title endangered the historic Second Christian Church, a case of demolition by neglect. The original congregation outgrew the building and moved in the late '40s, eventually becoming Light of the World Christian Church, a thriving and influential institution today. Other churches took over the Ransom Place structure until it fell vacant in the '90s.

Indiana Landmarks took temporary custody of the 1910 Craftsman-style church through a court-appointed receivership in 2007. It rebuilt the roof, restored the exterior—re-painted in the original color scheme—and addressed interior structural failures caused by years of water infil-

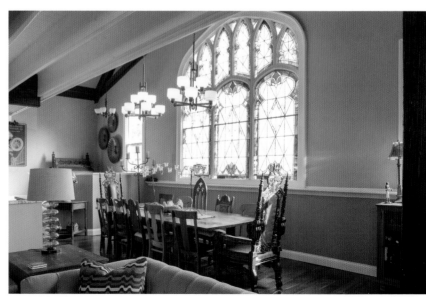

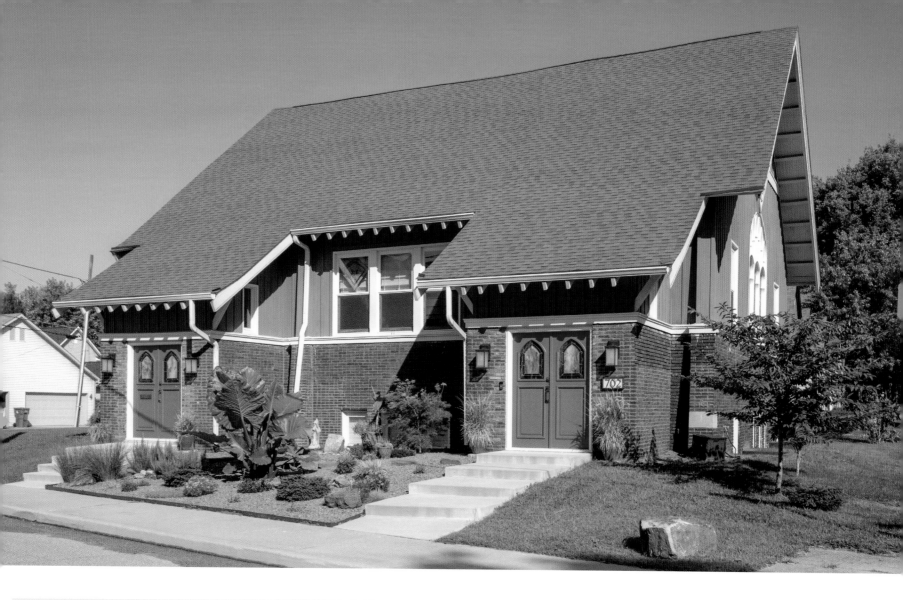

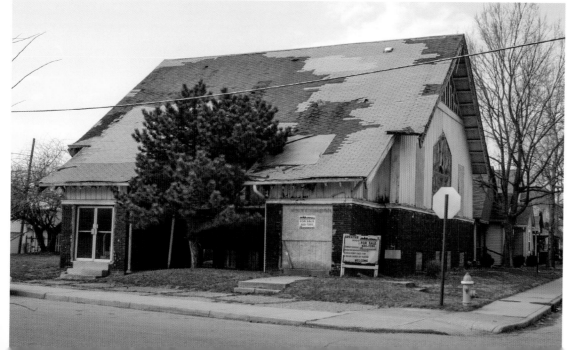

tration. A grant from the Efroymson Family Fund of the Central Indiana Community Foundation covered the repairs.

Once the work was complete and the owner elected not to repay the cost of repairs, the court awarded ownership to Indiana Landmarks, which found buyers Joel and Lauren Harsin. The young couple applied creativity and DIY skill to turn the 4,400-square-foot church into their home. They restored the stained-glass windows and incorporated original doors, trim, and artifacts, keenly feeling a responsibility to the building and its history as a cornerstone of the neighborhood.

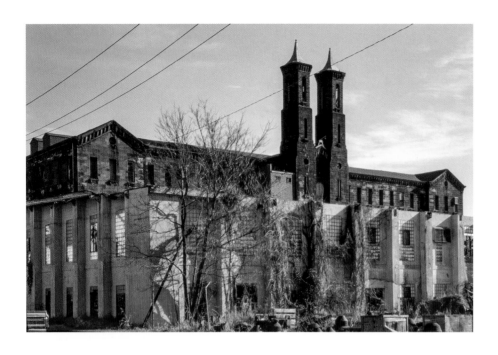

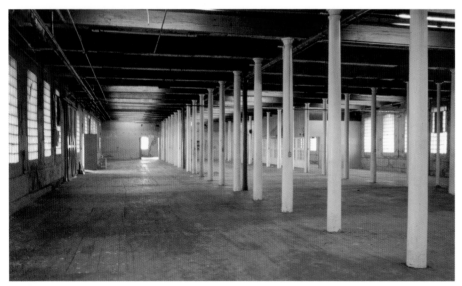

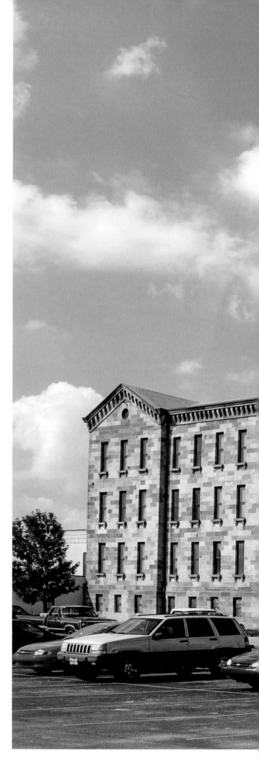

# Cannelton Cotton Mill CANNELTON

The larger the building, the longer the vacancy, and the smaller the town, the greater the revitalization challenge. The 70,000-square-foot Cannelton Cotton Mill, in a town with a population under 2,000, closed in 1954. Massive challenge.

The Ohio River mill landed on Indiana Landmarks' inaugural 10 Most Endangered list in 1991. Roof repairs in 1992 earned the building a brief reprieve, but after a series of owners and failed plans, it reappeared on the list in 1998, the same year federal officials declared it the most endangered National Historic Landmark in Indiana.

Designed to resemble the famous mills of Lowell, Massachusetts, the sandstone building was the largest factory west of the Allegheny Mountains when it opened in 1851. It operated with a labor force of German and Irish

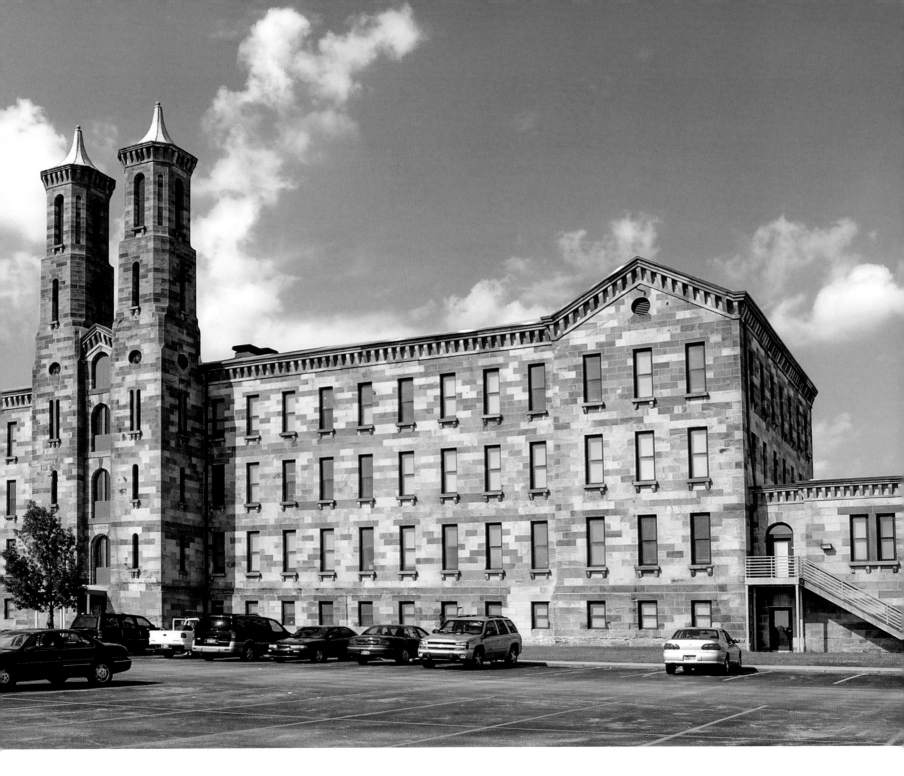

immigrant women and children as young as nine years old who worked 12- to 14-hour days. They produced cotton batting and sheeting as well as uniforms for soldiers in the Civil War, and World Wars I and II.

In 1999, the nonprofit Lincoln Hills Development Corporation bought the mill, helped by a $100,000 loan from Indiana Landmarks, and reinvented it as the 70-unit Cotton Mill Apartments. The $8 million restoration relied on affordable housing and historic rehabilitation tax credits, state and federal grants, and investors. The awe-inspiring landmark reopened in 2002 after nearly 50 years of vacancy.

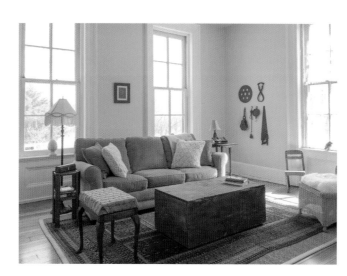

# Van Reed Farmstead WILLIAMSPORT VICINITY

June Wright Kramer loved the historic Van Reed Farmstead in northwest Indiana. To ensure its preservation, she bequeathed the property to Indiana Landmarks with a life estate reserved for her son. Years after her death, her son moved away and the vacant c.1855 farmhouse, summer kitchen, and c.1860 Sweitzer barn deteriorated.

Indiana Landmarks bought out the life estate, re-roofed the house and summer kitchen, repaired the barn roof, and sought a buyer who relished a restoration challenge. Chicago-area residents and experienced restorers Tim and Mary Cozzens' online search for a weekend escape from the city led them to the Van Reed Farmstead. They bought the place in 2015, revealing that

Indiana Landmarks' preservation covenant appealed to them. After all, who wants to contemplate the work of years of sweat equity vanishing under a neglectful future owner?

The couple began working weekends at the Greek Revival and Italianate-style house, sleeping on an air mattress under a ceiling fan and using five-gallon camp showers for bathing. They fixed the plumbing, restored the wood windows, and repaired the masonry, the first projects in a years-long effort. While friends and family enjoy the increasingly comfortable weekend and summer retreat, the Cozzenses see themselves as temporary stewards in what they hope will be a long line of caretakers.

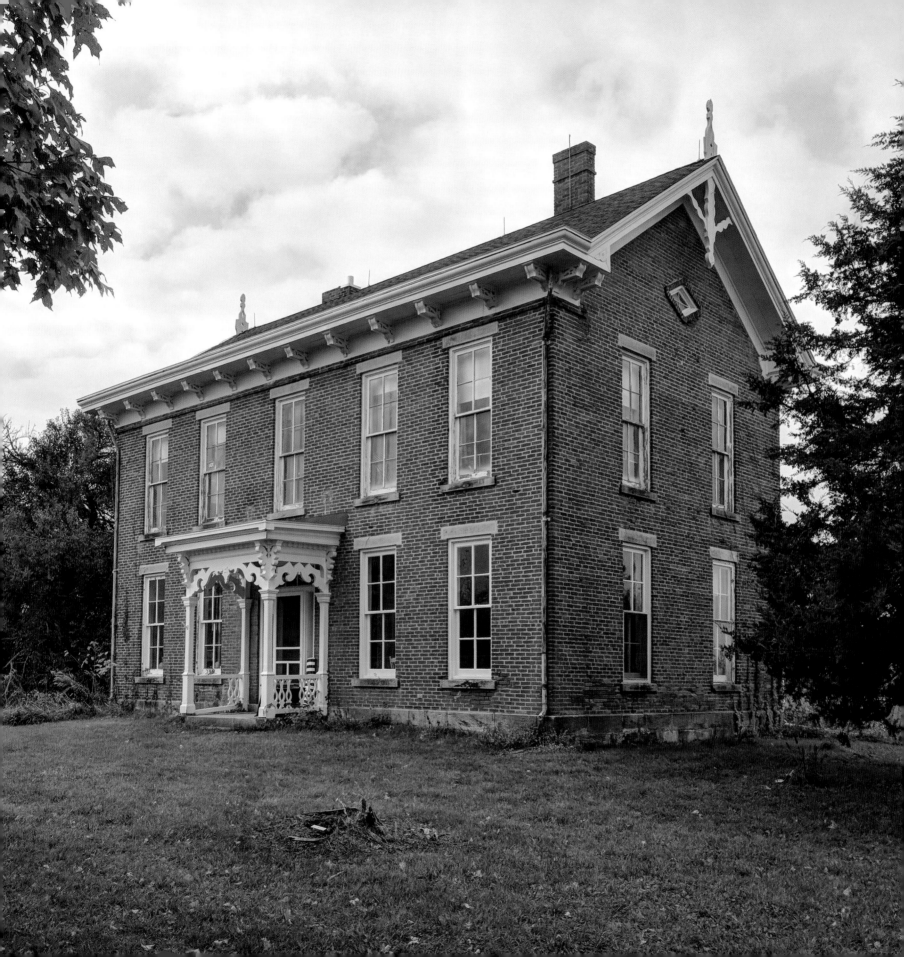

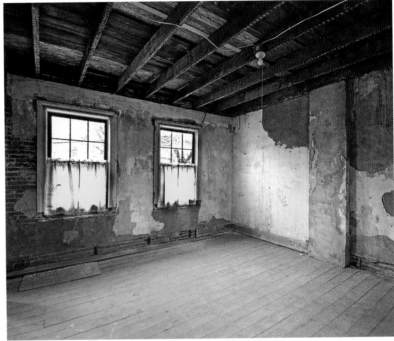

# Alber House WABASH

Philip Alber, an immigrant mason from Lichtenstein, built his home in just 10 days in 1849. The family lived on the upper floor and turned the lower level into a German-style café that opened to a backyard beer garden. The Federal-style house still has the original wood staircases, wide-plank floors, and limestone floor on the lower level, where hand-hewn wood beams remain from the Bavarian café days.

The oldest surviving house in Wabash, it was condemned in 2016 when Indiana Landmarks gladly accepted it as a donation from the owner and persuaded the city to chip in the money it had earmarked for demolition. With additional support from the Efroymson Family Fund and the Alber family, Indiana Landmarks restored the exterior while it hunted for a buyer.

Ed Norman grew up in Wabash and remembers being intrigued by the Alber House's unusual, picturesque appearance. He and his husband Tim Parnell—both experienced restorers—live in Indianapolis. It was serendipity that they were looking for a pied à terre in Wabash and found the house for sale. They kept all the original features, installed a master suite on the formerly unusable second floor, and kept the limestone floor on the lowest level, which functions as a guest suite for visiting family.

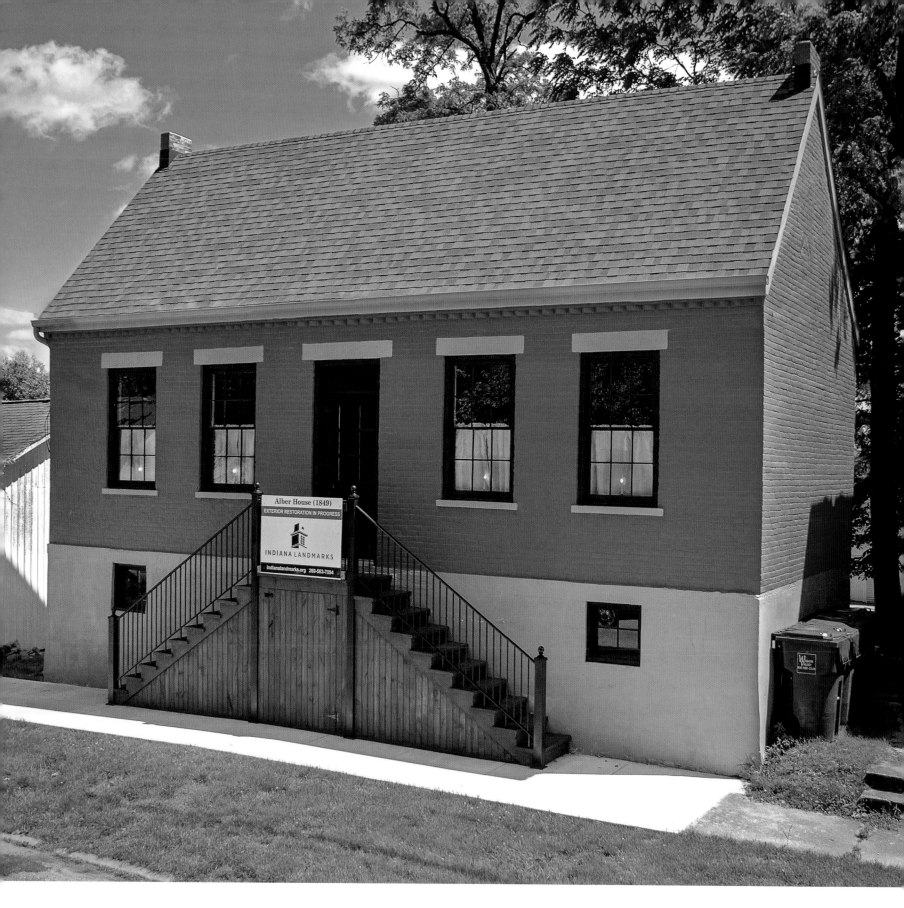

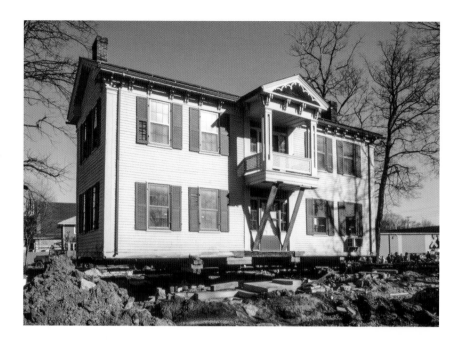

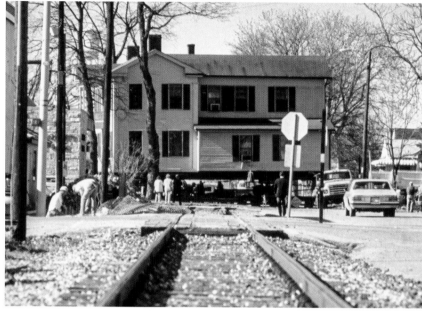

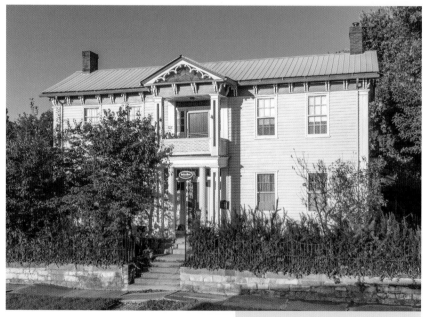

ROBINSON HOUSE

# Spencer OWEN COUNTY

**W**ithout historic preservation, the town of Spencer in Owen County might be like so many other struggling rural communities that have lost population, local shops, and downtown movie theaters, where boarded storefronts give Main Street a sad, ghostly look.

The community's relationship to preservation goes back to 1991 when Patsy Powell heard a local bank planned to demolish the historic Robinson House for parking. She called on Bloomington Restorations, Inc., (BRI) and Indiana Landmarks for help in saving the 1857 landmark and swiftly acted on their advice, gathering a few others to create the nonprofit group Owen County Preservations, Inc. (OCP).

Within a week, OCP received an Indiana Landmarks grant for a feasibility study on moving the house. Since the brand-new organization had no money, BRI supplied the match. Armed with a $40,000 loan from Indiana Landmarks, OCP bought a lot on a prominent downtown corner, relocated the house, sold it, and repaid the loan.

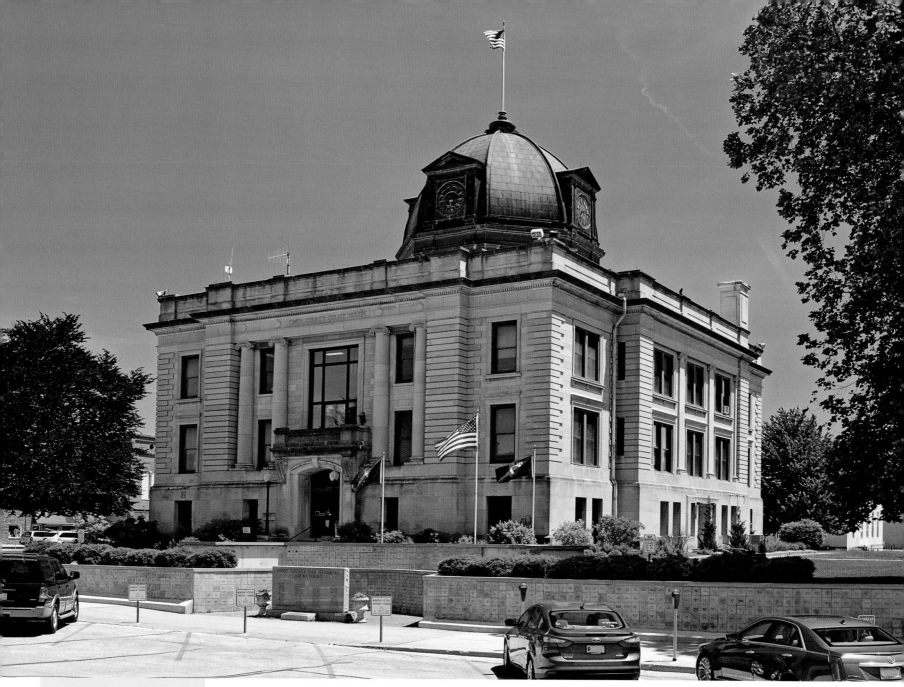

Soon after, when the county commissioners planned to lop the deteriorated copper dome off the 1911 courthouse, OCP raised money for a feasibility study and grants for repair. The group recruited Spencer elementary students to collect pennies for the repair project. More than anything else, this may have caused the commissioners to reconsider. In 1997, the commissioners approved spending $1.7 million to restore the dome.

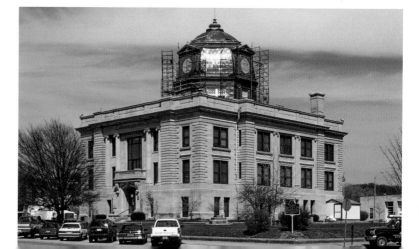

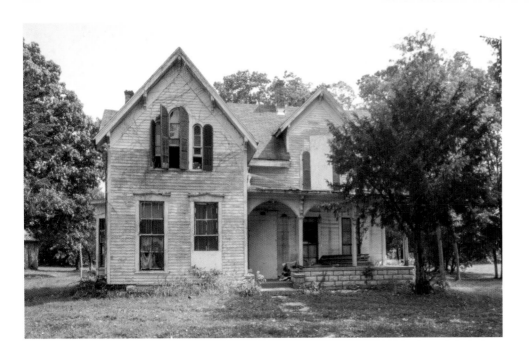

Emboldened by its success, OCP saved the 1870s house Mae Worman occupied until her death in 1991 at the age of 100. She willed the rundown house and nearly eight acres to a cemetery. Declining OCP's offer to buy the house, the cemetery sold the property to a developer who planned on demolition. OCP convinced the developer to sell the house and one-third acre of land. A $50,000 Indiana Landmarks loan covered the restoration. In 1996, the developer who had planned to demolish the house bought the restored and protected home for his grandson. Sweet!

WORMAN HOUSE

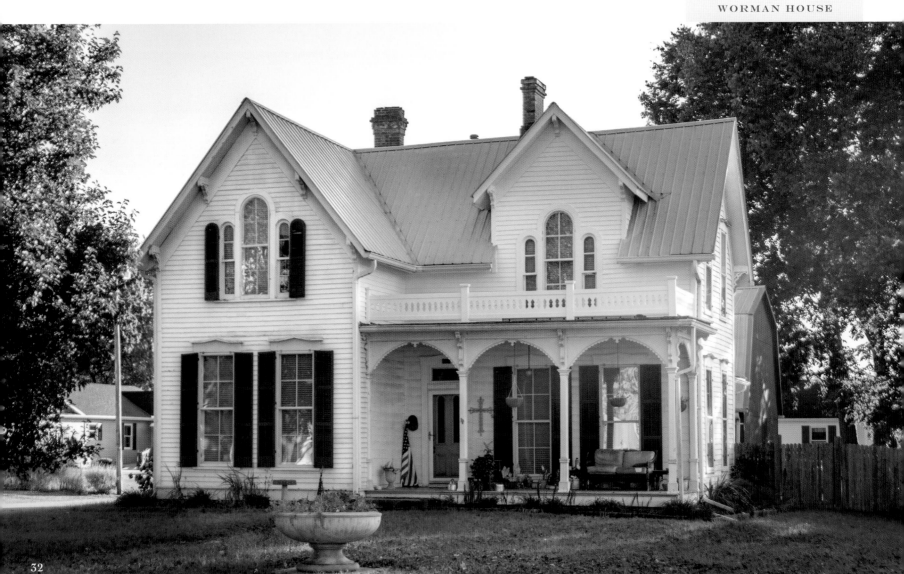

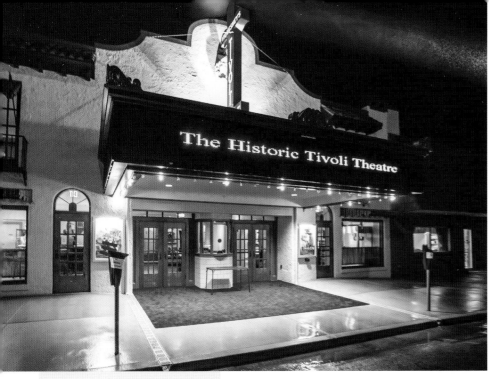

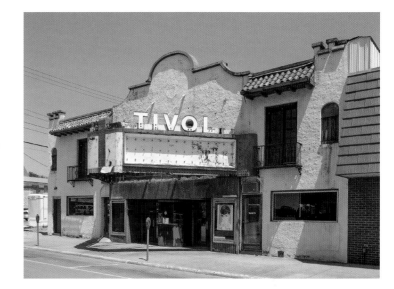

TIVOLI THEATRE

OCP scaled up in 2005, tackling the Mission Revival-style Tivoli Theatre when it faced demolition, with holes in the roof and water pooling on the floor. At the same time, the library board donated the 1911 Carnegie Library to OCP for redevelopment as the Owen County Heritage & Culture Center.

OCP's go-to reputation and track record influenced Bloomington's Cook Group to contribute to the restoration of the movie palace. It reopened in 2013, returned to its romantic 1920s splendor with a ceiling of constellations displayed in fiber optic lights and digital projection to accommodate first-run movies. The Tivoli also hosts theater productions and community events that bring hundreds of people downtown on evenings and weekends.

Thanks to OCP, downtown Spencer came alive. Coffee shops and restaurants followed, filling vacant storefronts. Now everyone sees the possibilities.

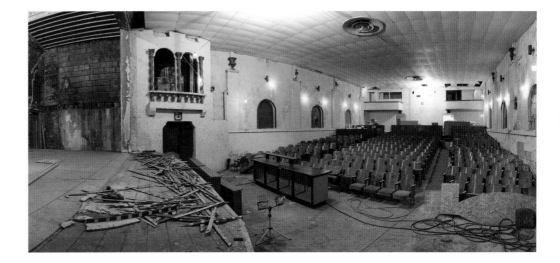

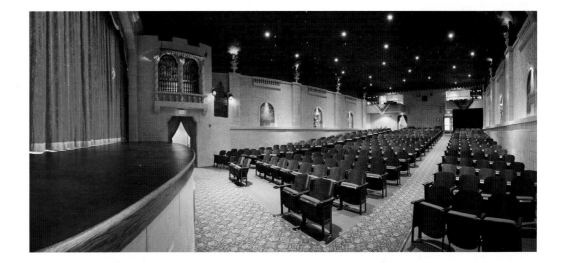

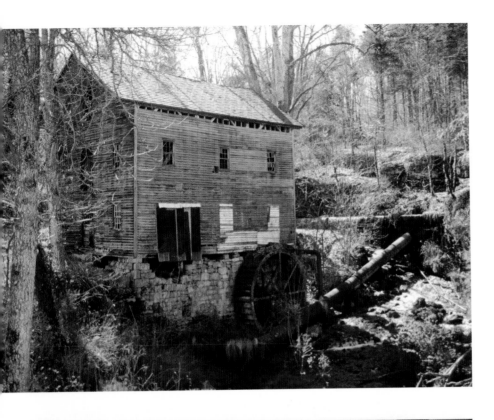

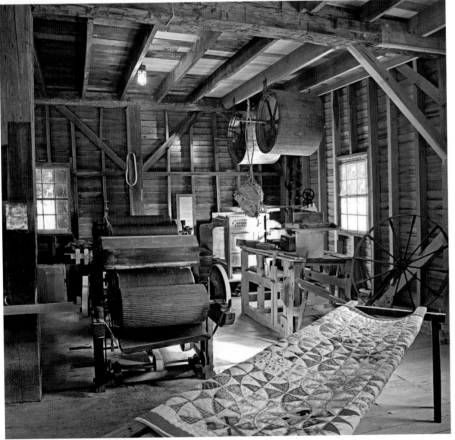

# Beck's Mill SALEM

For years, Beck's Mill—a picturesque rural ruin with weathered bare clapboard—drew photographers. Fearing that photographs soon would be the only thing left to document the historic place, Indiana Landmarks declared it a 10 Most Endangered site in 2005 and funded a conditions assessment.

Built in 1864 by the Beck family, the mill used a water wheel and turbine to propel grinding stones that produced flour and cornmeal. One of only 20 surviving gristmills of the 2,000 that once dotted Indiana, the building still contained original machinery and grinding stones, silent since the 1950s.

Publicity surrounding the mill's endangered status led to the creation of the nonprofit Friends of Beck's Mill and influenced the seventh generation of the Beck family to donate the property to the group. The Friends of Beck's Mill faced a years' long, grant-by-grant restoration project until 2007, when representatives of the Cook family, noted Bloomington industrialists and preservationists, unexpectedly appeared at a board meeting and offered to restore the mill—to wild applause and some tears.

Reopened in 2008, the mill's repaired equipment runs on water-power from the stream that rushes from a spring in the rocky bluff above the mill. You can visit on weekends spring through fall and buy cornmeal ground on the spot. Pack a picnic lunch and check out the hiking trails surrounding the mill.

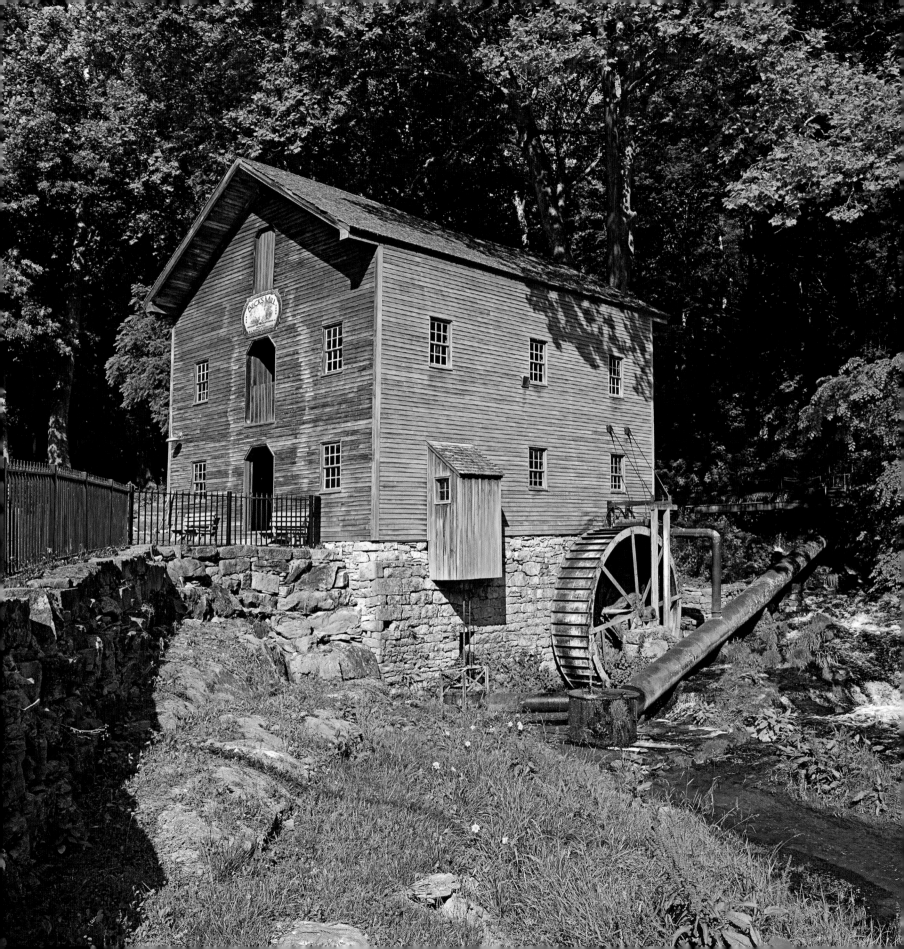

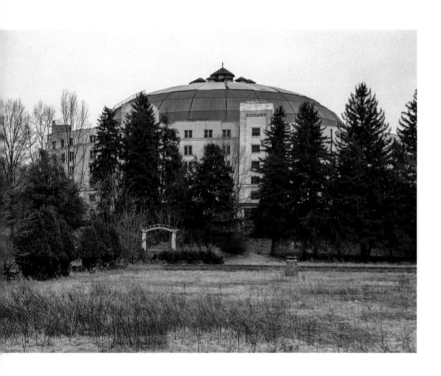

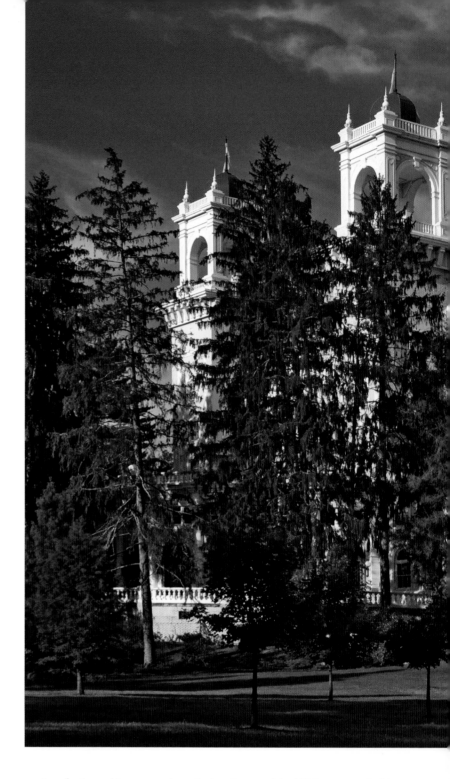

# West Baden
# Springs Hotel
WEST BADEN SPRINGS

"Call it a ruin and let people crawl on it." An East Coast real estate expert delivered the advice to Indiana Landmarks in the mid-1990s after a section of the West Baden Springs Hotel collapsed. Vacant since the mid-1980s, the National Historic Landmark inspired both awe and dread.

Awe for its architecture: when the hotel opened in 1902, many called it "The Eighth Wonder of the World" for its domed atrium, 200 feet across by 100 feet tall. The wealthy, famous, and occasionally infamous arrived for lengthy stays to "take the waters" until the hotel closed during the Great Depression. A Jesuit seminary occupied the property for 50 years, followed by 10 years as Northwood Institute and a decade of abandonment.

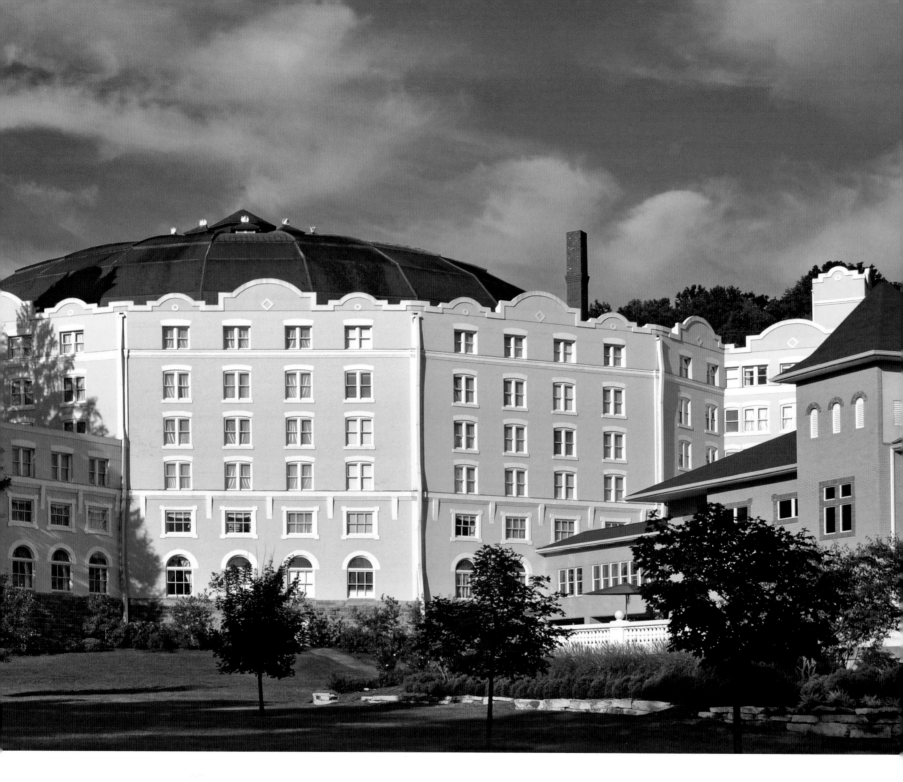

Dread for a daunting list of negative factors: its size, ruinous condition, cloudy title stuck in a bankruptcy court, distance from interstates. Following the collapse of a portion of the hotel in 1991, Indiana Landmarks invested in steel bracing to buy the place time. Five years later, ignoring the expert advice, the organization bought the hotel and won help for the rescue from medical manufacturers and philanthropists Bill and Gayle Cook. Experts in restoration, the Cooks offered to partially restore the building. A handshake, not paperwork, sealed the deal.

While Indiana Landmarks handled daily tours, marketing, environmental issues, and development incentives, the Cooks' team of architects and contractors began restoring the place so that a buyer could see the potential. The family spent nearly $35 million on a stunning restoration of the building

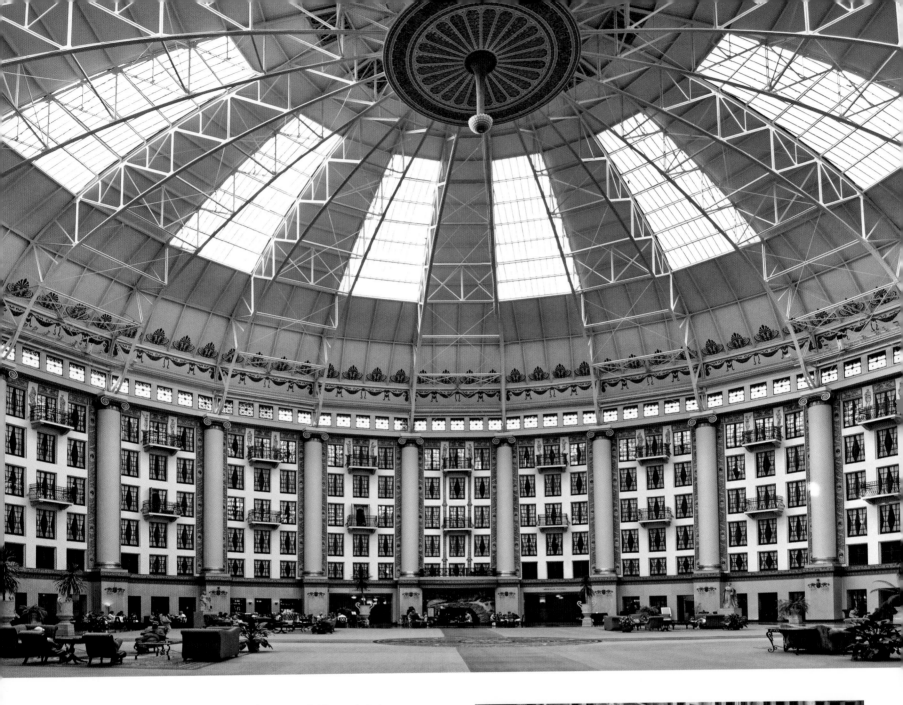

exteriors, the large garden, and the hotel's atrium, lobby, and dining room. The initiative to save the West Baden Springs Hotel helped win the Indiana legislature's approval of the casino license for Orange County. But while the property drew the attention of many developers, bottom-liners simply couldn't see the upside given the remaining renovation need.

The civic-minded Cook family decided to go all in. Bill and Gayle, joined in the endeavor by their son Carl, bought and restored the equally historic French Lick Springs Hotel a mile away and built a casino next door to support both historic landmarks. In 2006, Indiana Landmarks handed the

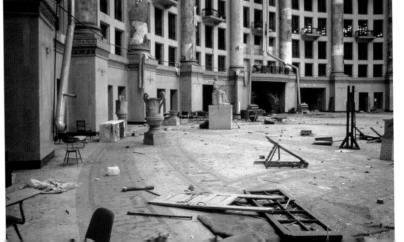

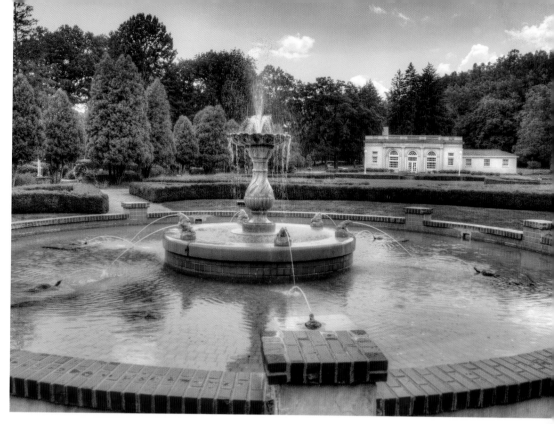

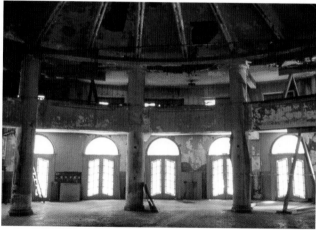

West Baden Springs Hotel to the Cooks, grateful that they were committed to finishing what they started. A year later, the hotel welcomed guests to spend the night for the first time since 1933 in 243 luxurious rooms.

With 1,800 employees, the French Lick Resort—the name of the combined historic hotels, casino, and golf courses—elevated the economy of the entire region and led to other new hotels and attractions, restaurants, shops, and service businesses. Many call it the "Save of the Century."

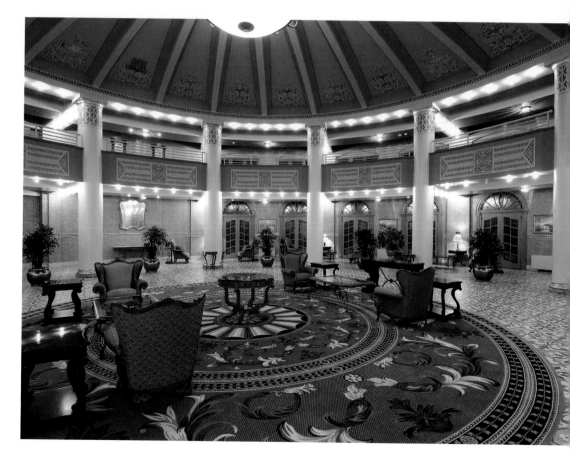

# RECONNECTED

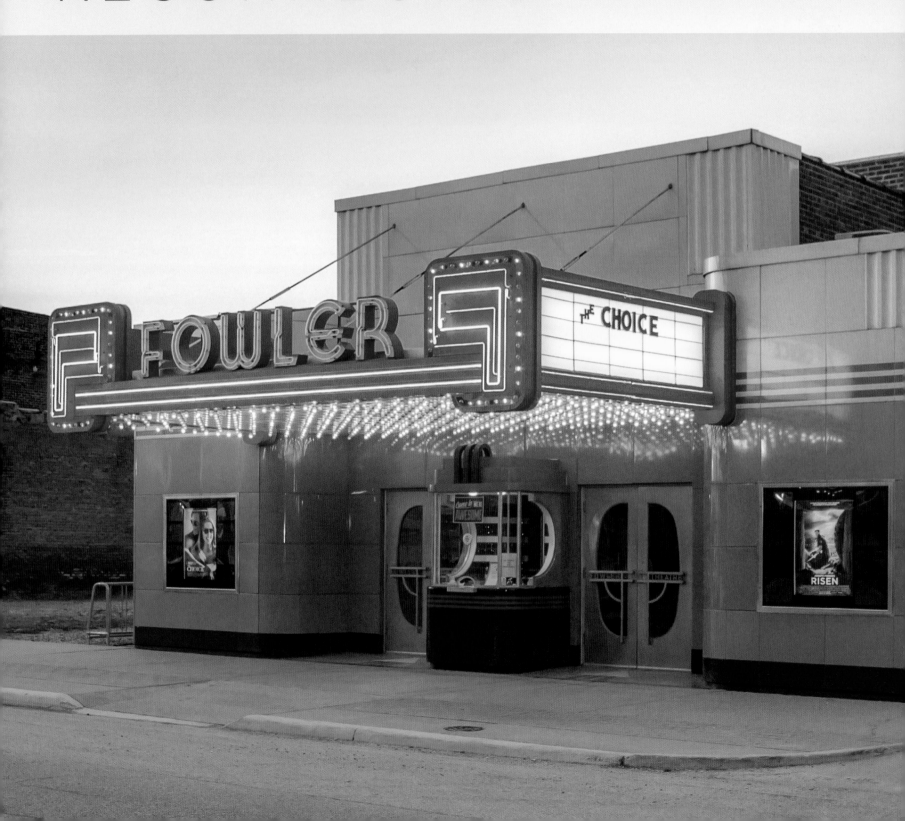

# Fowler Theatre FOWLER

Sometimes a landmark gets rescued and restored because it's lodged in the community consciousness as an important place, one whose history commands attention or inspires affection and whose presence adds meaning to life in the present. It might be a school, a street clock, a barn, or a church that connects people across generations. In Fowler, it was the local movie theater.

In the first half of the twentieth century, people flocked to the downtown movie house for entertainment and escape. In 1946, 90 million people saw a movie every week in the U.S. The movie theaters of that era reflected the importance of cinema in their locations and in architecture that aimed for Art Deco glamour or Middle Eastern exoticism or ancient Mayan mystery, with extravagantly illuminated marquees.

By the 1990s, the lights were going out at historic movie theaters, their popcorn eaten by impersonal multi-screen cinemas on the outskirts of town. It was about to happen in Fowler, population 2,300, northwest of Lafayette. Locals discovered that the owner of the Fowler Theatre planned to strip out the Art Deco elements and sell the building for storage. The place was in ragged shape, but the Prairie Preservation Guild coalesced to save it.

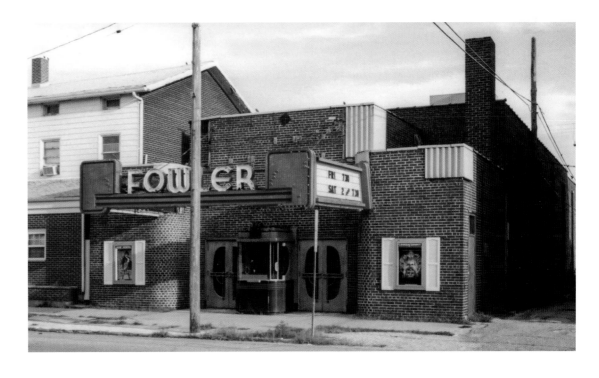

The Guild got a loan from Indiana Landmarks in 2001 to cover the $30,000 purchase price, plus more for immediate repairs. They envisioned a three-phase, pay-as-you-go restoration plan, beginning with the roof, the main façade, and the marquee. Volunteers did a lot of the dirty work, pulling up carpeting, removing soggy plaster, and cleaning so the show could go on each weekend to help pay the bills.

To restore the 840-bulb marquee, Prairie Preservation Guild "sold" each light bulb for a $10 donation. In Phase III, all the auditorium's 210 new seats found a $350 donor. A bank loan and sizeable contributions and grants came from North Central Health Services, Benton County Community Foundation, and many others.

"Mission Possible" appeared on the marquee when the group closed the place for five months in 2012 to restore the lobby and concession stand and revamp the antiquated restrooms to meet accessibility codes. They also created more stage space to attract other income-producing uses. Prairie Preservation Guild finished the restoration in 2015.

The Guild's 300 volunteers include entire families who sign up for a night when they sell the tickets, make and sell the popcorn, and clean up after the shows, restrooms included. Under the brilliant marquee lights, it's the place where people gather and talk with friends and neighbors, a historic community connector.

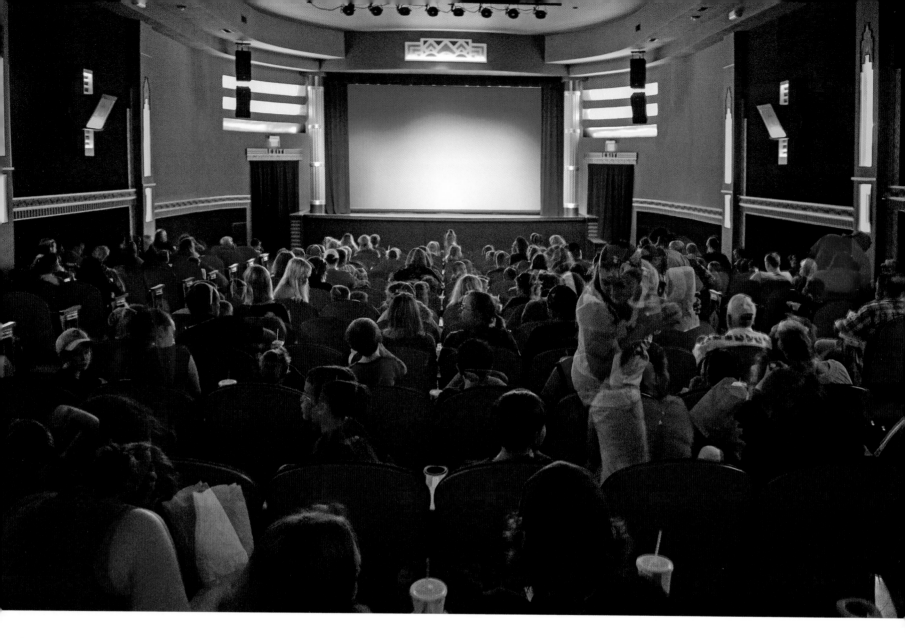

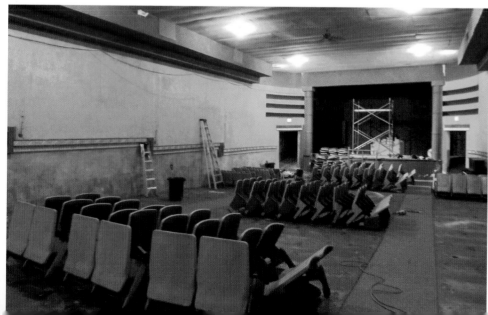

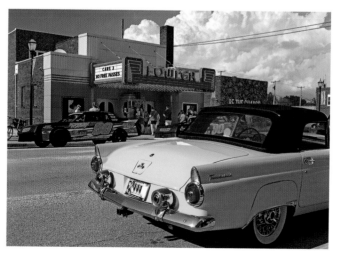

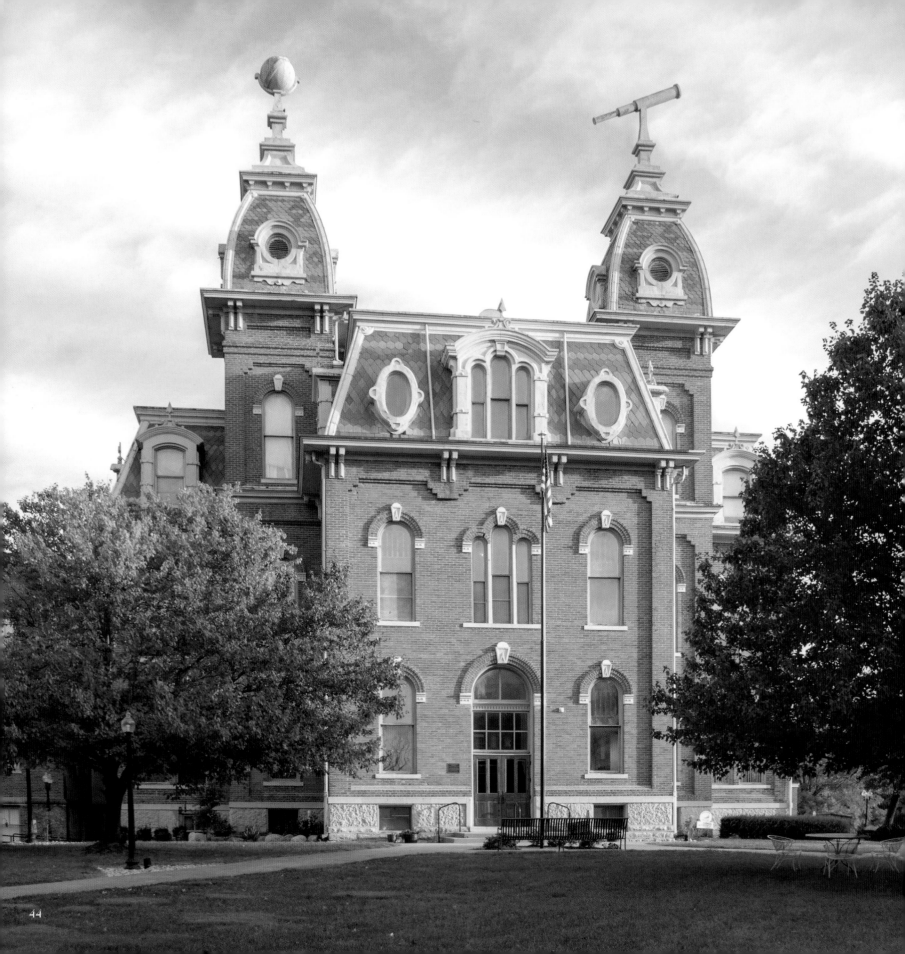

# Knightstown Academy
## KNIGHTSTOWN

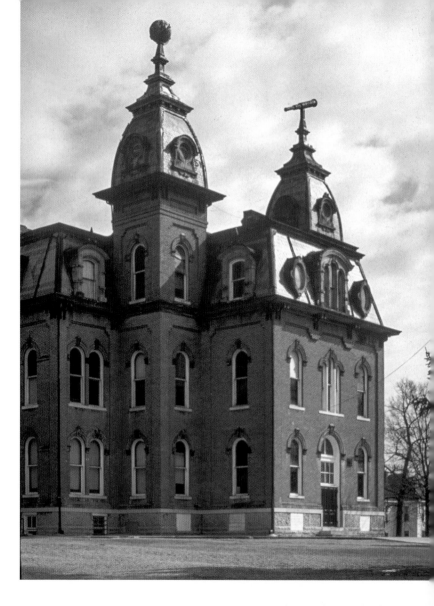

Traveling along the historic National Road (U.S. 40) in eastern Indiana, look north as you pass through downtown Knightstown and you'll glimpse in the distance two towers, one topped by a globe and the other a telescope. Intriguing, right? The towers belong to an 1876 school designed in the French Second Empire style by a German-born architect.

The building's style and ornamentation indicate the high value placed on education in the community. Additions went up in 1890s, 1920s, '30s, and '60s. The 1986 movie *Hoosiers* used the school's 1921 gymnasium as the home court of the Hickory Huskers. But that same year, the grand building was abandoned, replaced by new public schools.

After Historic Knightstown, Inc., tried unsuccessfully for three years to find a new use for the landmark, the school corporation sought demolition bids. To avert such a loss, neighbors and preservationists Tom and Peggy Mayhill made a donation that allowed Indiana Landmarks to buy the building. Advertised nationally as a redevelopment opportunity, it sold with a protective covenant to a Michigan firm that converted it to apartments for seniors.

Academy Place opened in 1993. In 2018, a new locally based non-profit organization bought the landmark, which includes alumni among its tenants. A separate nonprofit manages the famous Hoosier Gym where high school athletes from across the state come to play games in a Hoosier basketball shrine.

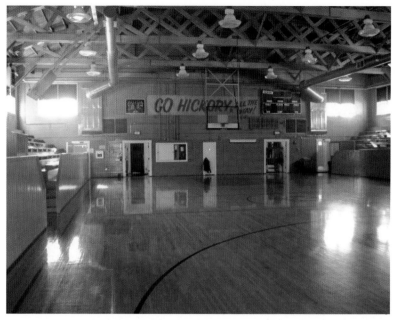

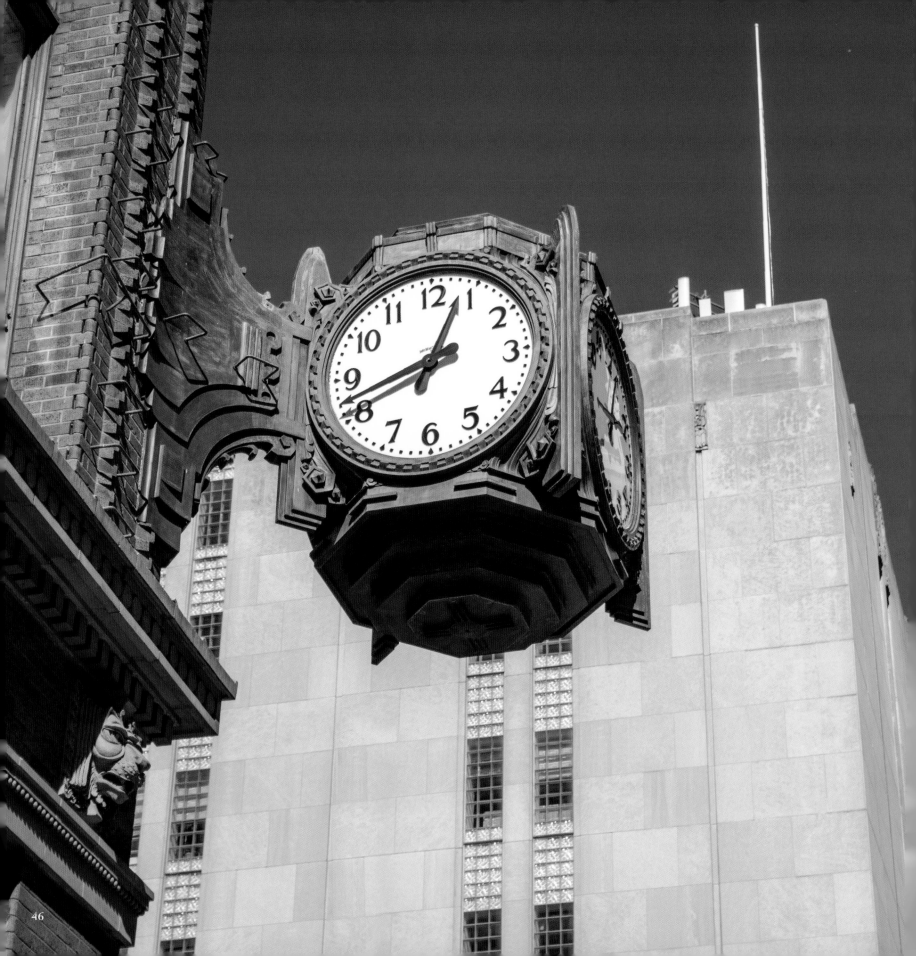

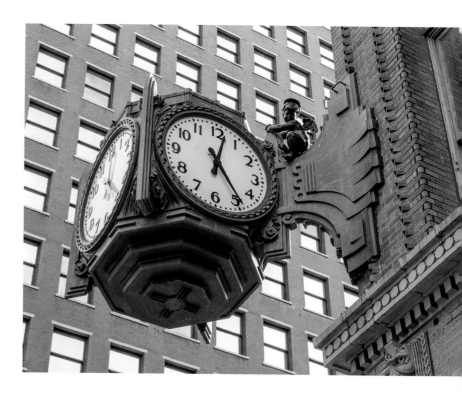

# Ayres Clock INDIANAPOLIS

**B**ack in the day at L. S. Ayres—the city's top department store—you could find everything from an elegant silver tea service to needles and thread. Vonnegut and Bohn designed the store in 1905 and added the bronze clock in 1936. Suspended from the corner of the building, 29 feet above the sidewalk at Washington and Meridian streets, it gave passersby the time from all four directions.

The flagship store closed in 1992. The city owns the building now, along with the 10,000-pound clock. Every Thanksgiving Eve, a three-foot-tall bronze cherub arrives to perch on the clock—an annual holiday tradition since 1947.

In 2016, two Indiana Landmarks members, Mary Kummings and Paul Smith, asked if the organization could help fix the clock. No one remembered how long it had been out of order. Each of its four faces displayed a different time, none correct.

Indiana Landmarks launched a grassroots campaign in early October of that year and by the end of the month had raised $70,000 from 370 people and corporations to repair the beloved civic timepiece. The money also covered restoration of the faces and night-time illumination, as well as cleaning the bronze case and a fund for annual maintenance for years to come. The time was right when the cherub arrived on Thanksgiving Eve 2016, and has been ever since.

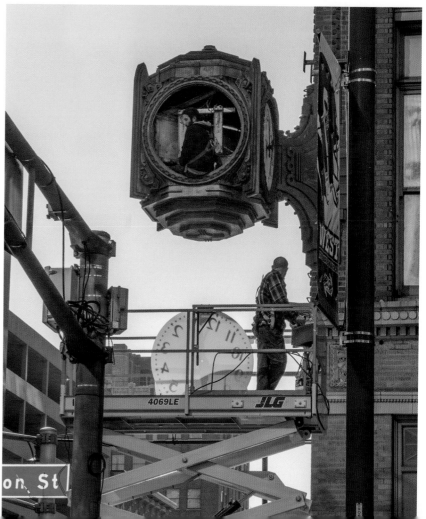

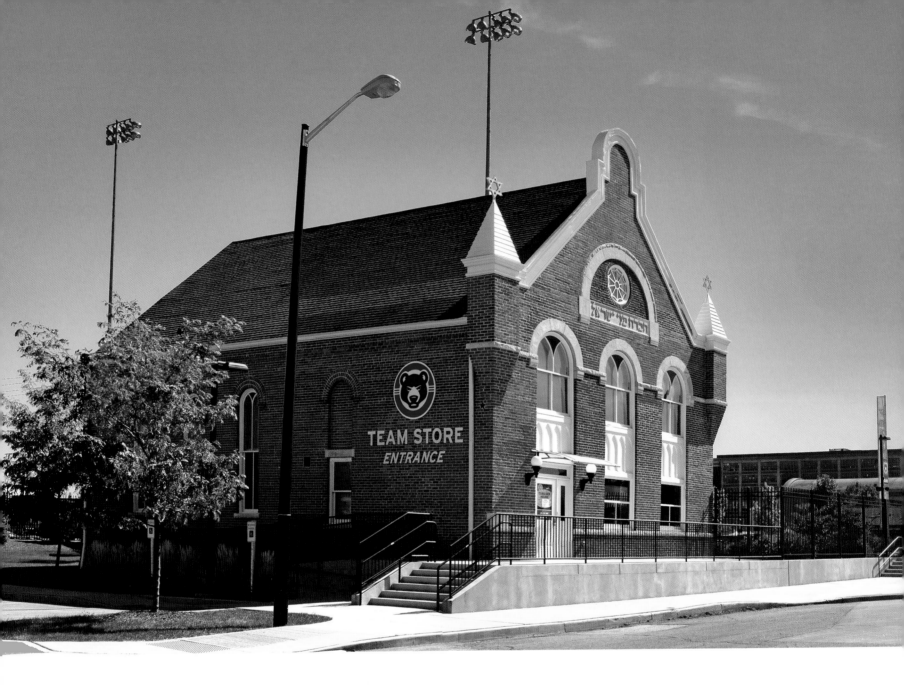

# B'Nai Synagogue SOUTH BEND

**E**ighty feet from left field at South Bend's Four Winds Field, a Chicago Cubs minor league team logo decorates the roof of a historic Jewish synagogue. Old and new blend cleverly and respectfully in the c.1901 building reinvented as The Cubs Den, the team store.

The city's first synagogue remained in religious use for 90 years until the dwindling congregation closed the building in 1991. The remaining members donated the structure to Indiana Landmarks so that it could be protected, including some interior features, and guaranteed a respectful new use.

After a buyer's plan to turn it into a home failed, the organization considered moving the building until 2010, when the City of South Bend proposed incorporating the landmark in improvements to the facility, then known as Coveleski Stadium, aka The Cove.

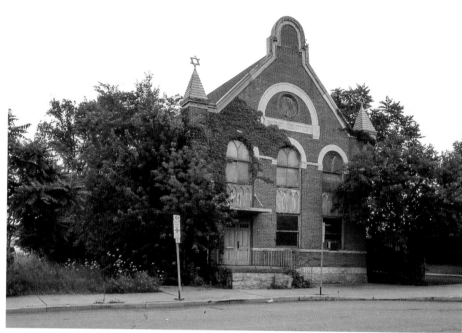

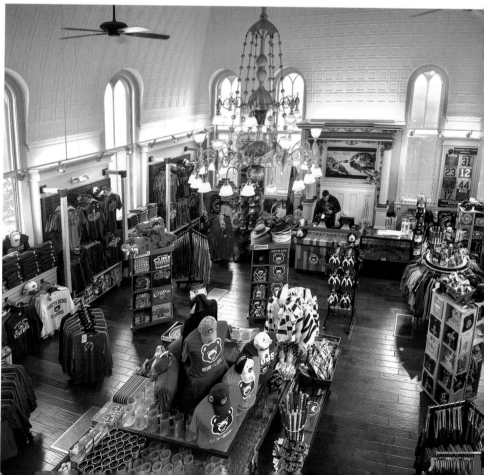

Sales soared when The Cubs Den opened. From the tin ceiling to the hardwood floors, the space retains original details that reflect the building's heritage. "Rain Delay," a painting in the former altar space, depicts Noah's Ark.

"It is the coolest team store in all of major and minor league baseball," says Andrew Berlin, South Bend Cubs chairman and owner.

# Cardinal Ritter Birthplace NEW ALBANY

In 2001, the City of New Albany issued a demolition order for an unsightly old house. Paul Graf, who'd grown up in the neighborhood, alerted Indiana Landmarks to the building's provenance as the boyhood home of Cardinal Joseph Ritter (1892-1967), one of the most influential American Catholic clergymen of the twentieth century.

Beginning in the 1870s, the Ritter family operated a bakery in the house where Joseph worked as a youngster. Ordained a priest in 1917, he rose in rank to bishop, archbishop, and cardinal. As bishop in Indianapolis in 1938, he received death threats and burning crosses from the Ku Klux Klan for desegregating the Catholic schools. He did the same in the late '40s for

Catholic schools in St. Louis, years before racial segregation in public schools was ruled unconstitutional by the Supreme Court.

Indiana Landmarks rescued the house in 2002, restoring the exterior with support from the Efroymson Family Fund, City of New Albany, Caesars Foundation of Floyd County, and others while helping to organize the Cardinal Ritter Birthplace Foundation. The group took over in 2005 and finished the $1.5 million renovation.

The house shelters nonprofit tenants and, in the space occupied by bakery ovens in Ritter's boyhood, a museum that tells the story of a man who led and inspired others in promoting equality and combatting injustice.

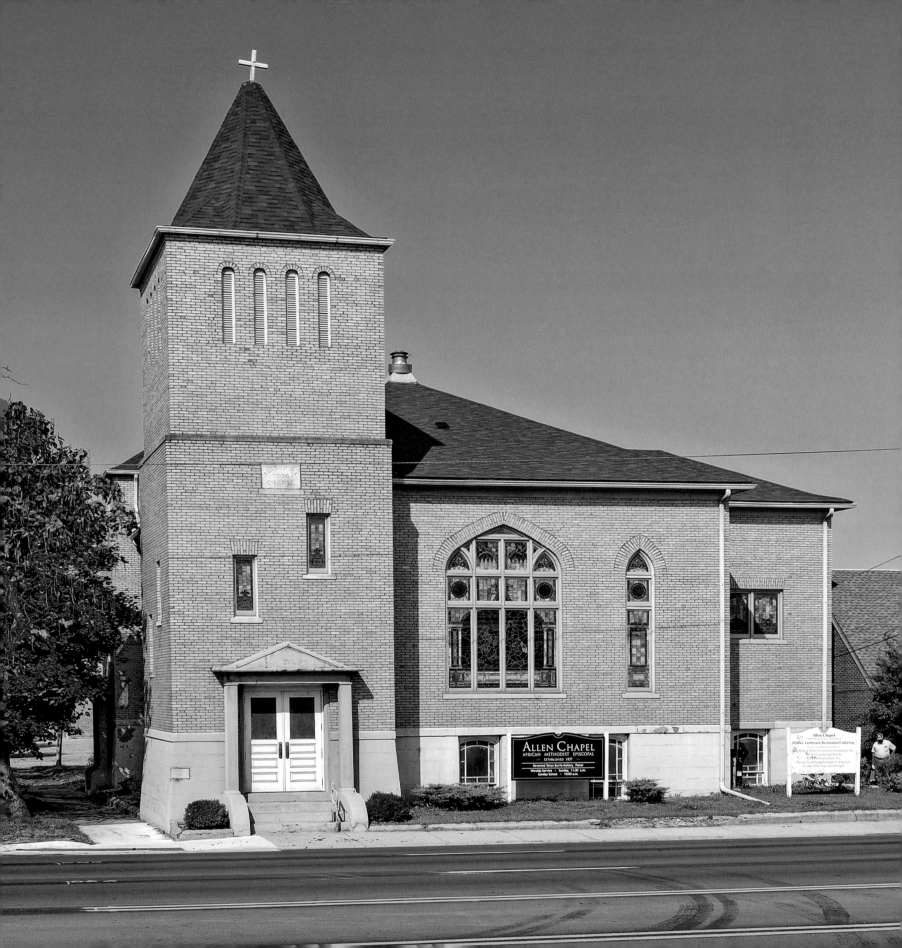

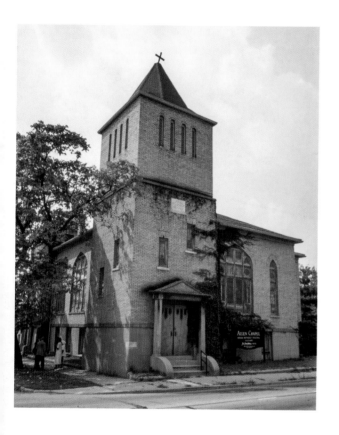

# Allen Chapel TERRE HAUTE

From its founding in 1837, Allen Chapel was a potent force in the life of Terre Haute's African American population. A station on the Underground Railroad, the church created the city's first school for black children when segregation excluded them from public schools. The congregation built the current church after a 1913 fire destroyed its 1870 predecessor.

Urban renewal decimated the African American neighborhood around the church in the 1960s and '70s, causing a decline in membership and in the structure. The building's dire condition drew notice, and in 1997 the Friends of Historic Allen Chapel formed to restore the landmark.

Indiana Landmarks supplied a challenge grant to get the ball rolling and other grants along the way. The determined Friends group raised money and ticked off projects one by one over two decades: a new roof; masonry repair; refurbished pews and restored stained-glass windows; updated systems; a new kitchen; accessibility improvements. A matching grant from the state's Historic Preservation Fund in 2017 covered the final phase that included rebuilding staircases, repairing interior plaster, painting, and refinishing doors and trim.

Older church members recall that when the church was on the ropes, someone offered to buy and demolish it for a parking lot. The congregation stood fast, and with help from its Friends group, donors, and the community, so does historic Allen Chapel.

# Naval Armory INDIANAPOLIS

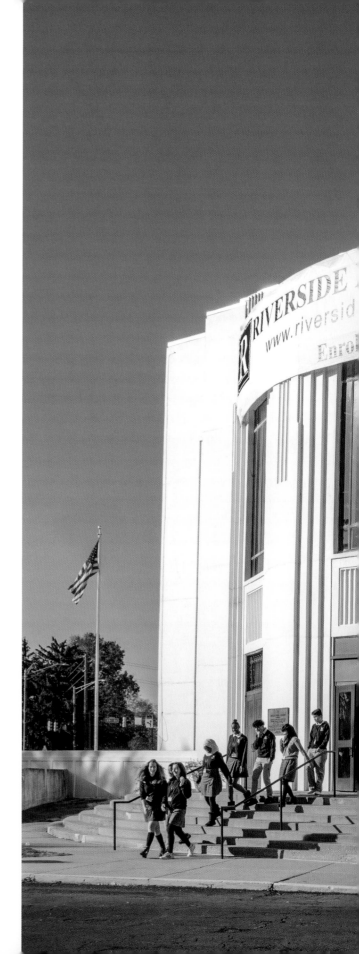

Evoking a sparkling white ship moored on the White River at 30th Street, the Art Moderne armory debuted in 1938 as a Naval Reserve training center. During World War II, the U.S. Department of the Navy commandeered it to train more than 1,000 radio operators and as a planning site for naval war strategy.

After the armory was decommissioned in 2015, no state or city agencies saw a use for the structure. Indianapolis Classical Schools, operator of Herron High School, had its eye on the armory as the perfect site for a second school, one that could act as a revitalization catalyst for the Riverside neighborhood.

But it needed a nonprofit to whom the city could give the property. Indiana Landmarks stepped in, accepting the building while the charter school raised money for the adaptation. Indianapolis Classical Schools raised $7.5 million to open Riverside High School and moved into the building in 2018. When it transferred ownership, Indiana Landmarks retained a covenant that guarantees long-term preservation.

Elements remain to reflect the original nautical origins—porthole windows in interior doors, stair rails wrapped in nautical rope, world globe light fixtures in the officer's mess hall that's now the student cafeteria overlooking White River. The drill hall with murals depicting famous naval battles serves now as home gym for both Riverside and Herron high schools.

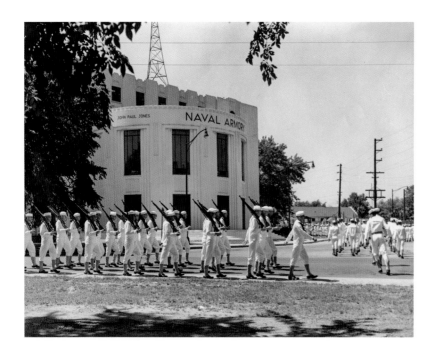

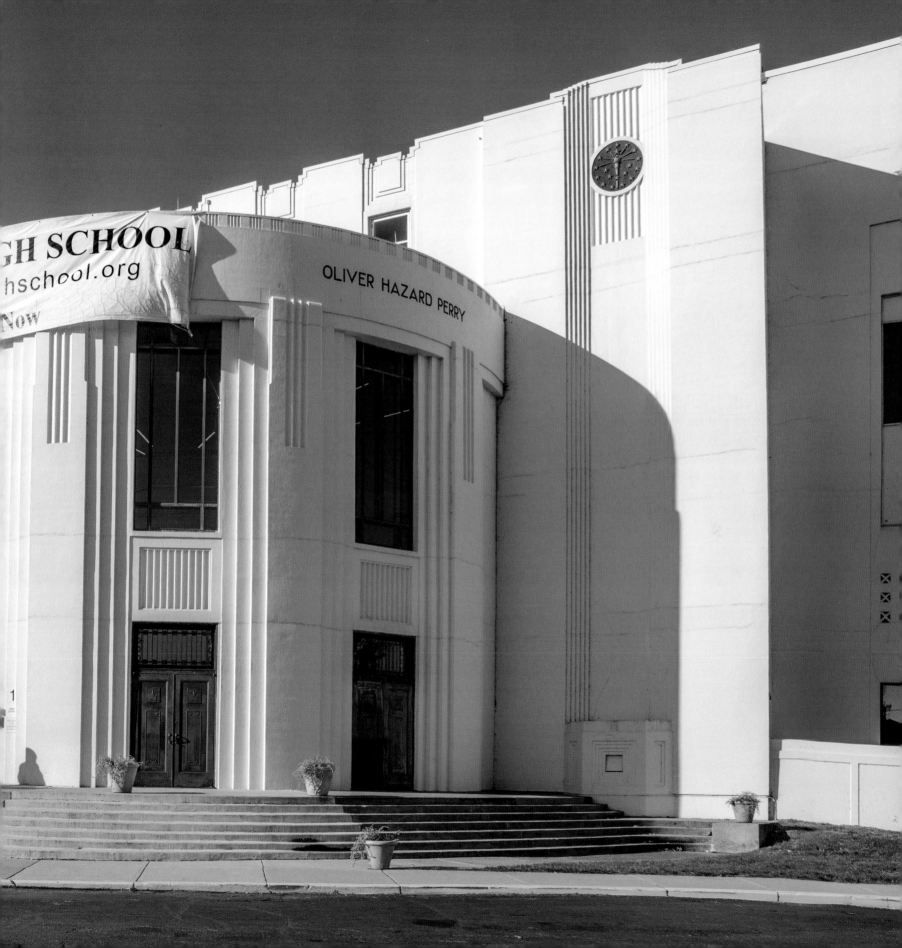

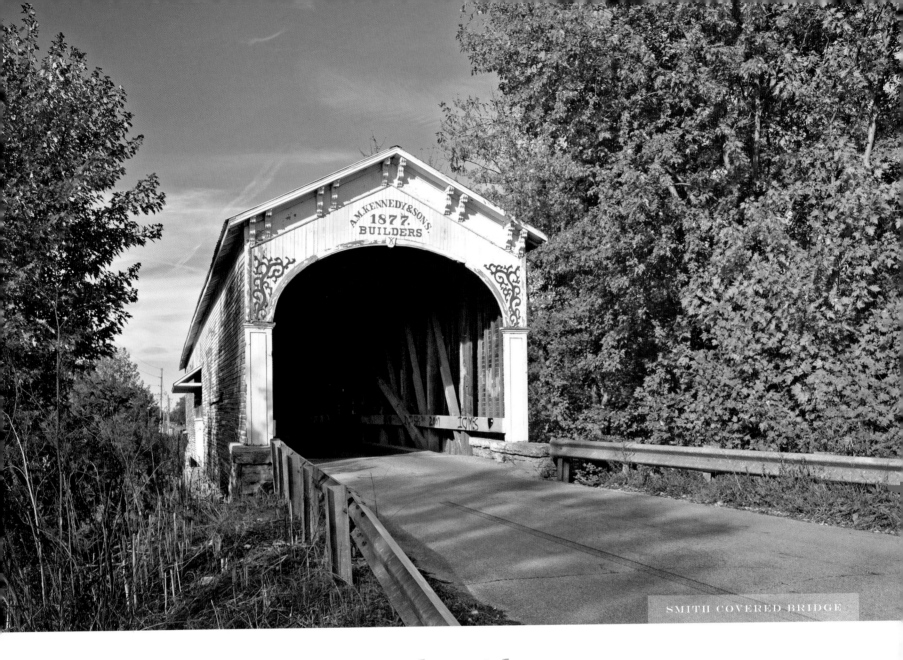

# Rush County Covered Bridges

Covered bridges, sturdily built for a utilitarian purpose, today seem to signify a bygone, less hurried America. After settling in Rush County, Archibald McMichael Kennedy constructed many such bridges. He launched a family bridge building dynasty that stretched for three generations and produced nearly 60 covered bridges in Indiana and Ohio.

Rush carefully tends its six remaining Kennedy covered bridges, all listed in the National Register of Historic Places. But they weren't always safe. In 1986, Rush County Commissioners voted to destroy the 1873 Ferree Covered Bridge. In fact, they intended to replace all but two of the county's covered bridges and assumed little opposition. Wrong. The vote triggered the formation of a preservation organization, Rush County Heritage, Inc., and a grassroots campaign that unseated incumbent commissioners in favor of pro-heritage candidates.

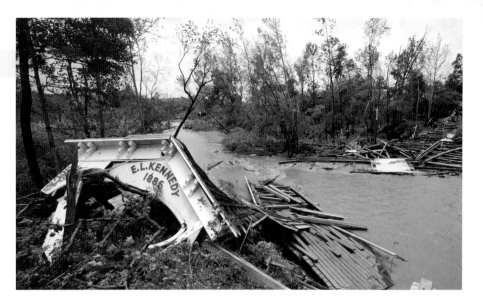

The official change of attitude showed in 2008 after a tornado blasted the 1886 Moscow Covered Bridge into the Flatrock River. The Rush County Commissioners quickly voted to rebuild the bridge, not knowing where they'd find the money. Indiana Landmarks joined Rush County Heritage, Inc., in raising much of the $1.4 million cost, with the state Division of Forestry contributing timber to accompany salvaged wood from the original bridge. Riding his motorcycle, then Governor Mitch Daniels led the parade that dedicated the restored bridge in 2010.

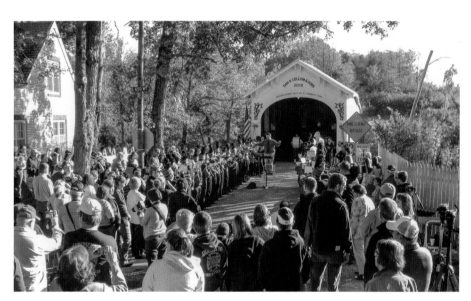

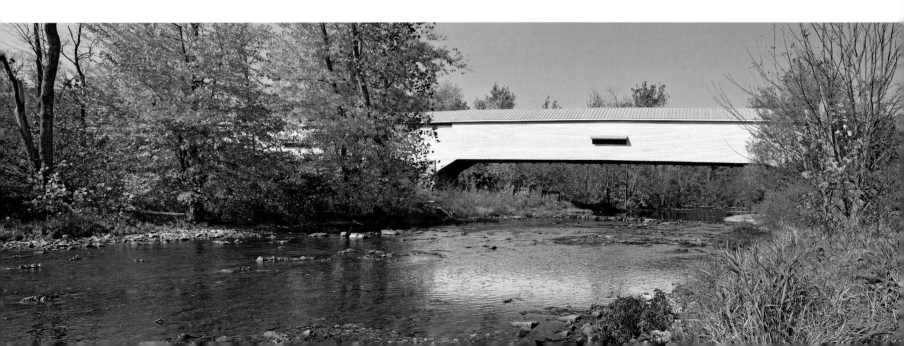

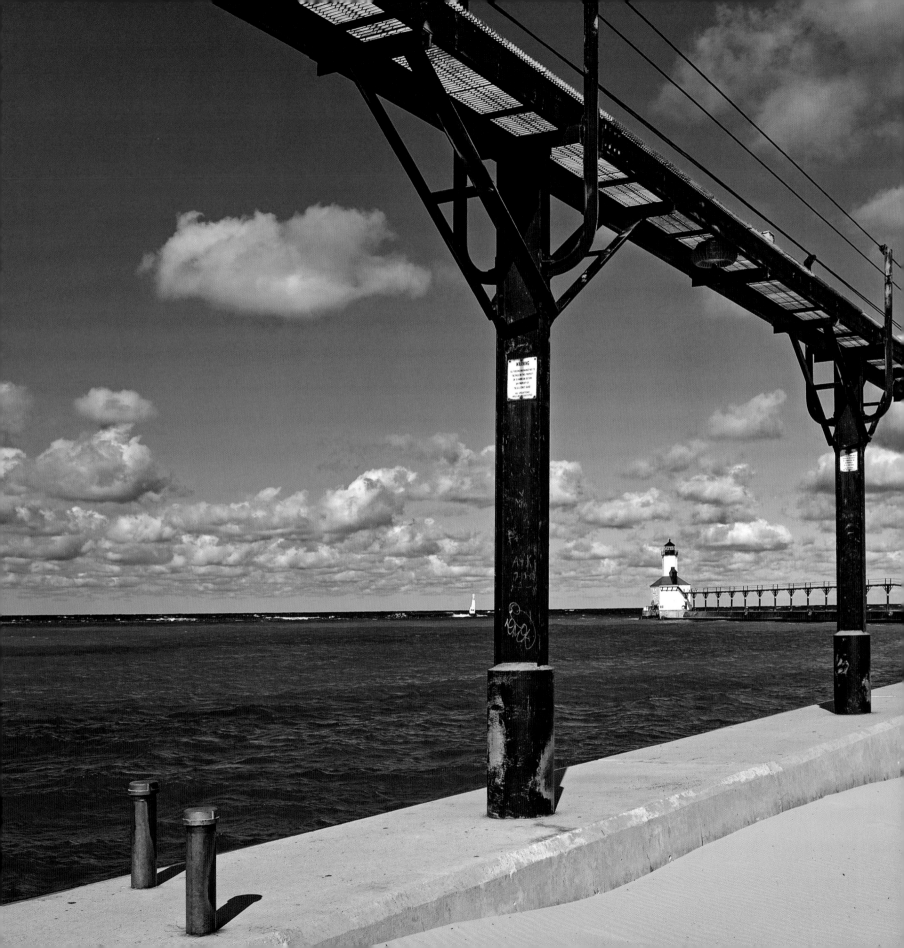

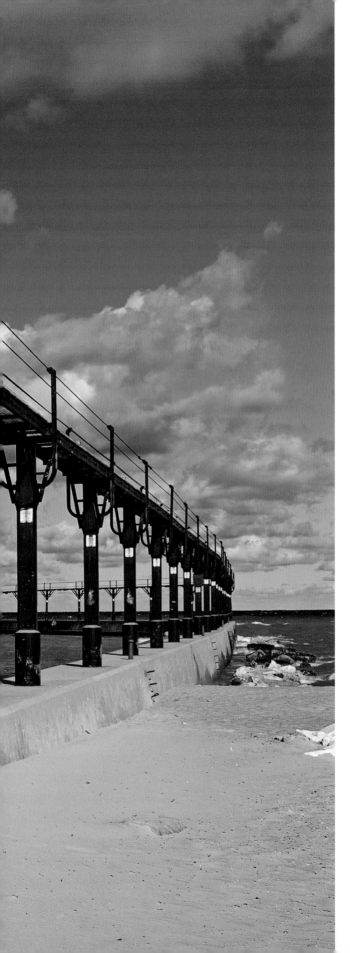

# East Pierhead Catwalk
## MICHIGAN CITY

For more than 170 years, pleasure boaters and the captains of giant cargo ships relied on the lighthouse at Michigan City to keep them from running aground on Indiana's sliver of Lake Michigan. To ensure the light stayed on when storms with huge waves lashed the pier, the lighthouse keeper held on for dear life as she traversed a catwalk 20 feet above the pier (Harriet Colfax was the keeper from 1861 to 1904). An iron catwalk replaced the wood version Colfax used.

By 1960, automation of the light eliminated the need for harrowing trips across the catwalk, so the Coast Guard ceased maintaining it and declared it a liability. Michigan City begged to differ, viewing the pier-catwalk-lighthouse combo as an essential part of the community's identity.

Patricia Gruse Harris and Betty Moore Rinehart started Citizens to Save the Catwalk and allied with the Michigan City Historical Society. Indiana Landmarks broadened awareness statewide when it put the deteriorated catwalk on its inaugural 10 Most Endangered list in 1991.

In 1993, instead of demolishing the catwalk, the Coast Guard deeded it to the city and a federal grant allowed its restoration. Only four of Lake Michigan's lighthouses still have their catwalks, an essential part of the lighthouse story and a delight for sunset watchers, photographers, and pharologists. Look it up!

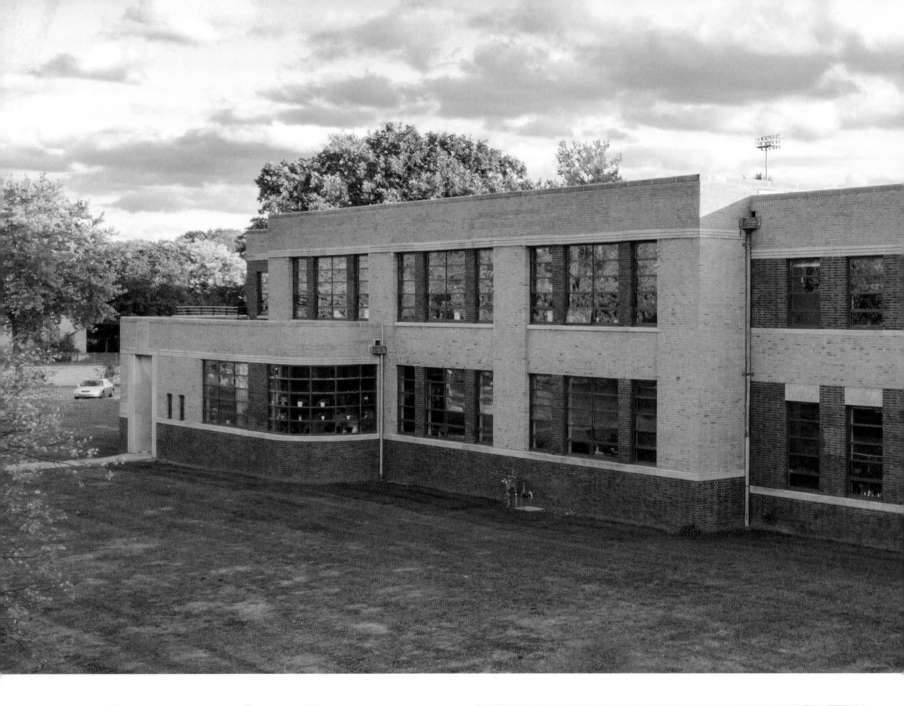

# Roberts School #97

INDIANAPOLIS

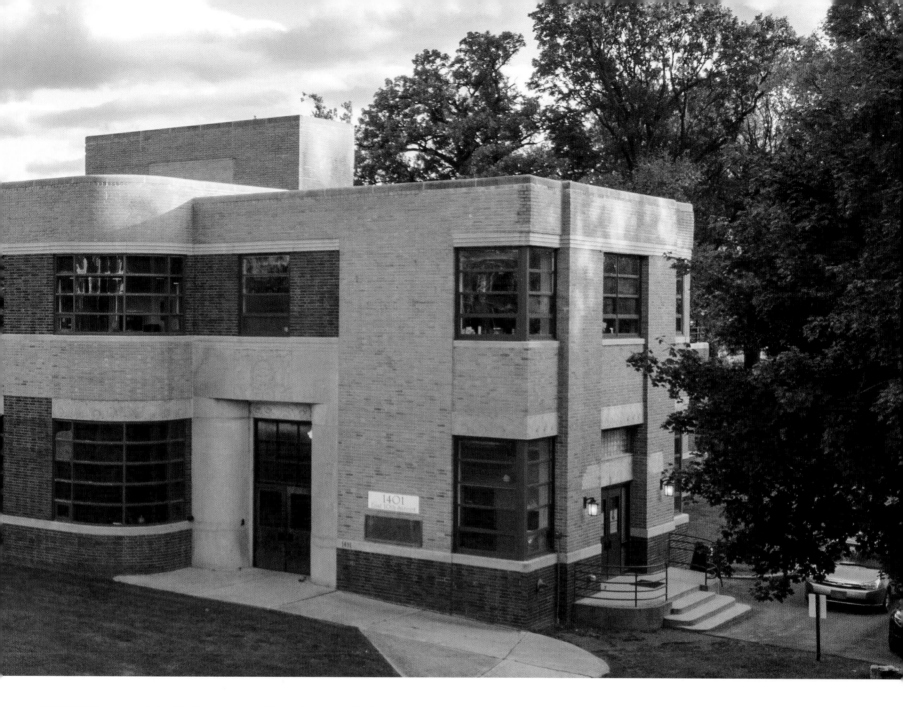

The unusual Art Moderne design of School #97 matched its unique, ahead-of-its time function as a public school for children with disabilities. The 1936 building included ramps for wheel-chair users and an elevator, unheard of in Indianapolis schools at the time, as well as rooms for physical and hydrotherapy, and a sun deck.

When legal and policy changes mandated that classrooms include all children, regardless of their abilities, School #97 became a middle school until it closed in 2006. Indianapolis Public Schools planned to demolish it for a parking lot, an outcome deplored by many who regard the school as a landmark for confirming the right to education for students with disabilities.

Indiana Landmarks declared it a 10 Most Endangered site in 2007, joining the surrounding near eastside historic neighborhoods—Cottage Home, Windsor Park, and Woodruff Place—in advocating for its reuse.

When the deed appeared to restrict the property to use solely as a school, Indiana Landmarks' legal team came up with a solution that allowed Core Redevelopment, with a 40-year renewable lease, to repurpose it as 33 apartments. Roberts School Flats opened in 2018 with the original apple green lockers lining the hallways, historic chalkboards complementing granite countertops in the units, and the sun deck for tenants' use. Best of all, the respectful restoration won praise from the disability rights community.

# Wolcott House

## WOLCOTTVILLE

Thickets of scrub trees and overgrowth hid the 1840 house built by the founder of Wolcottville. Deteriorating in legal limbo caused by an unpaid bank note and an unsettled estate, it may have caved in but for a chance encounter.

Tim Hudson—George Wolcott's great-great-great grandson—arrived from Michigan to do genealogy research in the town library, where he struck up a conversation with local historian Rex Fisher about the house. Their meeting led to a fundraising campaign that allowed the LaGrange County Community Foundation to pay off the bank note and donate the house to Indiana Landmarks.

After putting on a new roof and making other crucial repairs, Indiana Landmarks sold the house with a preservation covenant to Middlebury-area physicians Dan and Diane Kragt, who first saw the landmark as the "Save This Old House" feature in *This Old House* magazine in 2017.

Dan's practice includes the area's Amish population, with experts in timber frame construction and carpentry they're tapping to restore and expand the house. On eBay, the couple found a dismantled 1760 house from Meriden, Connecticut, very near where the Wolcotts first settled. Amish craftsmen have reassembled it using the original mortise-and-tenon construction method as an accessible addition to the house.

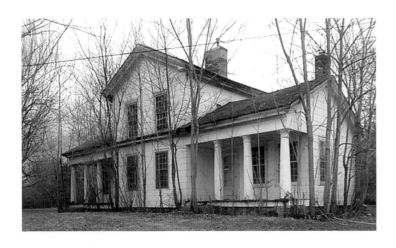

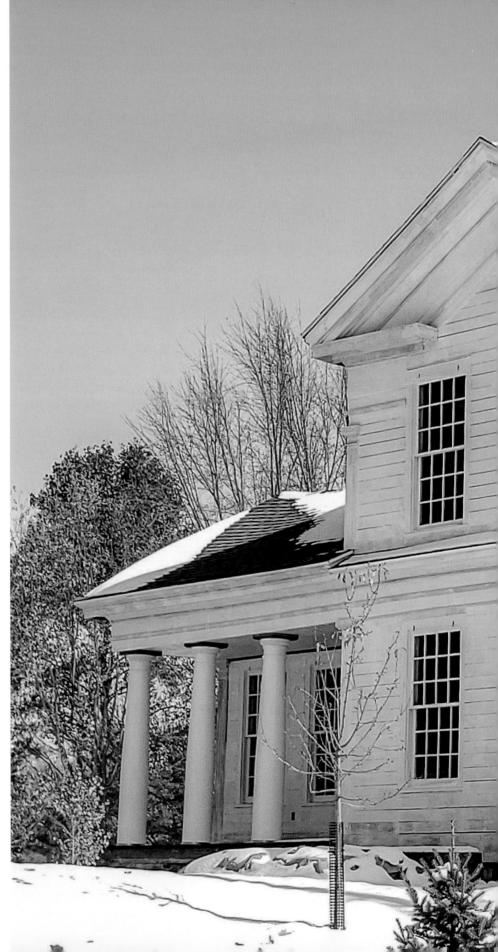

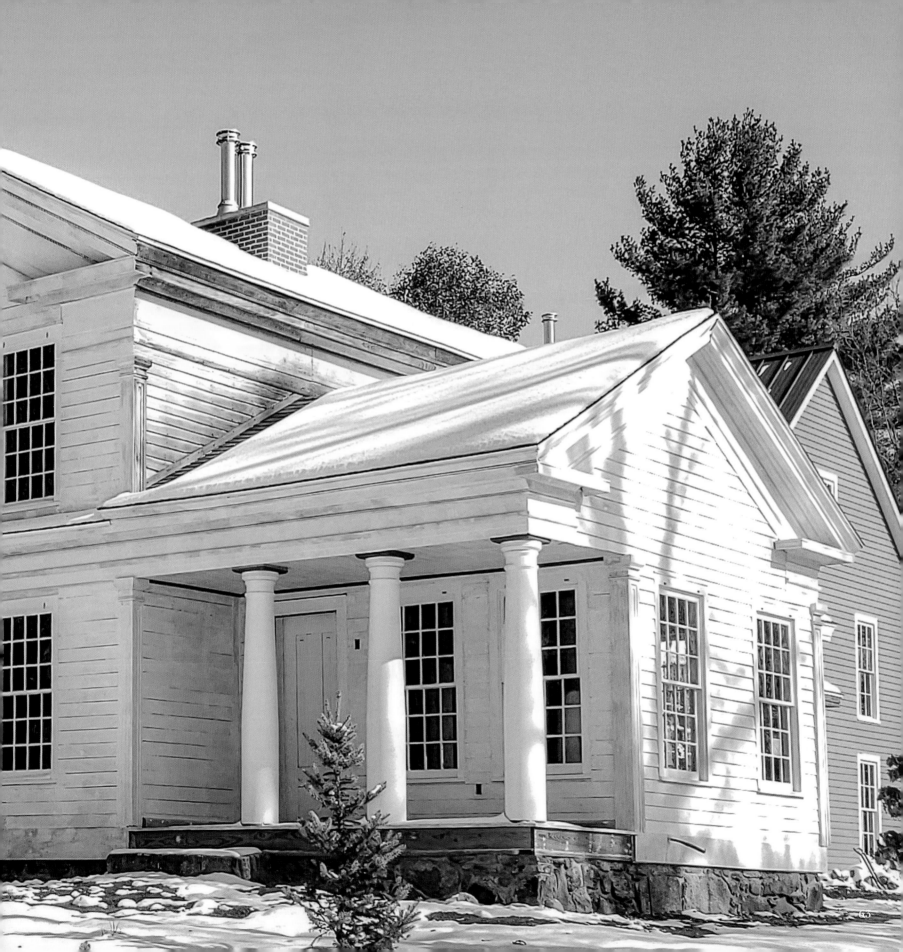

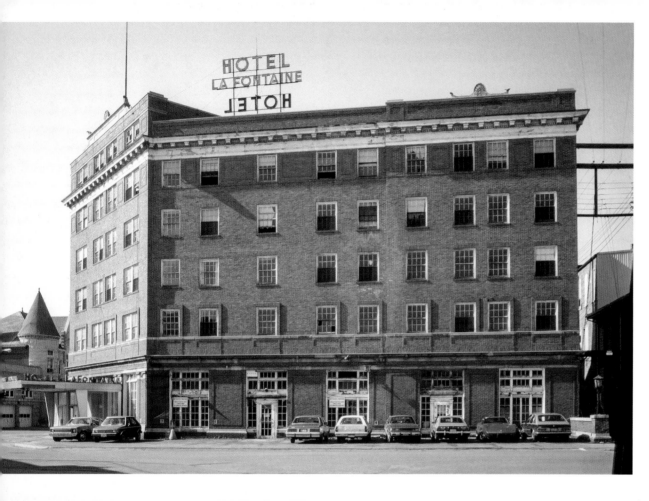

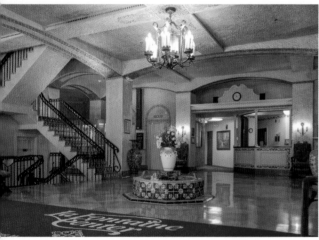

# Hotel LaFontaine HUNTINGTON

Local entrepreneur J. F. Bippus built the Hotel LaFontaine in 1925. With a reputation for luxurious rooms and fine dining, it drew famous guests—Amelia Earhart, Henry Ford, Carole Lombard, and Johnny Weissmuller, a.k.a. Tarzan—and the infamous John Dillinger. The hotel included a barber shop, ice cream parlor, ballroom, eight-lane bowling alley, and an Egyptian-themed swimming pool.

In the long run, the market wasn't sizeable enough to make the hotel profitable, especially during the Depression. It closed in 1974, a threadbare shadow of the sparkling venue of the '20s. In vacancy, vandals and weather preyed on the place. Demolition seemed the inevitable outcome.

A visionary group of locals led by Jean Gernand and Emmy Purviance advanced another idea in 1981. Indiana Landmarks helped them form a nonprofit organization, the LaFontaine Center, Inc., and win a $2.5 million HUD loan to convert the structure into senior housing with the Retirement Housing Foundation of the United Church of Christ as operator.

Two hundred volunteers restored the first-floor lobby with its signature frog fountain and stenciled walls. When it opened with 66 apartments in 1987, the residents included people who had worked as maids and bellhops in the hotel. The award-winning adaptation endures as a home, event venue, source of local pride, and prominent contributor to Huntington's historic downtown character.

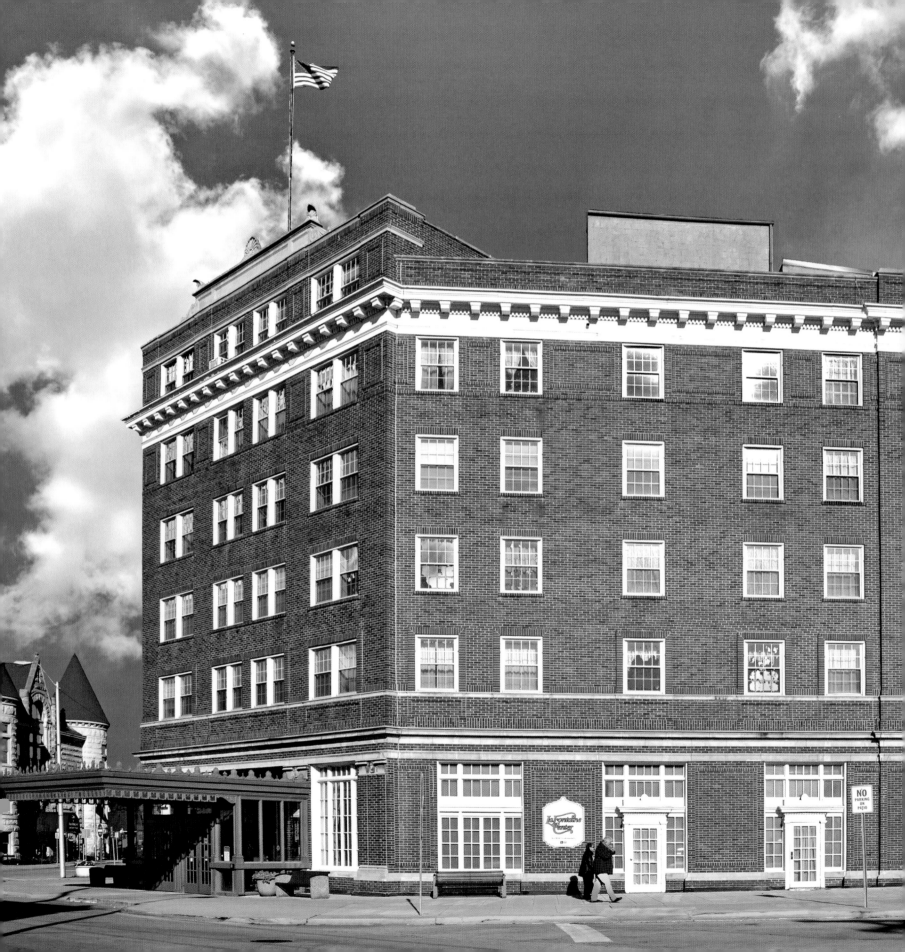

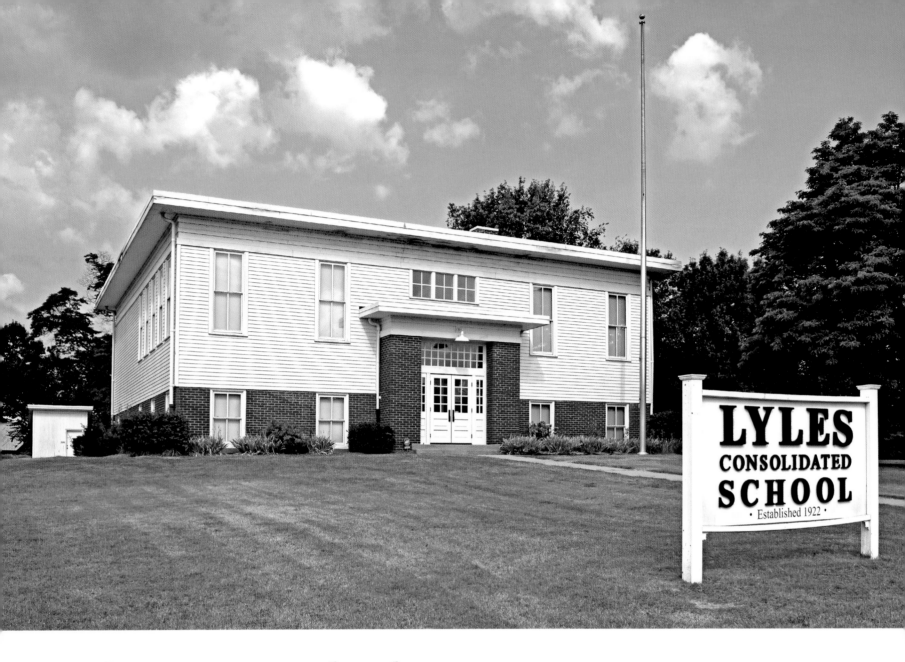

# Lyles Station School PRINCETON VICINITY

The Power of Place exhibit in the Smithsonian National Museum of African American History and Culture in Washington, DC, spotlights Lyles Station, one of the last of dozens of free black settlements where land is still being farmed by descendants of the pioneers. Started in 1849 by a freed Virginia slave, the town in southwestern Indiana prospered in agriculture, commerce, education, and achievement in a time of rigidly enforced segregation. It began to dwindle from a population high of 800 following the devastating 1913 flood of the Patoka and Wabash rivers.

The school built in 1919, a 10 Most Endangered site in 1998, is one of the few historic buildings remaining to represent the town's singular heritage. It was on the verge of collapse in the 1990s, when teacher, farmer, and descendant Stanley Madison launched a campaign to save it. He and others formed the nonprofit Lyles Station Historic Preservation Corporation and bought the property with a loan from Indiana Landmarks.

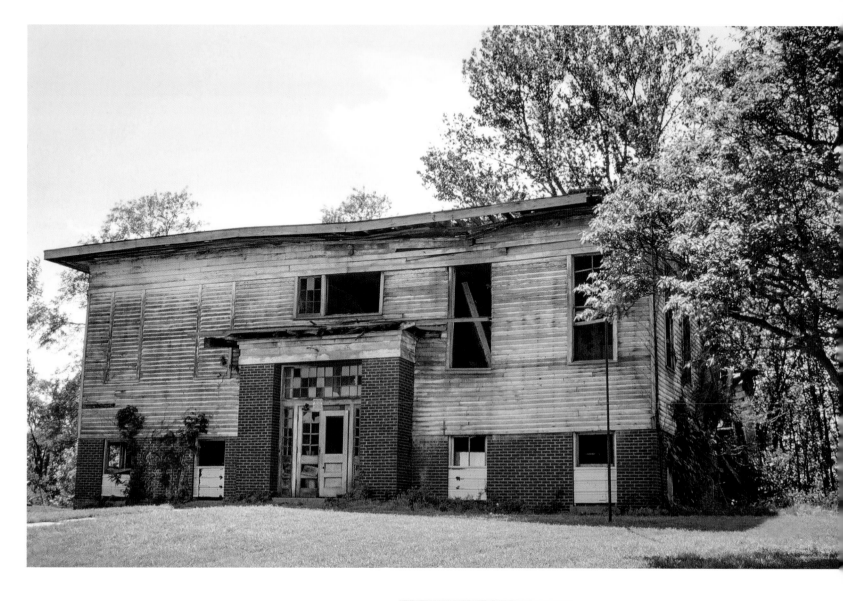

On the corporation's behalf, Indiana Landmarks won grants for restoration from the U.S. Department of Agriculture and the Efroymson Family Fund that, together with other contributions and grants, totaled $1 million. The Lyles Station School began anew in 2003 as a museum where elementary school students from three states and adult visitors from across the U.S. absorb the community's unique story.

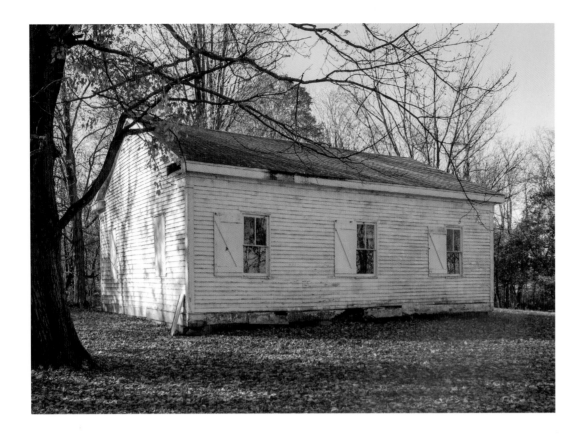

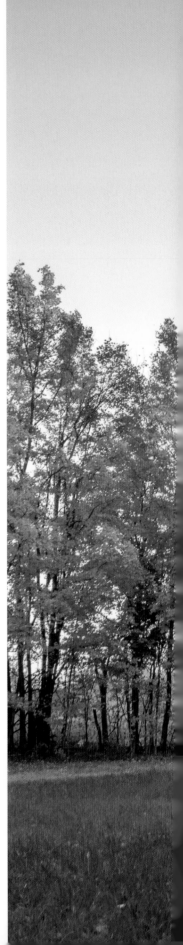

# Mt. Pleasant Beech Church
## CARTHAGE VICINITY

Free blacks began making their way from North Carolina and Virginia to Rush County in 1828, drawn by the area's large antislavery Quaker population. They created Beech Settlement, a farming community that grew to about 400 African Americans at its height. In 1832, they established what is believed to be the first African Methodist Episcopal Church (A.M.E.) in Indiana.

The congregation built the simple Greek Revival church—the settlement's sole surviving building—around 1865 and worked to advance education and intellectual development as well as religion in the community. Many descendants of the early settlers achieved prominence in education, medicine, politics, and the A.M.E. church.

The descendants still gather every August for a reunion at "The Beech," but the structure is otherwise seldom used. After its caretakers and Rush County Heritage sought help to preserve it, the building landed on Indiana Landmarks' 10 Most Endangered list in 2016.

The endangered status drew a major contribution from Standiford Cox, a retired Eli Lilly chemist and executive, joined by other donations and grants. Restored with a new foundation, rebuilt roof, repaired windows and siding, and refurbished interior, the sparkling white and weather-tight survivor debuted at the 2019 reunion, inspiring pride and refreshing the souls of Hoosiers and Beech descendants nationwide.

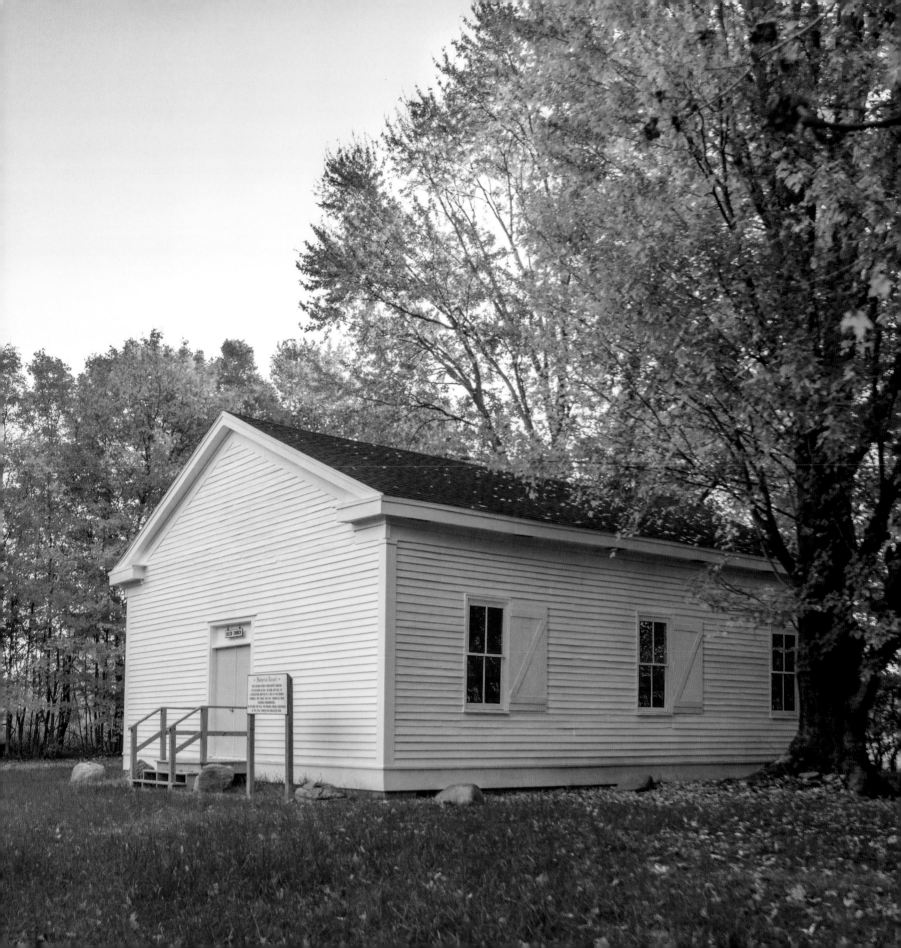

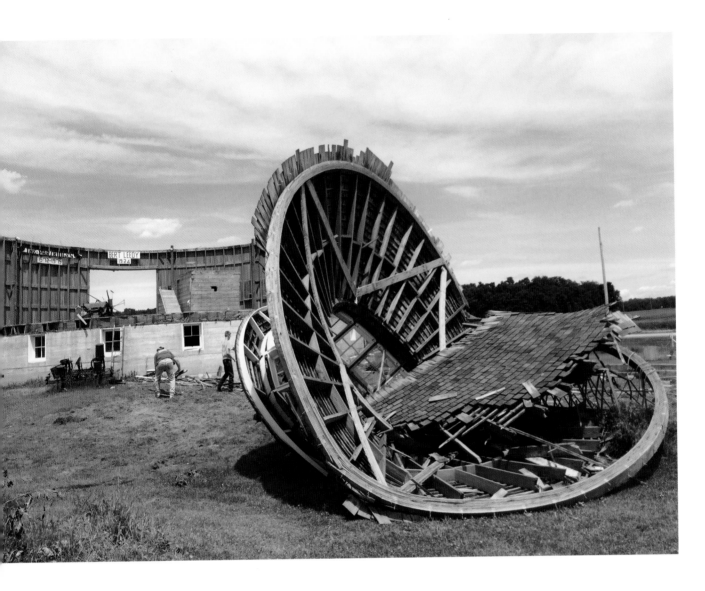

# Paxton Round Barn ROCHESTER

Indiana claims more round barns than any other state, most dating from 1880s to the 1930s. In the 1980s, the round barn count was 226. By 2015, storm damage, fire, neglect, and demolition whittled the number to 100. In Fulton County, which once boasted 17 round barns, seven remain standing including one with particularly hard-earned survivor status.

After a 1989 tornado picked up the roof and draped it over the side of their 1924 barn, Larry and Pat Paxton wanted to save it but couldn't afford repairs. They donated the ruin to the Fulton County Historical Society, which dismantled and rebuilt the barn four miles away on the grounds of its

museum on U.S. 31. A $40,000 loan from Indiana Landmarks and countless hours of volunteer labor went into restoring the rural cathedral. It opened in 1991 with displays of historic farm vehicles and implements.

Alas, nature was not done with the Paxton Round Barn. In 2015, a tornado-like storm tore off the roof and left about half of the circular wall standing. The historical society rebuilt it once more, salvaging original material and relying on the skill of Amish craftsmen in the reassembly. The county's round barn count remains seven and holding.

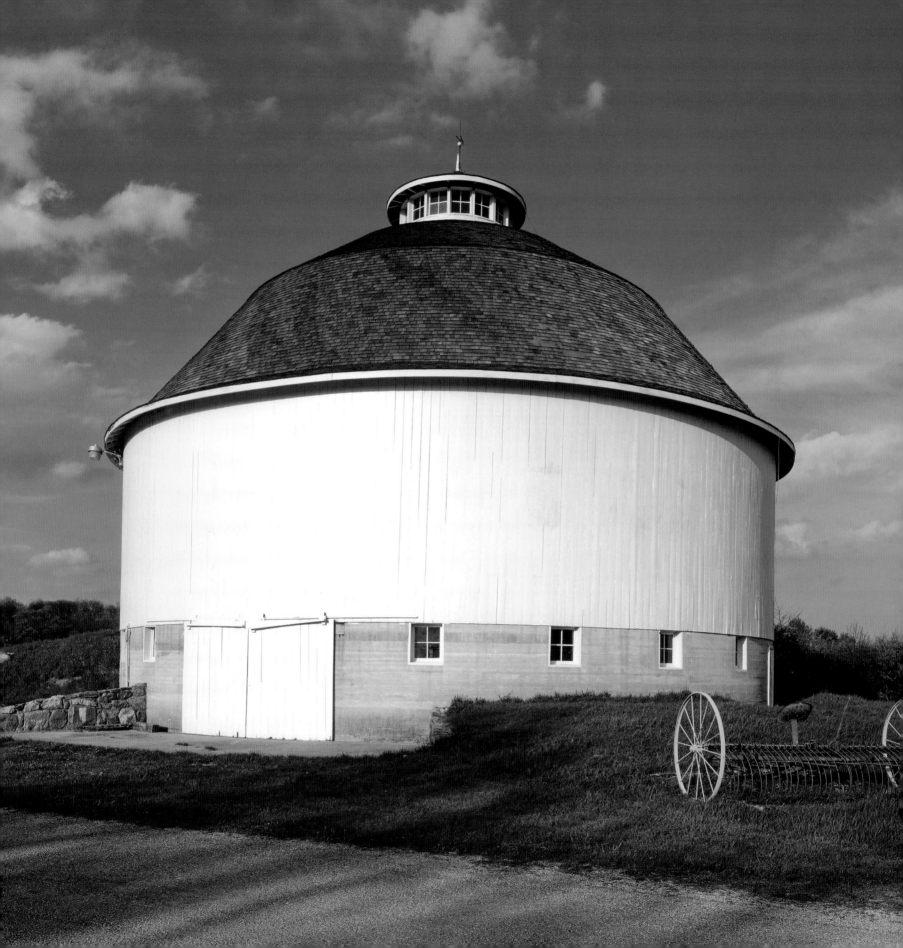

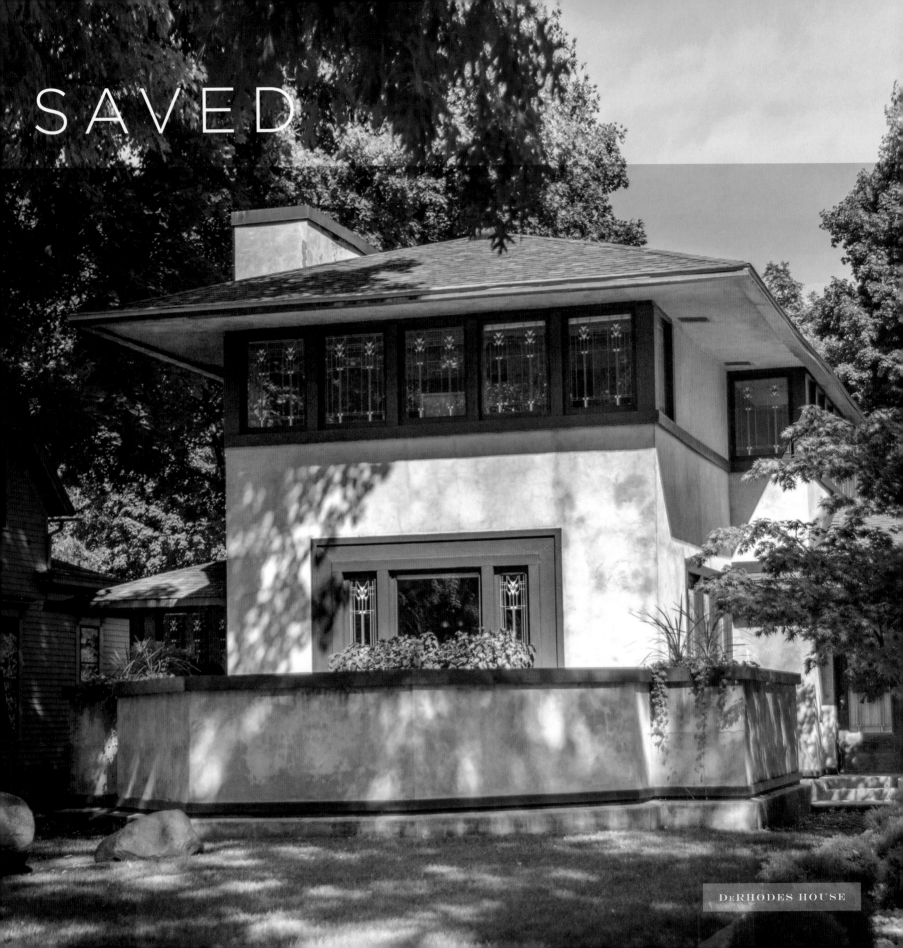

SAVED

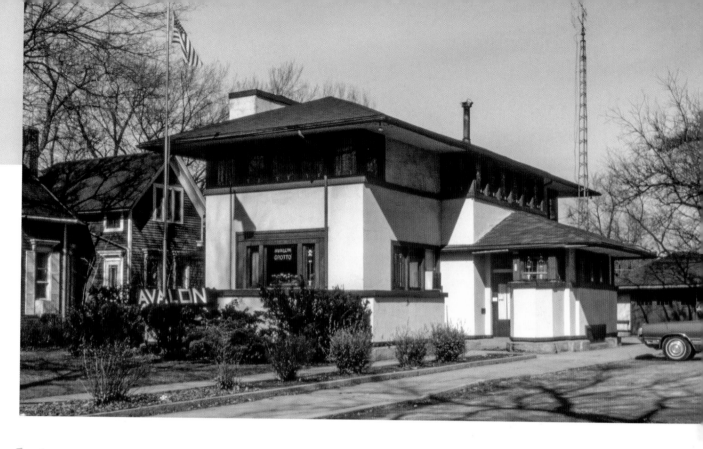

# West Washington Historic District SOUTH BEND

In South Bend, from the 1850s through the first decade of the twentieth century, wealthy industrialists—Studebaker, Oliver, O'Brien, and others—built homes on West Washington Street. By the late 1960s, the area shared the declining fate of many inner-city neighborhoods: grand houses sat vacant or neglected and divided into apartments. Demolition and arson fires spawned weedy lots.

South Bend Heritage Foundation triggered a few dramatic transformations beginning in the mid-1970s that stabilized the neighborhood and encouraged restoration. Indiana Landmarks made loans to the group to save endangered structures. Passersby started to see the potential. National Register historic district status in 1975 helped.

In 1978, South Bend Heritage passed a loan from Indiana Landmarks to Tom and Suzanne Miller to help buy the Frank Lloyd Wright-designed DeRhodes House on West Washington. From 1906 until her death in 1952, Laura DeRhodes maintained Wright's Prairie-style design, but the following owner eliminated or damaged most of the interior features and neglected the stucco exterior for more than two decades.

Tom Miller had written his doctoral dissertation on Frank Lloyd Wright, and the house was his dream come true. In their decades-long, meticulous, mostly DIY restoration, the couple replicated lost original cabinetry, woodwork, interior paint colors, even furniture. In 2012, Miller donated a preservation easement on the house to Indiana Landmarks to ensure long-term protection of the recaptured architectural character.

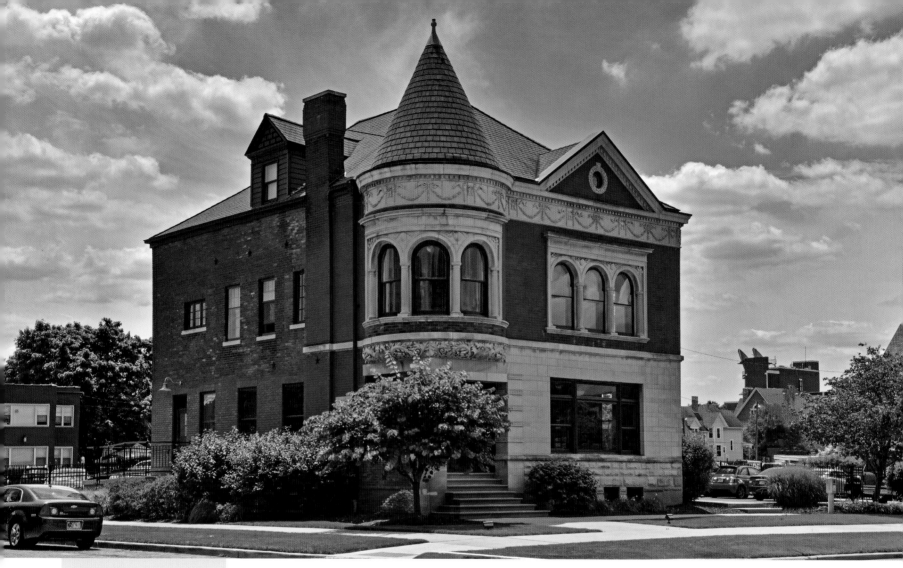

REMEDY BUILDING

Indiana Landmarks protects many structures on West Washington, including the Studebaker mansion-turned-restaurant Tippecanoe Place and the Remedy Building. It took two moves to save the Remedy, constructed in 1896 for a patent medicine business. Expansion of the *South Bend Tribune* in 1988 required the first move, a collaboration between the newspaper, South Bend Heritage Foundation, and building mover Tim Lykowski.

Unable to sell the Remedy after years of trying, Lykowski donated it to Indiana Landmarks, moving it again in 2000 to fill a vacant lot. Donations and grants from the Efroymson Family Fund of the Central Indiana Community Foundation and the state Division of Historic Preservation and Archaeology helped Indiana Landmarks restore it as its northern office.

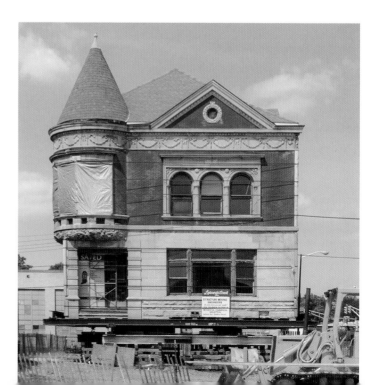

When the City of South Bend asked Indiana Landmarks to take on a problem property on West Washington, the organization sold the Remedy in 2018 to begin restoration of the 1885 Kizer House, locating its office in the two-story garage. After repairing the roof, cornice, and granite masonry, it invited neighbors to swing sledgehammers at concrete that paved the entire front yard. Restoration of the 7,000-square-foot interior continues.

The West Washington Historic District today is a visual feast with a stable and lively mix of museums, residences, and offices in the 330 historic buildings within its boundaries.

KIZER HOUSE

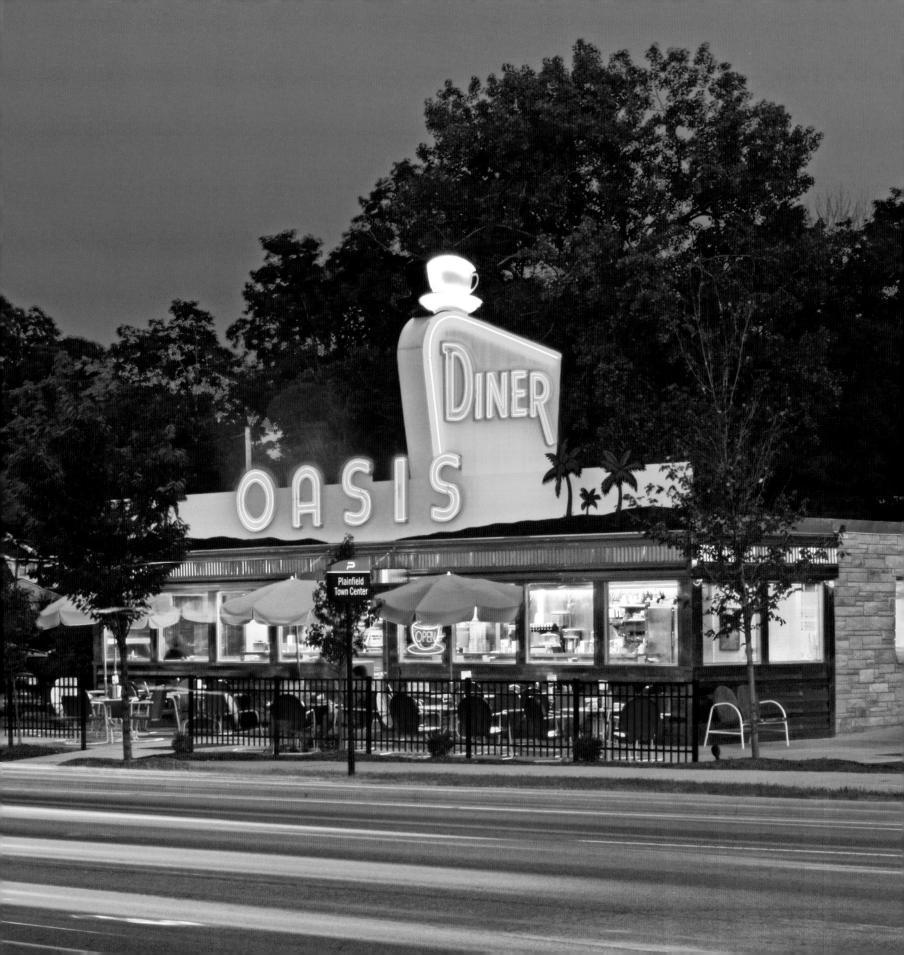

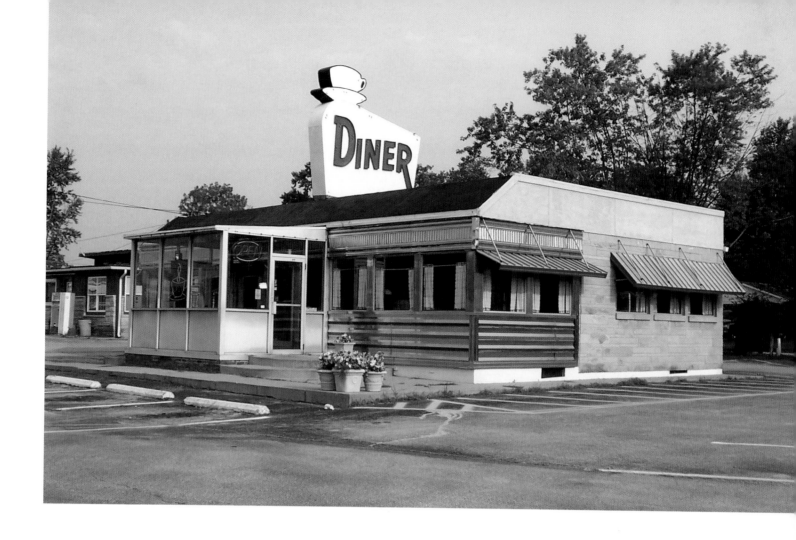

# Oasis Diner PLAINFIELD

In the mid-twentieth century, 5,000 streamlined roadside diners manufactured for the motor age dotted America's thoroughfares. By the twenty-first century, fast-food chains, urban sprawl, and interstates made the diners a dying breed of architecture. Indiana Landmarks named a rare Plainfield survivor to its 10 Most Endangered list in 2010.

The diner, originally named The Oasis, arrived by rail in 1954 from a New Jersey manufacturer, sleekly designed in the Art Moderne style to attract motorists on the National Road (U.S. 40), which doubles as Plainfield's Main Street.

After the health department shuttered the dilapidated diner, owner Wally Beg sold the building to Indiana Landmarks for $1 and the promise to move it off the valuable real estate it occupied. The City of Plainfield provided a site four miles away on Main Street.

An Efroymson Family Fund grant helped Indiana Landmarks move the diner, which it then sold for $1 and a perpetual preservation covenant to Doug Huff and his father-in-law Don Rector. The partners moved and masterfully restored the diner—inside and out—including recreating the exuberant original palm tree sign.

You can fill up on National Road Specials—themed breakfast entrees—as well as salads, sandwiches, burgers, root beer, and the all-time diner staple of hot coffee and fresh pie.

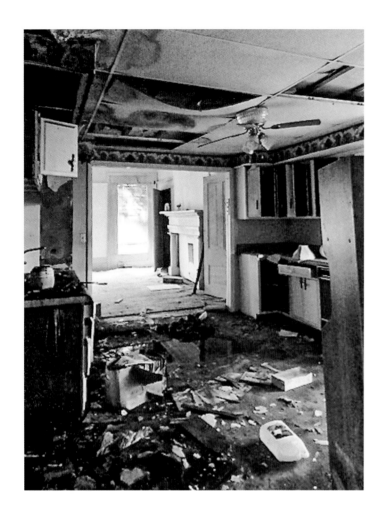
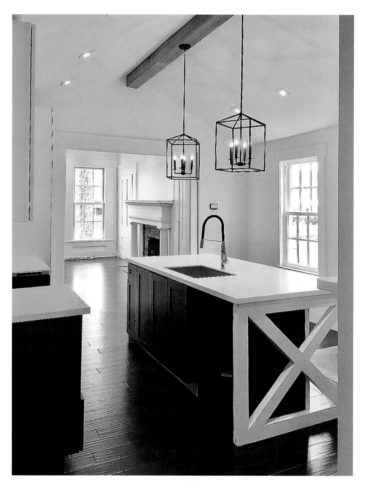

# Butler House DUPONT

When Indiana Landmarks discovered the Levi Butler House, 10 miles north of Madison, it was hidden beneath ivy gone wild on a site overtaken by nature. The 1847 diamond-in-the-rough had holes in the roof, vanishing paint, and a crumbling chimney.

In his influential 1962 book *Indiana Houses of the Nineteenth Century*, Wilbur Peat called attention to the Butler House and other one-story "Grecian cottages." He called them quiet cousins of the more imposing Greek Revival houses, derived from the same refined architectural aesthetic.

Stuck in foreclosure and facing a tax sale, the Butler House couldn't stand another winter without intervention, so Indiana Landmarks bought it, fixed the roof and chimney, peeled away the ivy to reveal the Greek Revival gem, and listed it for sale.

Meanwhile, Mark Hopkins sat in his 25th-floor condo in Miami, nearing early retirement after 23 years in sales for Gucci and contemplating a move to be near family in Indiana. Scrolling through the Old House Dreams website, he found the Butler House and immediately scheduled a visit. He bought it from Indiana Landmarks for $25,000.

He restored the original three-room house while removing later aluminum-sided, vinyl-windowed additions and replacing them to create a cohesive design. It's his old house dream come true.

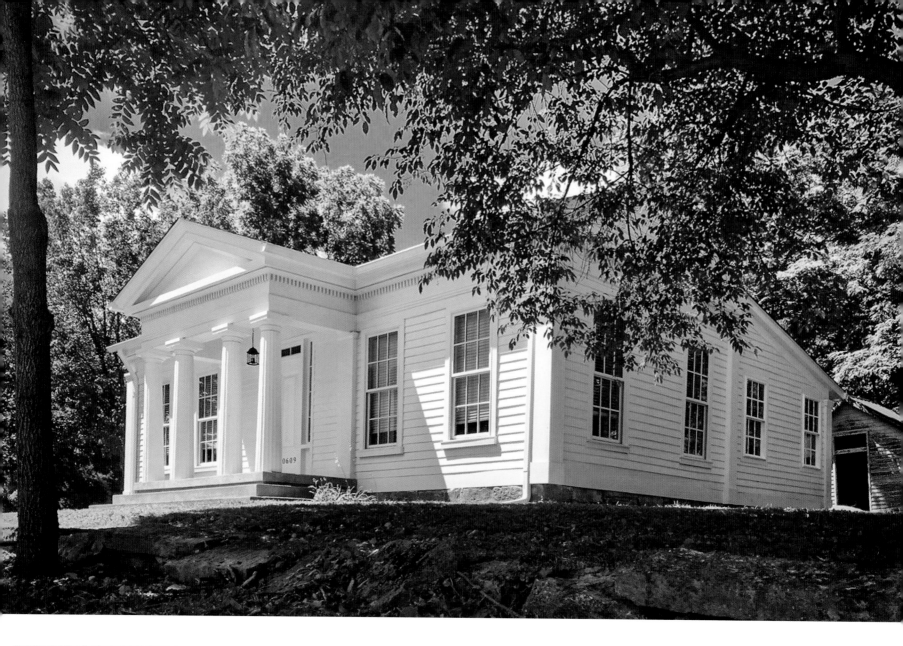

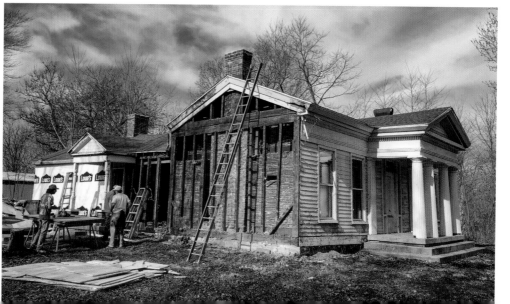

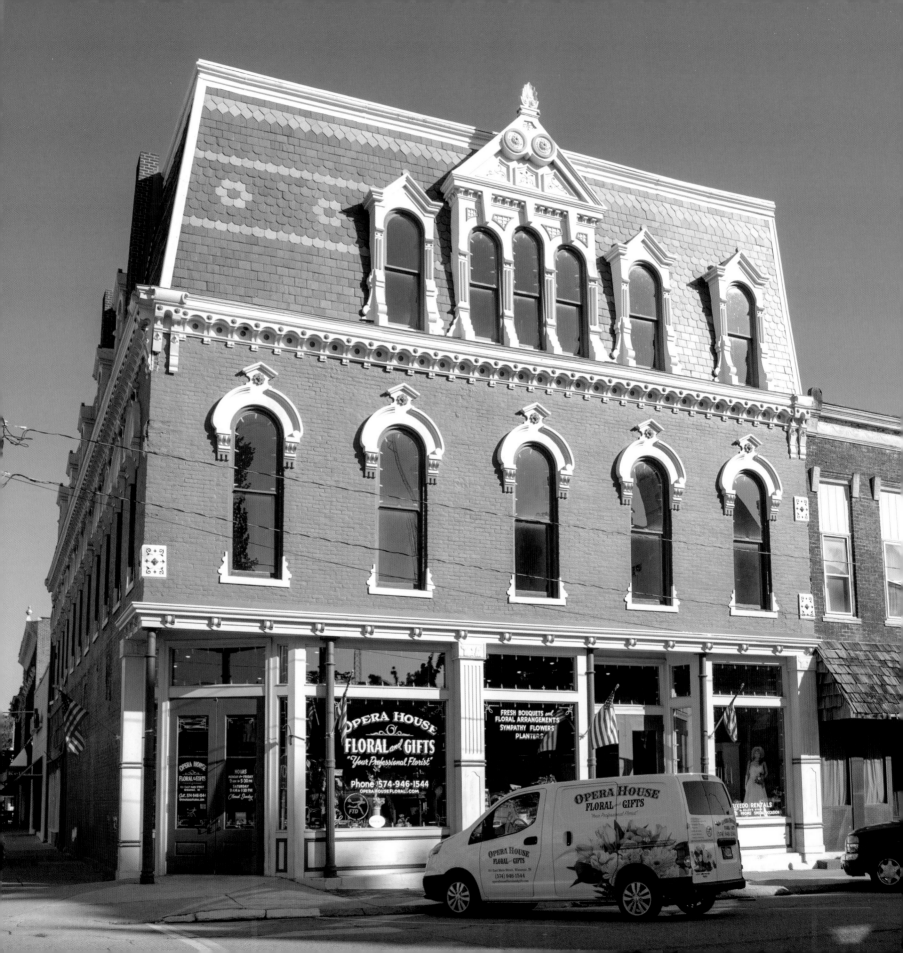

# Vurpillat's Opera House

WINAMAC

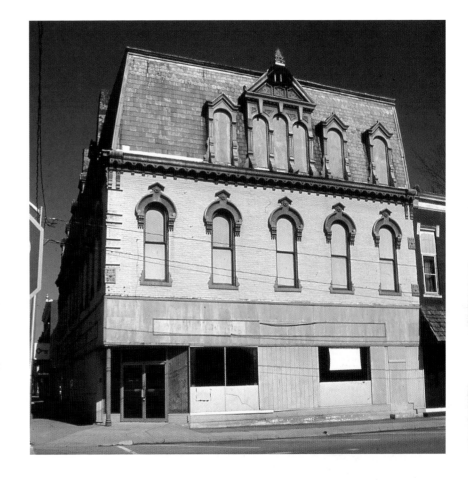

In the post-pioneer era, after carving out places to live and work, people hankered for culture and entertainment. Towns and entrepreneurs built opera houses, a more socially acceptable term for theater in the nineteenth century. Joseph Vurpillat opened a Second Empire-style opera house in his town in 1883 that shared a plan common to many: retail shops on the ground floor, offices on the second floor, theater on top.

The opera house became a hub of commerce, recreation, social, and cultural enrichment in the Tippecanoe River town. The 600-seat theater hosted touring performances, high school graduations, dances, club meetings and political conventions and, less frequently, operas. But with the passage of time, the opera house suffered fates also common to many: fire, difficult theater access, loss of audience to movie palaces and newer venues, and finally closure.

When the Pulaski County Historical Society rescued the building in 2000 from demolition proposed by the county, the first floor had been vacant for a few years, the second floor used for storage for 40 years, and the theater dormant even longer. With lots of volunteer labor and grants and a loan from Indiana Landmarks and others, the society incrementally restored the exterior. In 2017, a flower shop became the society's first tenant on the refurbished street level.

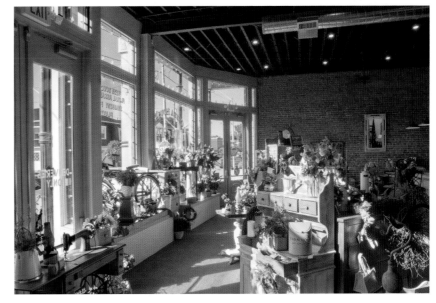

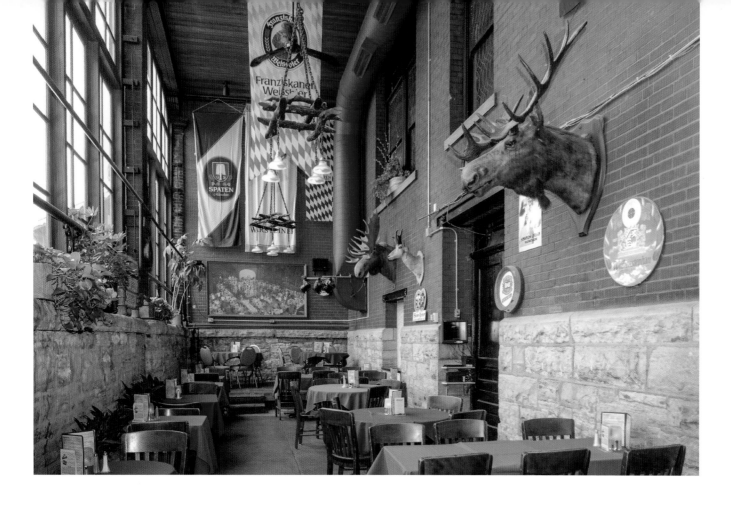

# Athenaeum INDIANAPOLIS

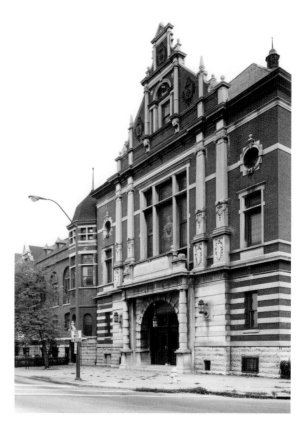

When free-thinking Germans immigrated to Indianapolis, they brought along their club culture. In the 1890s they built Das Deutsche Haus, where a variety of clubs pursued the collective goal of "a sound mind in a sound body" in the building's meeting rooms, lecture hall, gymnasium, theater, bowling alley, restaurant, bars, and biergarten.

Architect Bernard Vonnegut designed the German Renaissance Revival structure as a cultural celebration. Author Kurt Vonnegut regarded it as his grandfather's masterpiece. Bowing to anti-German sentiment around World War I, the landmark's name changed to the Athenaeum.

By the 1980s, with ethnic identity diluted, the half-block-long building was leaking and shabby, with a bank waiting in the wings to foreclose and make the corner a parking lot. Indiana Landmarks bought the mortgage and later assisted an energetic new organization, The Athenaeum Foundation, by guaranteeing a construction loan—the start of an ongoing restoration program that began with a new slate roof and refreshed the emphasis on the sound mind/sound body ethos. The Athenaeum won National Historic Landmark status in 2016.

Still about as German as you can get in the U.S., the lively, refurbished landmark functions as a downtown club open to all, offering the original mix of fitness, culture, conversation, beer, and German food.

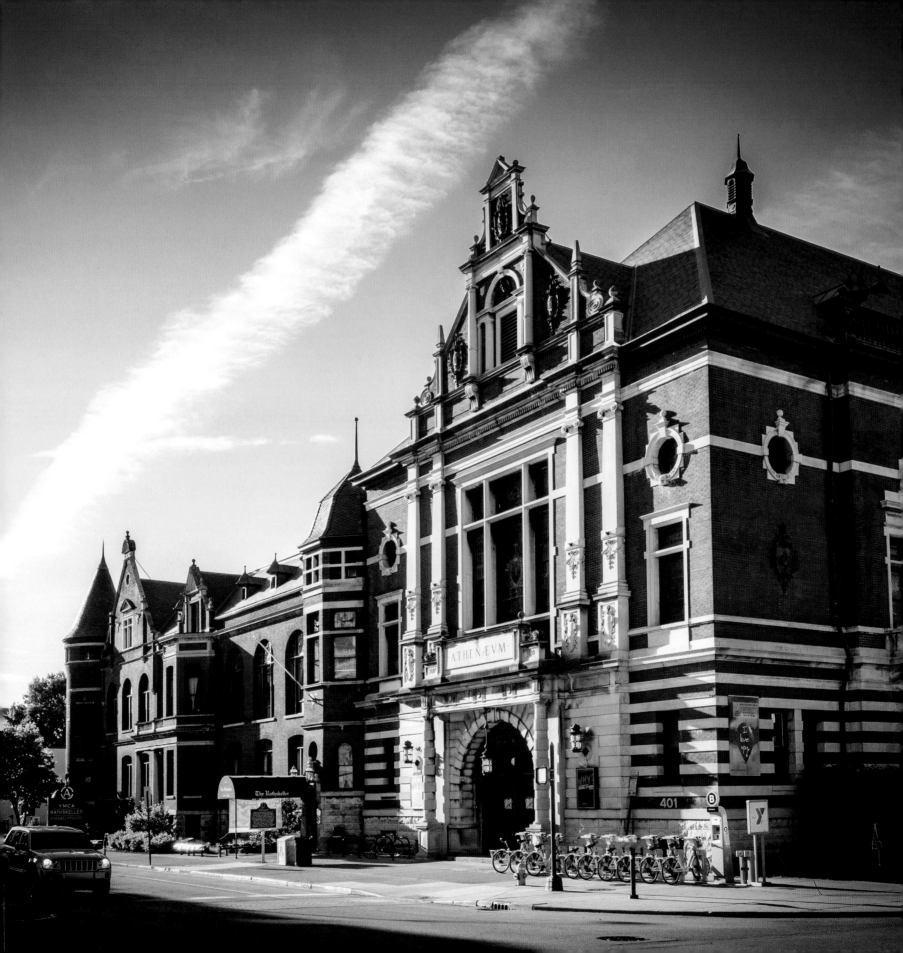

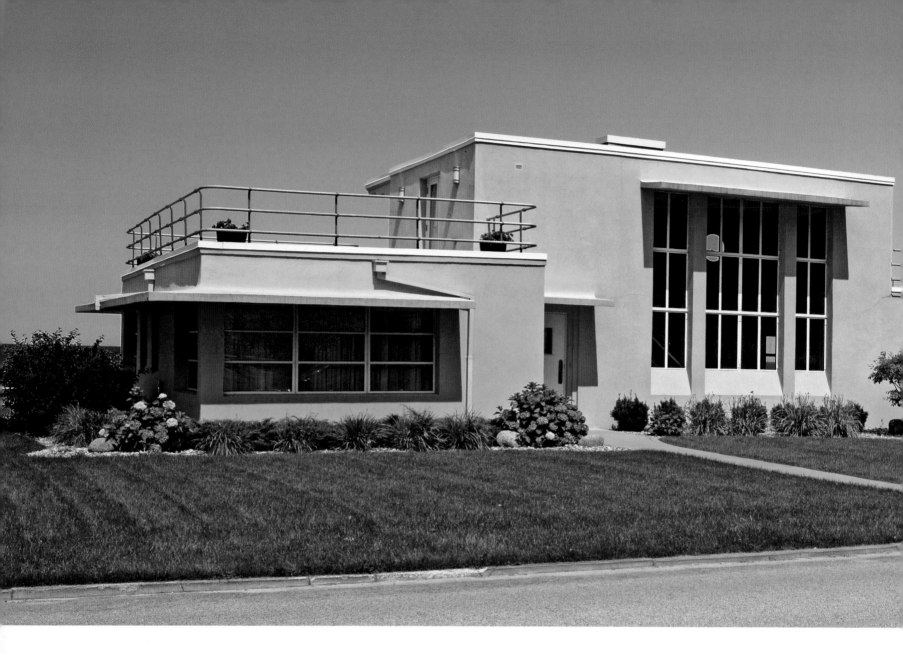

# Century of Progress Historic District
## INDIANA DUNES NATIONAL PARK

In the midst of the Great Depression, the 1933-34 Chicago World's Fair offered millions of visitors a hopeful vision of a brighter future. While not many structures remain from the fair, five of the houses from the expo's Home and Industrial Arts Exhibit survive on the Indiana shore of Lake Michigan.

In 1935, real estate developer Robert Bartlett imported the houses to Beverly Shores and later sold them to individuals. In 1966, the community became part of what is now the Indiana Dunes National Park. The National Park Service bought the houses, allowing the owners to remain for specified periods with little incentive for maintenance.

Indiana Landmarks declared the neglected structures among the 10 Most Endangered from 1993 through 1997. Negotiations with the National Park Service to save the houses produced a novel solution: Indiana Landmarks leased the houses from the federal government, then subleased them $1 for 50 years to people who restored them. Four of the five have been restored.

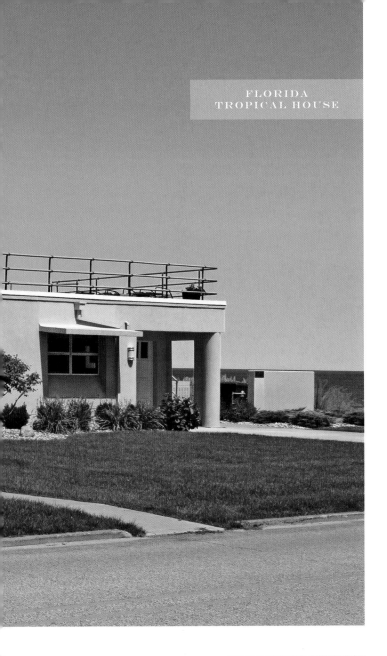

FLORIDA
TROPICAL HOUSE

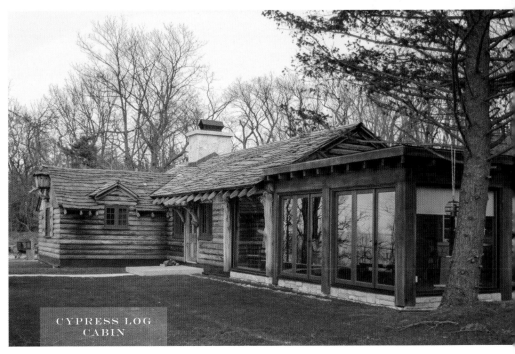

CYPRESS LOG
CABIN

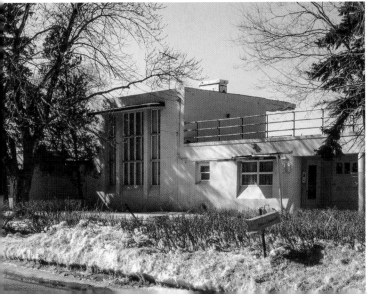

Bill and Marci Beatty signed on first, leasing the Florida Tropical House after Marci saw a news story about the "free house." After Marci died of cancer, Bill considered abandoning her dream house. When he married Lisa in 2008, she insisted they finish the restoration that Bill calls the stupidest financial move he ever made and the best thing he has ever done.

After Hurricane Katrina in 2005, lessees Clint and Jamie Alm suddenly were able to secure cypress from uprooted trees in the sizes they needed to replace missing and damaged elements in the Cypress Log Cabin, built at the fair to promote the wood as a building material.

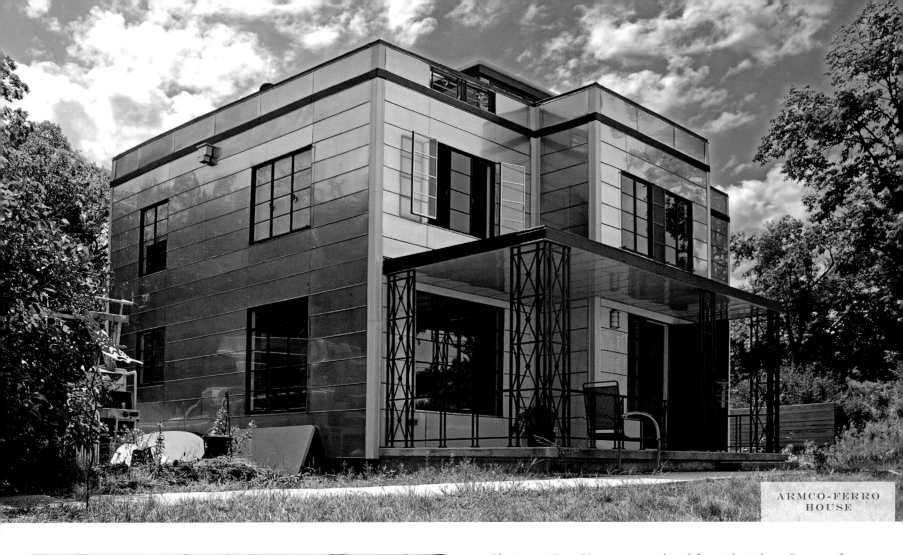

ARMCO-FERRO
HOUSE

The Armco-Ferro House promoted steel for residential use. Because of unaddressed leaks over many years, the enameled steel panels and framework rusted like an old car. Lessees Christoph and Char Lichtenfeld enlisted Local 395's apprentice steel worker program led by Rich Hertus to repair the steel structure and panels.

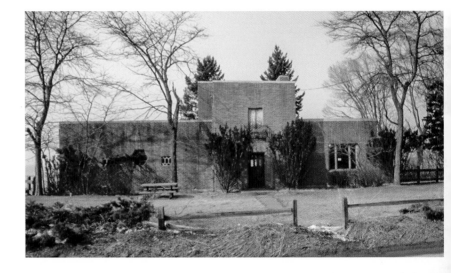

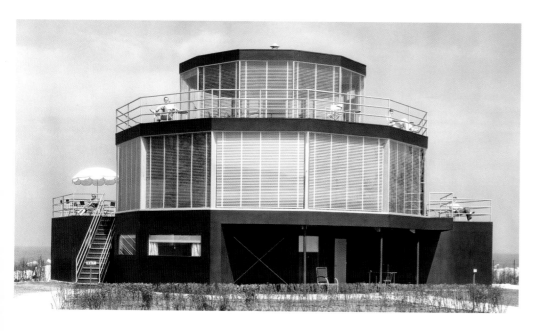

The Rostone House featured a new building material that didn't fare well on exposure to acid rain. The Rostone failure led to leaks that rusted the steel frame. Ross Gambril restored the structural steel and fabricated durable new cladding to match the look of the original Rostone.

The House of Tomorrow, designed by Chicago architect George Fred Keck, is the lone unrestored structure in the district. The house set the direction for how we live today with its open floor plan, walls of glass, central air conditioning, electric dishwasher, and attached garage with push button entry—all startling new features in 1933. It remains available for lease, with a head-start on restoration in the form of pre-approved construction drawings commissioned by Indiana Landmarks.

ROSTONE HOUSE

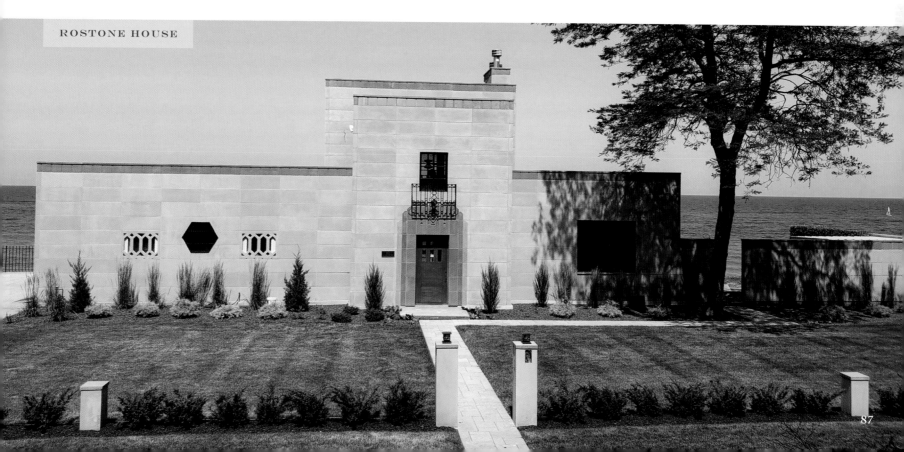

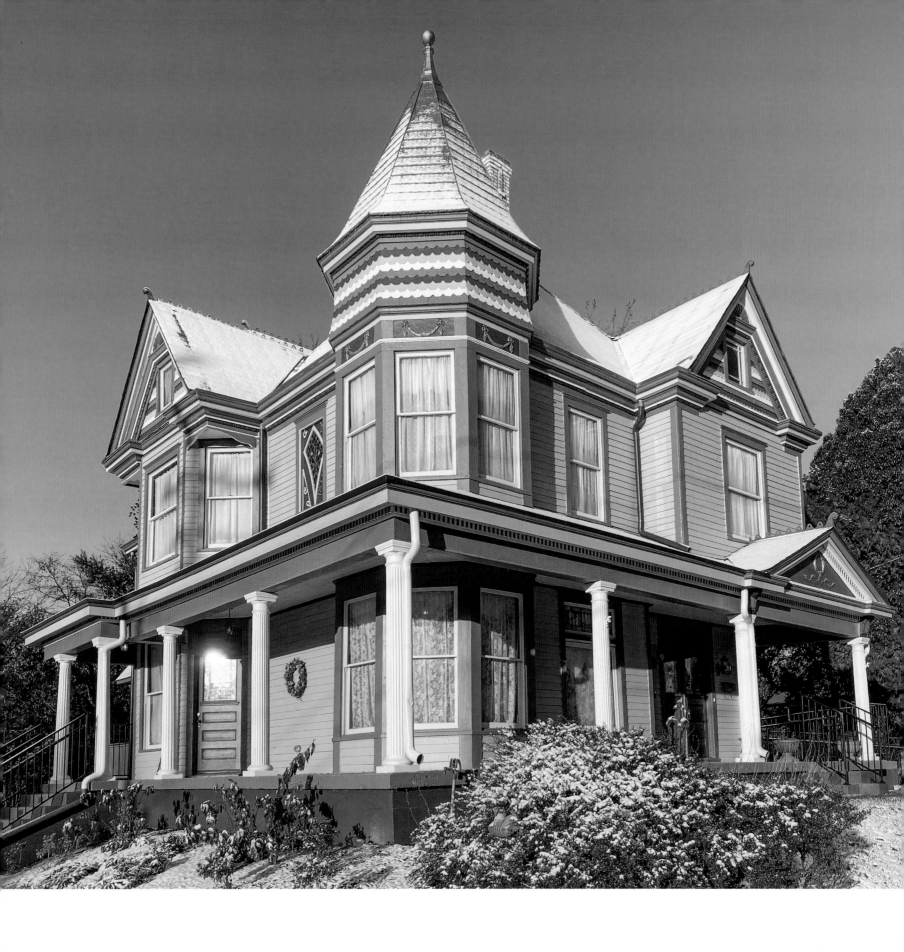

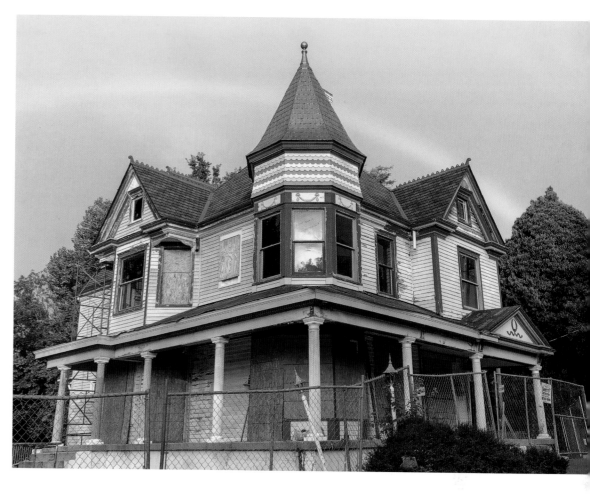

# Kunz Hartman House NEW ALBANY

After German immigrant and mill owner Louis Hartman prospered in New Albany, he and his third wife Anna Katherine Kunz built their fashionable Queen Anne-style home in 1898-99. From the 1970s until 2009, the house served as a funeral home. A January 2017 fire left the house with holes in the roof, charred siding and attic timbers, interior water damage, and an uncertain future.

Seeing the turnaround potential and the revitalization upside for the State Street house and the surrounding neighborhood, Indiana Landmarks bought and restored the house as its Southern Regional Office.

The organization funded the restoration through the sale of its previous office in Jeffersonville, along with support from the Horseshoe Foundation of Floyd County, the City of New Albany, the Paul Ogle Foundation, the Kunz family, PC Home Center, Develop New Albany, and individual contributors.

Outside, the house got a new roof, repaired siding, and a Victorian paint scheme. Inside, much of the woodwork—white oak, cherry, and butternut—had been removed and stacked by the previous owner, bound for salvage shops. Amish craftsmen solved the jigsaw puzzle to put the woodwork back in place. The parquet floors, butternut staircase, and stained-glass windows recovered their original warm glow in time for the office's opening in 2019.

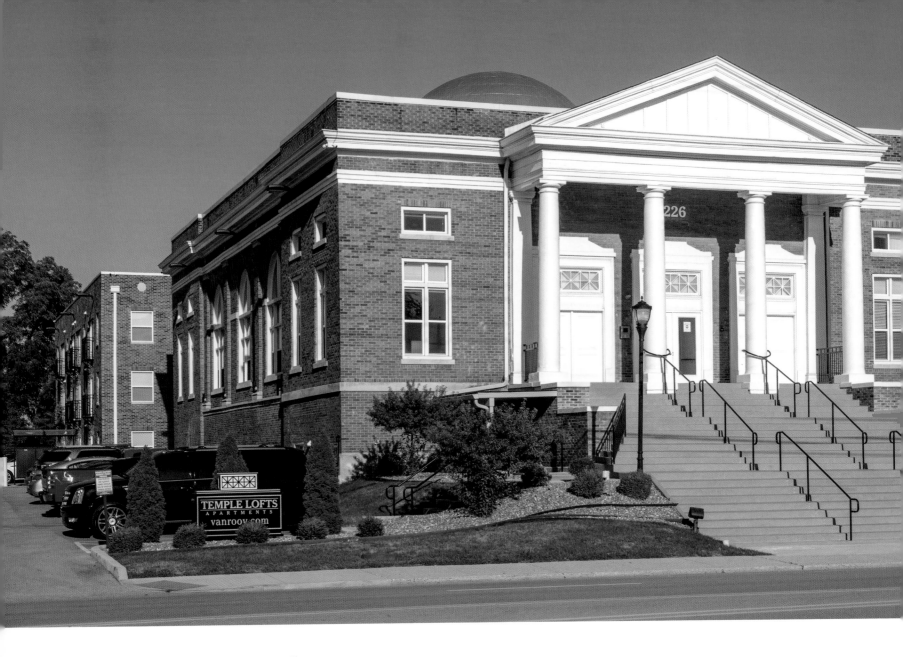

# Phillips Temple INDIANAPOLIS

For decades, the Neoclassical church built in 1924 by and for African Americans served as an anchor on Indianapolis's near west side. Located in the Flanner House Homes Historic District, the vacant landmark appeared on Indiana Landmarks' 10 Most Endangered list in 2013, threatened by holes in the roof and a demolition plan. Indianapolis Public Schools (IPS) expected to raze the church to create additional parking for Crispus Attucks High School next door.

Because African Americans could not get conventional mortgages in the era of segregation, the Flanner House social service agency created an innovative cooperative to build homes. Between 1950 and 1959, African Americans—including many World War II vets—contributed sweat equity to the cooperative building their homes, with Phillips Temple providing important support to the initiative.

Indiana Landmarks won a reprieve to assess reuse possibilities. With a grant from the Efroymson Family Fund and permission from IPS, the

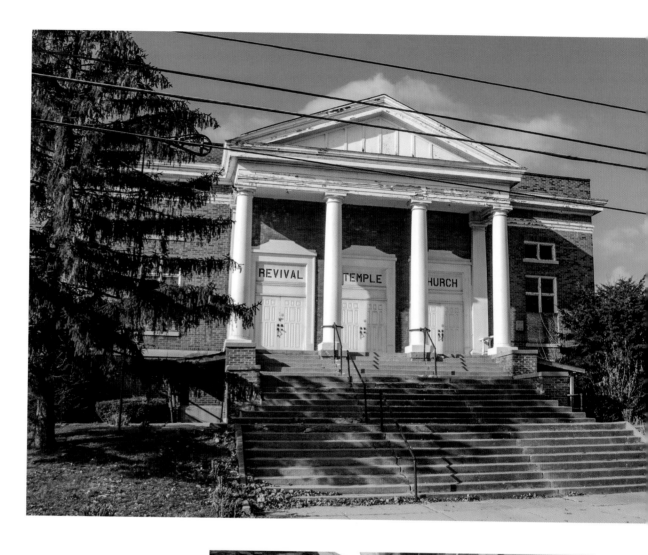

preservation group stabilized the most fragile areas of the domed structure. And with help from City County Councillor Vop Osili and neighborhood advocates, a solution emerged.

IPS sold Phillips Temple to Van Rooy Properties for redevelopment as 18 market-rate apartments, with a new 24-unit building on the site. Temple Lofts contributes to the tax base, offers quality housing, and remains to tell an important part of the city's story.

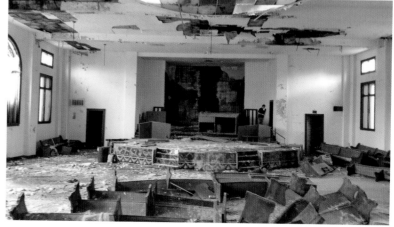

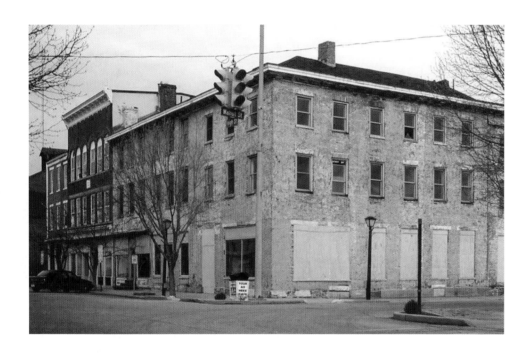

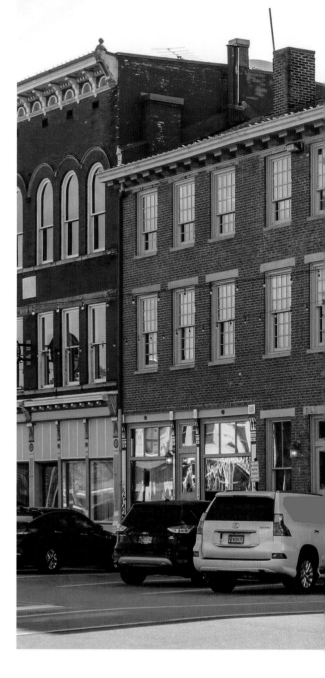

# Jesse Hunt House LAWRENCEBURG

After the state approved riverboat gambling in the 1993, fierce competition among gaming companies to win the licenses created drama in many of the casino towns. In Lawrenceburg, founded in 1802, Golden Nugget bought up three blocks of High Street, 23 buildings dating from 1818 to 1899. When it didn't win the license, the company abandoned the buildings.

For years, High Street felt like a ghost town—quiet, empty, suspended. Golden Nugget applied for a demolition permit for the long vacant and extra-dilapidated Jesse Hunt House. Built in 1818, the Federal-style hotel at High and Walnut streets was the first three-story structure in Indiana.

In 1998, the city bought the empty real estate and began tearing down buildings. Indiana Landmarks declared High Street a 10 Most Endangered site and sued to stop the destruction. In a mediated settlement, Indiana Landmarks bought and committed to restore 14 of the buildings in the National Register-listed district, including the Jesse Hunt House.

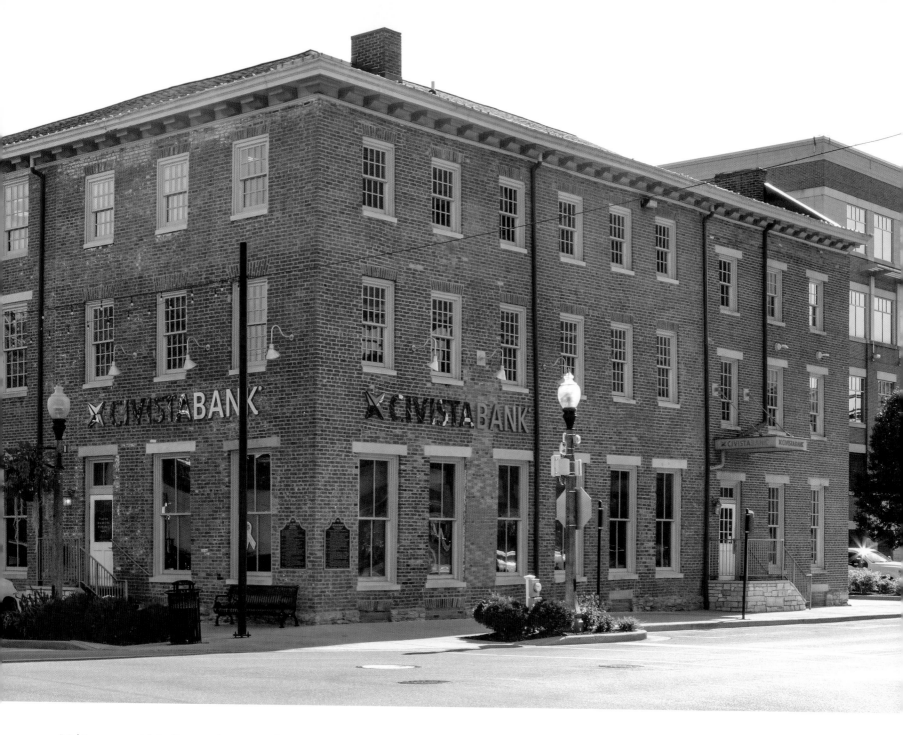

Making peace with its former adversary and winning the city's cooperation in securing federal and state grants, Indiana Landmarks also used $4 million of its own funds to restore the structures, starting with the old hotel. With the exterior restored, Indiana Landmarks sold the building in 2003 to United Community Bank (now Civista), which adapted the interior for its headquarters, a milestone in the rebirth of a historic street.

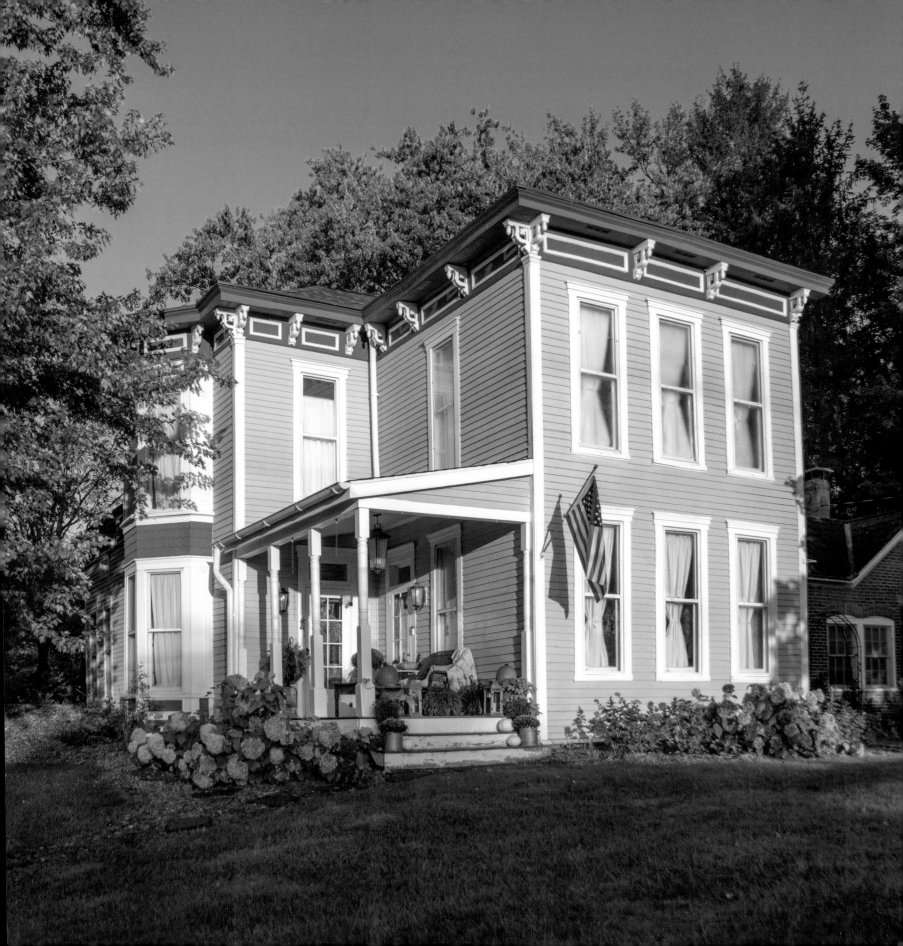

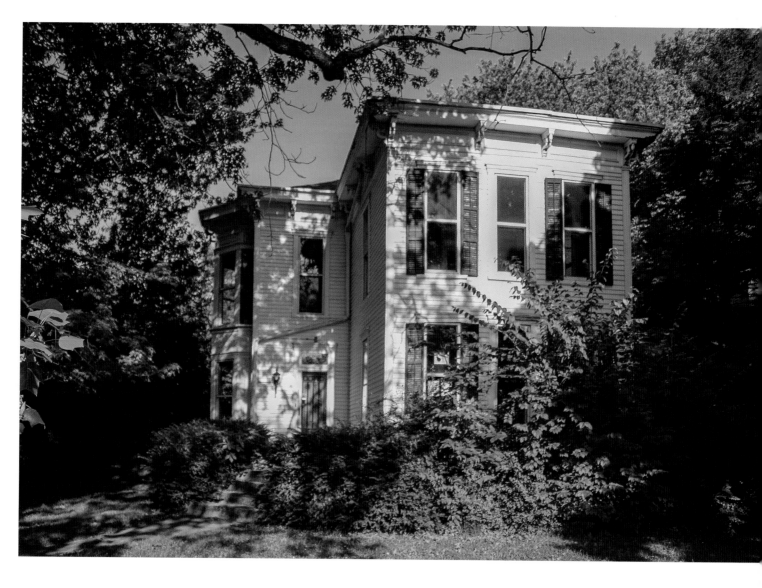

# McShane House CARMEL VICINITY

As Carmel rocketed from a sleepy little town on the outskirts of Indianapolis to one of the state's 10 largest cities, historic farmhouses, barns, and fields gave way to new housing, and commercial and retail developments. The Carmel Clay Historical Society asked Indiana Landmarks for help when it discovered that the vandalized and neglected c.1886 McShane House was headed to auction.

Built by Hamilton County pioneers and reflecting the area's agricultural heritage, the 1.5-acre property was likely to be bought for its land value, and the house and outbuildings replaced by McMansions. Tapping its Efroymson Family Endangered Places Fund, Indiana Landmarks won the 2012 auction

with a bid of $129,000, an outcome cheered by many observers in the crowd.

The preservation organization sold the property with a protective covenant for roughly the same amount to Paul and Emily Ehrgott who left a home they built in Fishers to restore the McShane House.

They rehabbed the siding, brackets, and trim, and reconstructed the missing front porch. Inside, the couple preserved the original features of the farmhouse, including built-ins and hardwood floors. After all the work—accomplished with the help of family and friends—the Ehrgotts see it as "the holy grail, the house for the rest of our lives."

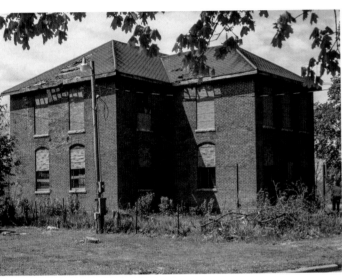

# Booker T. Washington School

RUSHVILLE

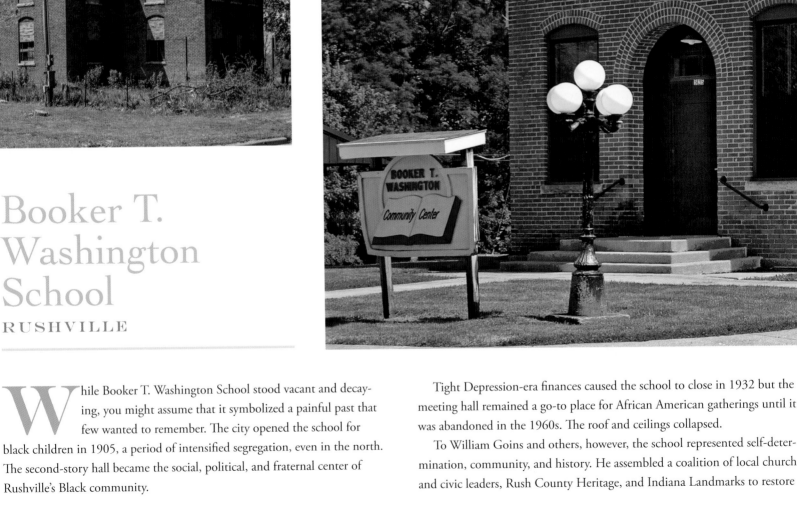

While Booker T. Washington School stood vacant and decaying, you might assume that it symbolized a painful past that few wanted to remember. The city opened the school for black children in 1905, a period of intensified segregation, even in the north. The second-story hall became the social, political, and fraternal center of Rushville's Black community.

Tight Depression-era finances caused the school to close in 1932 but the meeting hall remained a go-to place for African American gatherings until it was abandoned in the 1960s. The roof and ceilings collapsed.

To William Goins and others, however, the school represented self-determination, community, and history. He assembled a coalition of local church and civic leaders, Rush County Heritage, and Indiana Landmarks to restore

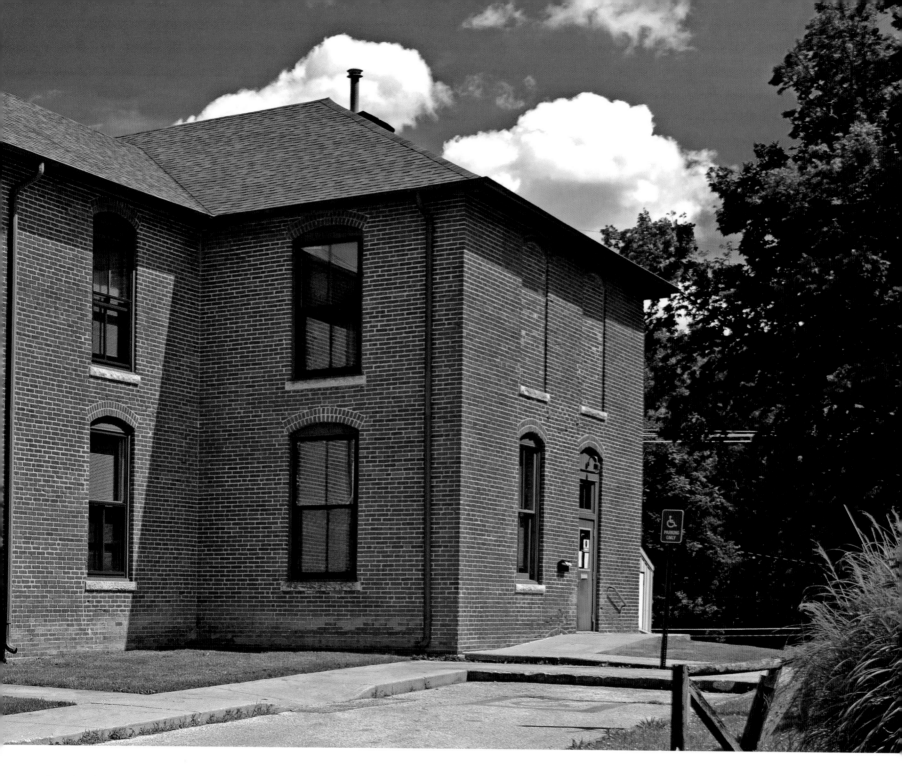

the school as a community center. The owner donated the building and Indiana Landmarks loaned the money for a new roof.

The Booker T. Washington Community Center Association formed to raise money for restoration, winning grants and contributions and staging events, including homecomings for alumni and their descendants.

Reopened in 1992, the landmark's upstairs hall once again hosts meetings and events; downstairs tenants include Head Start and the Interlocal Community Action Program. Originally a symbol of social division, the Booker T. Washington School now represents cooperation and community spirit.

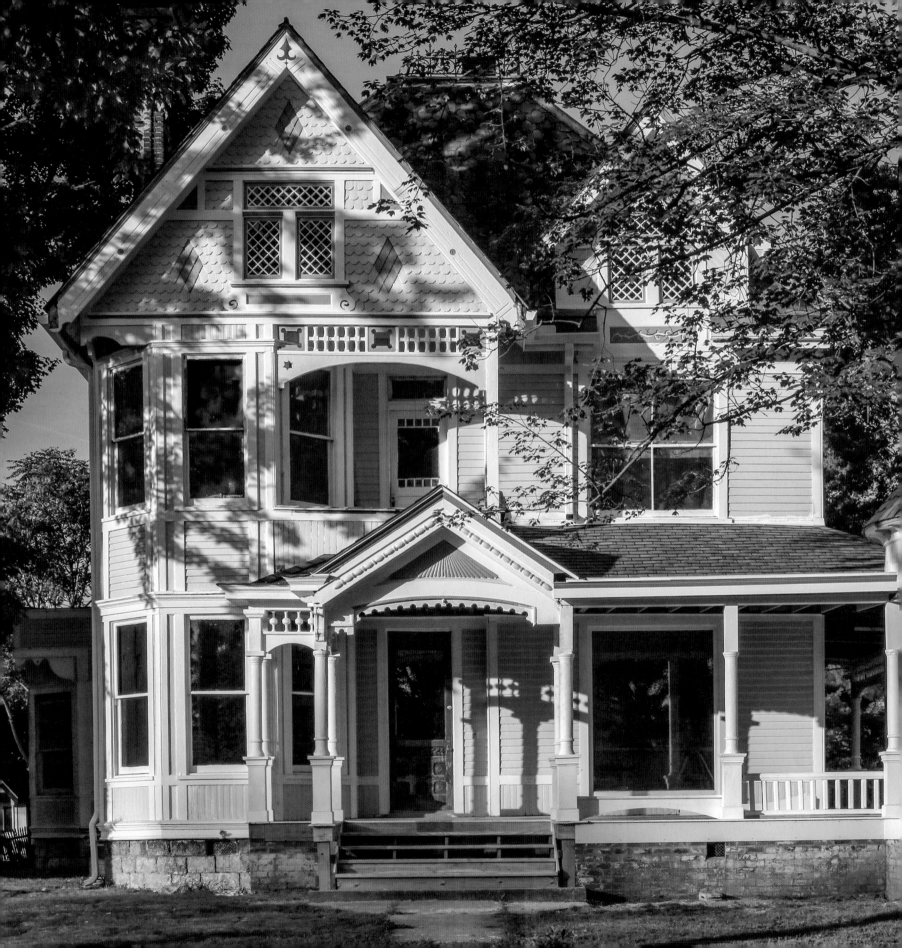

# Cone House NORTH VERNON

In the 1890s, banker Joseph Cone bought house plans from George F. Barber, a Tennessee architect known for his mail-order catalogs of residential designs for Queen Anne-style houses. The hallmarks included gingerbread, patterned shingles, tall brick chimneys, decorative slate roofs, and elaborate porches.

The Cone House ticked all those boxes, but by 2017 it was nearly a ruin. The county declared the place unlivable and issued a demolition order. In an 11th-hour save, Indiana Landmarks convinced the owner to donate the house and Fannie Mae to forgive the remaining mortgage.

With a promise to make quick repairs, Indiana Landmarks won an injunction that suspended the demolition order. A grant from a legal aid program administered by Indiana Landmarks and the Indiana Bar Foundation helped pay for the legal work.

Indiana Landmarks' Efroymson Family Endangered Places Fund and a contribution from Tony Jordan financed the exterior restoration. The county sheriff lent inmate labor for an interior cleanout that filled several 40-yard dumpsters. Jordan then bought the house from Indiana Landmarks and launched the interior restoration.

Passersby honked and gave the thumbs up during the restoration, and several neighbors undertook repairs of their own, a testament to the catalytic effect of turning around the worst house on the block.

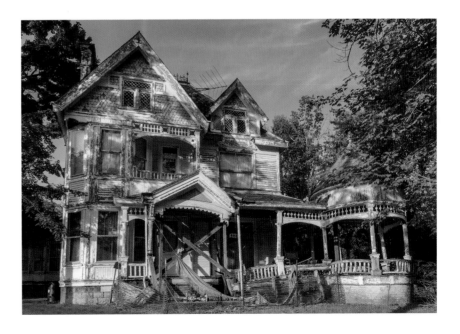

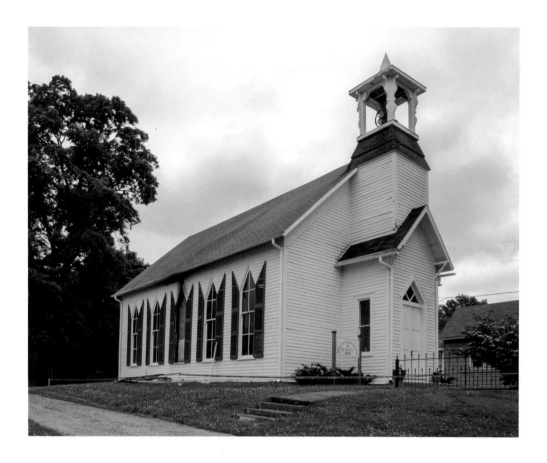

# Poland Historic Chapel POLAND

Built in 1869, the Presbyterian church also hosted lectures, music lessons, and social gatherings, perhaps because the other area church at the time held services only in German.

Although dwindling numbers caused the church to close in 1929, the remaining members looked after the building, renaming it Poland Chapel. The place was in bad shape in 1966 when residents banded together to restore it, showing local devotion to a picturesque hilltop landmark overlooking green soybean fields that turn gold in the fall. Indiana Landmarks assisted in the chapel's window and shutter restoration and listing in the National Register of Historic Places in the early 1990s.

Before dawn on a June day in 2009, the postmaster's dog began barking, alerting her to a fire at the chapel across the street. Volunteer firefighters arrived in six minutes to extinguish the arson fire, but the damage was daunting.

Volunteers stepped up once again, donating countless hours of labor and raising $100,000 for another restoration, including grants from Indiana Landmarks, Efroymson Family Fund, and Wabash Valley Community Foundation. It's a sign of the times: before the fire, the chapel was open 24-7; now it's open only one Sunday a month. But it still holds Christmas and Easter services, weddings, a lecture series, and the loyalty of Poland people who live near and far away.

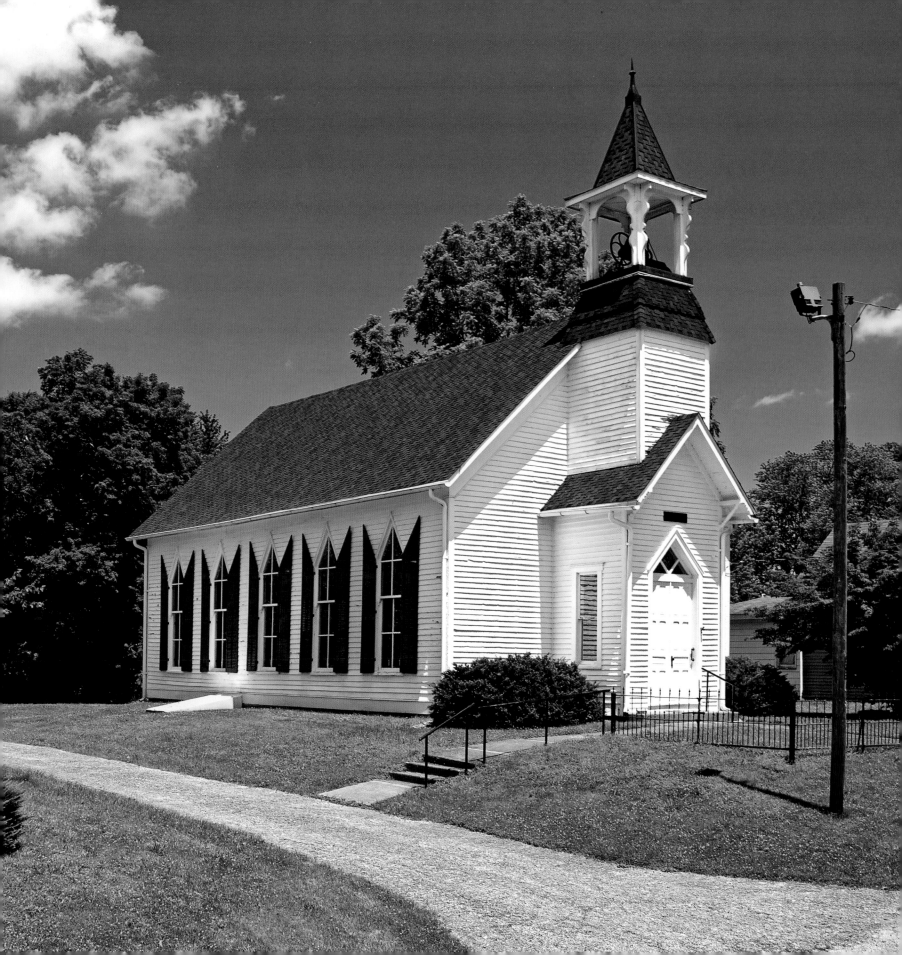

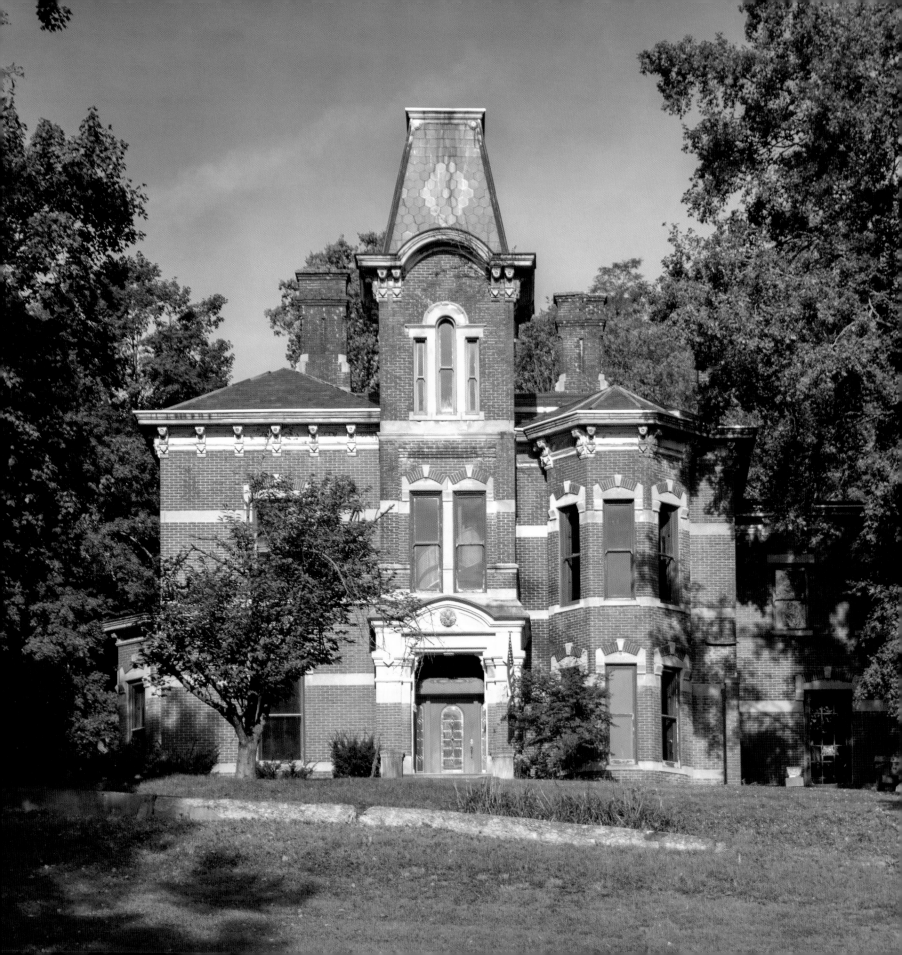

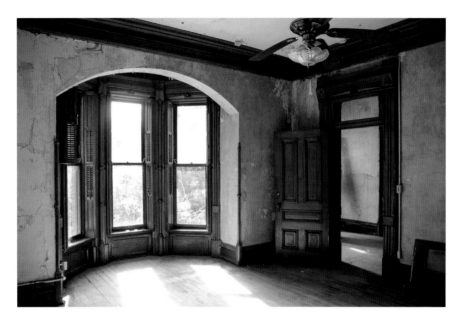
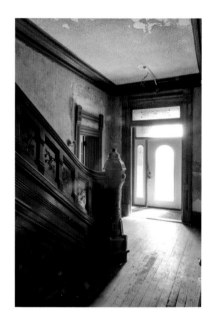

# Newkirk Mansion CONNERSVILLE

The 1880 mansion embodies the more-is-more approach typical of Victorian architecture—towers, brackets, carved ornament, fancy interior trim, lots of fireplaces. It still had all that going for it, but in 2017 the 10 Most Endangered landmark also had a leaking roof, broken rafters, a vandalized interior, and a carriage house nearly destroyed by arson.

Indiana Landmarks negotiated an option so it could hunt for a buyer, fielding interest from throughout the U.S. and finding the perfect answer close to home. Mike and Jenny Sparks bought the mansion for the second time, having owned it before they moved with their young children to a nearby farm. They sadly watched the house deteriorate over the intervening years.

What made them buy it back? The beautiful staircase and newel post. The ornate butternut trim and deep crown molding. The size of the rooms and the windows. The hilltop site overlooking Connersville. And Indiana Landmarks' preservation covenant, which guarantees the house will be protected no matter who owns it in the future.

In 2019, the couple and their now adult offspring made countless 120-mile trips to an 1883 church in western Indiana destroyed by a tornado, where they salvaged floorboards, rafters and joists the same size as water- and fire-damaged ones in the mansion and carriage house. It's a DIY restoration in progress by community-minded stewards with the highest standards.

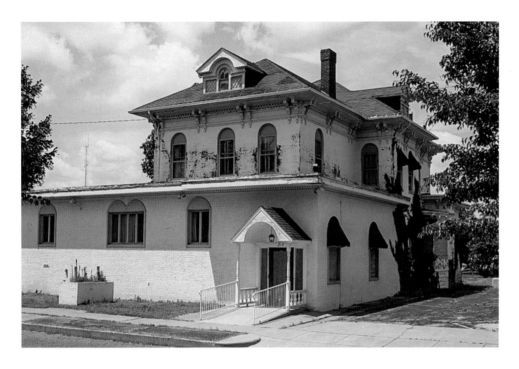

# Sage House ELKHART

Preservation advocates promote adaptive use to save landmarks that outlive their original functions. One industry latched onto adaptive use long before the preservation movement gave the concept a name. In big cities and small towns, mortuaries converted grand old houses into funeral parlors, an ideal reuse that offered mourners the comfort of a homelike setting.

The Sage House went full circle, from a stately c.1865 Italianate residence to a funeral parlor and back again. The city of Elkhart donated the vacant house to Indiana Landmarks in 2008 with the stipulation that it revert to single-family status.

A cement block addition encased three sides of the 5,000-square-foot house. With support from the Efroymson Family Fund, Indiana Landmarks restored the exterior after removing the unsightly addition and recreating the wrap-around porch. Bobby and Anastasia Glassburn found the place when their Google search for "Landmark Houses Indiana" led them to the for-sale section of Indiana Landmarks' website.

Because the house was not habitable, the Glassburns couldn't get a conventional mortgage, so Indiana Landmarks acted as a bank and general contractor to finish the interior restoration as a four-bedroom, three-bathroom family home with 12-foot ceilings and beautiful hardwood floors. The couple loves the craftsmanship and sense of history while their five kids love all the hide-and-seek opportunities.

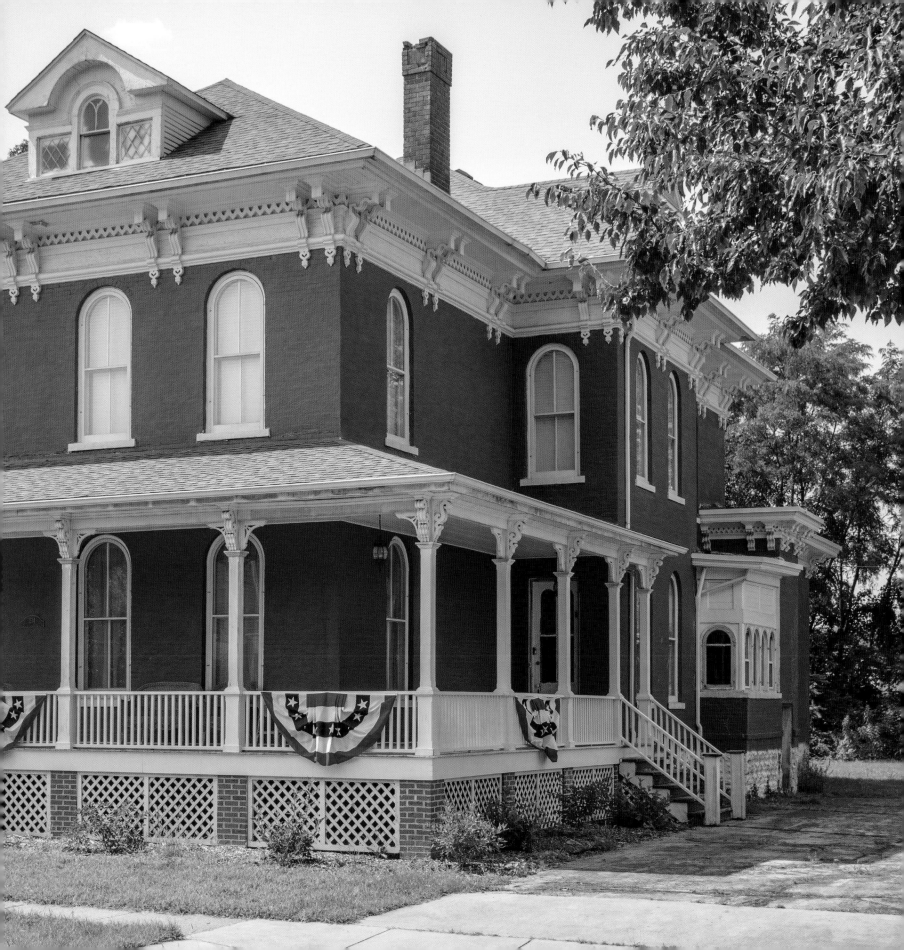

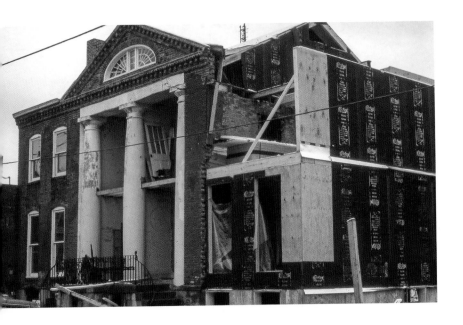

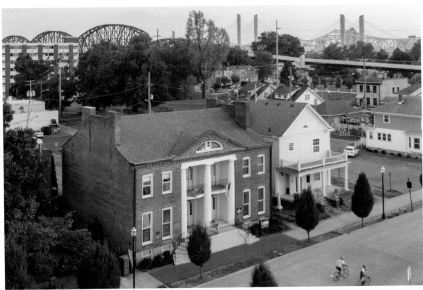

# Grisamore House JEFFERSONVILLE

Brothers David and Wilson Grisamore each owned half of the unusual double house they commissioned in 1837. The house has elements of both Federal and Greek Revival: Federal style in structure with typical end chimneys, and recessed entrances and balconies, a pediment, and massive Doric columns that tip Greek Revival.

Long recognized as a landmark in the river town and beyond, Grisamore House was documented in 1934 by the Historic American Buildings Survey (HABS), a New Deal program that photographed and produced architectural drawings of landmarks across the U.S.

After a 1981 fire destroyed a third of the house, it languished until local history buffs Rosemary Prentice and Harvey Russ stepped up and began restoring the house. The drawings HABS created in 1934 guided the pair in recapturing the original appearance. With help from Indiana Landmarks, they established JeffClark Preservation, Inc., a nonprofit organization, and deeded the house to the group.

JeffClark later asked Indiana Landmarks to take over the Grisamore property so it could tackle other projects. Indiana Landmarks finished the restoration for its southern office. The tag-team rescue became the first in a long list of saves by the two organizations that revitalized downtown Jeffersonville. In 2005, Indiana Landmarks sold Grisamore House in order to rescue the endangered Willey-Allhands House, moving it to a vacant lot next door, relocating the office there, and reviving the downtown streetscape yet again.

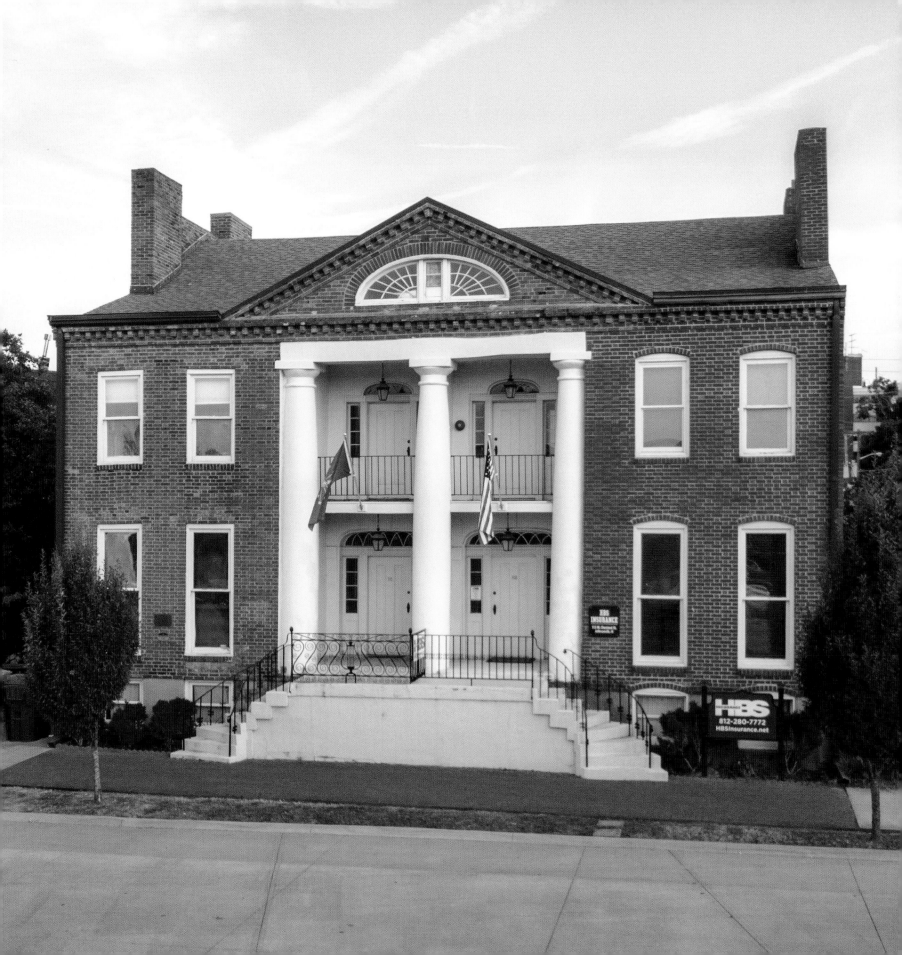

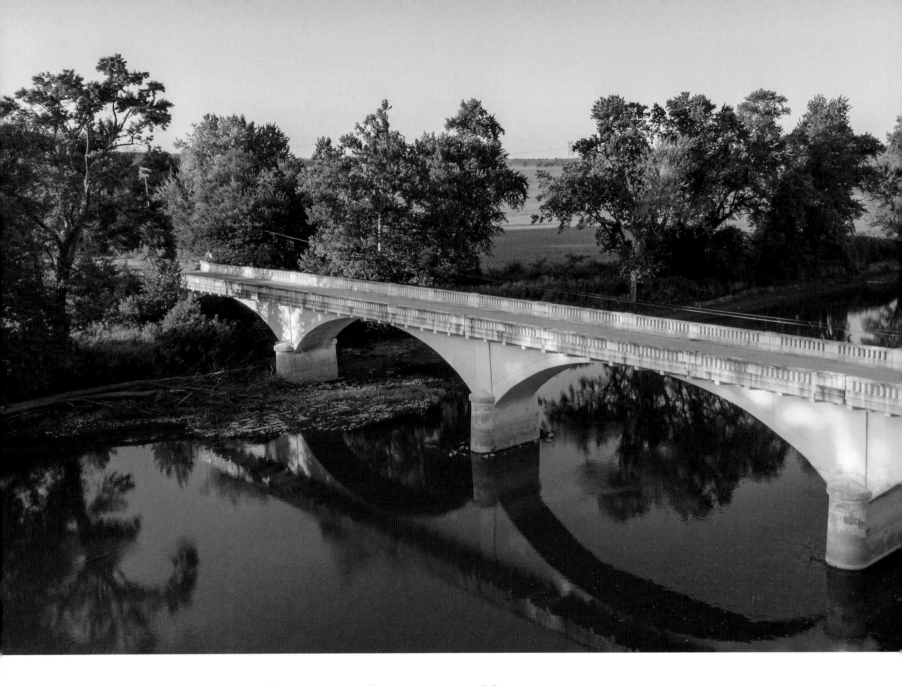

# Historic Bridges of Carroll County

I n 1995, a utility truck that exceeded the posted height and weight limits drove onto the 1891 Hamilton Street Bridge in Delphi, collapsing the span and contorting its metal trusses beyond repair. That incident set the stage for Carroll County's embrace of historic bridges.

In 1997, when county commissioners slated the 1898 Wilson Bridge for replacement, the threat inspired a preservation campaign for all the county's historic bridges. Grants from Indiana Landmarks for legal work and engineering studies helped propel the work of the grassroots Carroll County Historic Bridge Coalition. The restored Wilson Bridge reopened in 2008.

A decade-long effort saved the 1927 Carrollton Bridge, a concrete span across the Wabash River. You can still drive across the graceful restored bridge, looking up and down the river, a contrast with modern replacements whose concrete rails obscure waterways from view.

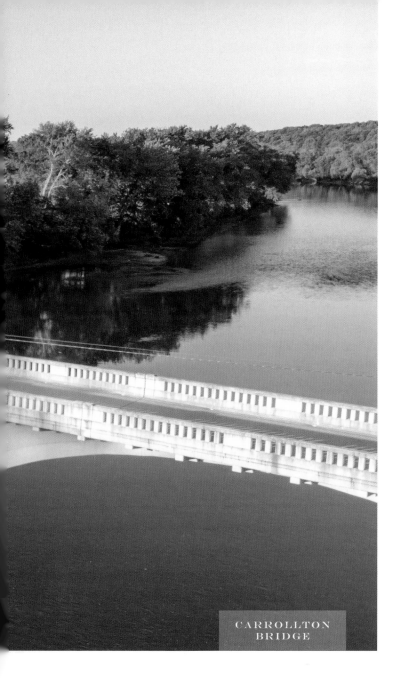

CARROLLTON
BRIDGE

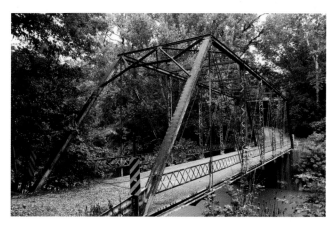

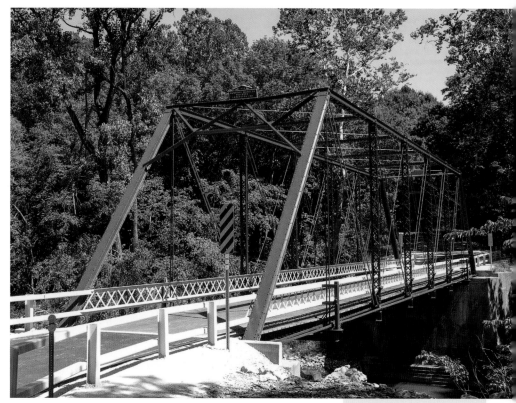

WILSON BRIDGE

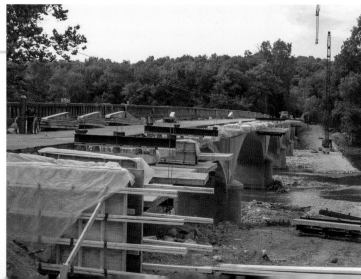

You'll find restored spans over the Wabash and Tippecanoe rivers, the Wabash & Erie Canal, Deer Creek, and other waterways. Some of the bridges are indigenous and some were discarded by other counties, disassembled, and re-erected to carry foot and bike trails over creeks and the canal. The Freedom Bridge, a soaring 1898 metal bridge decommissioned by Owen County, carries a trail over four-lane IN-25.

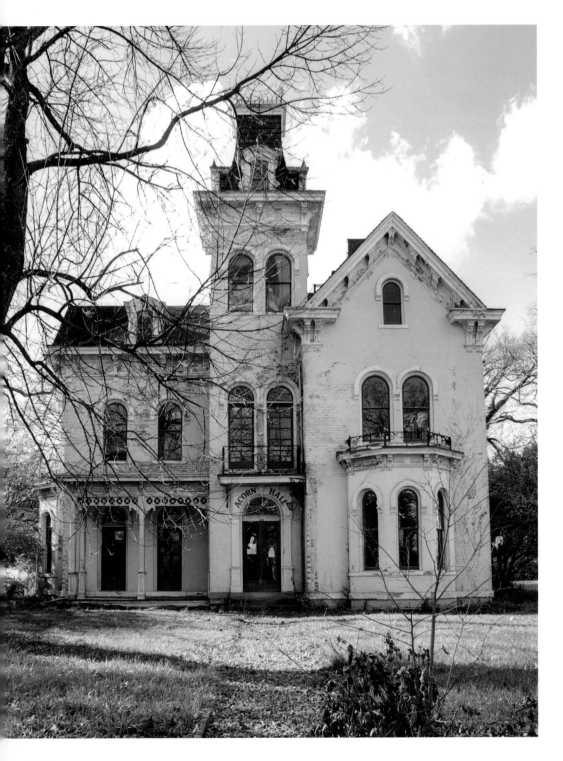

# Squibb House
## GREENDALE

In the early 1800s, people called Lawrenceburg "Whiskey City" because of all the distilleries. Industry moguls like William Squibb built stately houses on Ridge Avenue, known as Whiskey Row, next door in the town of Greendale. When Indiana Landmarks featured the 1883 Squibb House in a 2002 book on Indiana's historic houses, the Victorian home looked pristine, inside and out.

By 2015, the house exhibited shocking decline, moldering in mortgage foreclosure limbo. Because it held a preservation easement on the property, Indiana Landmarks intervened to iron out legal tangles that allowed the bank to auction the house.

Bill and Nancy Smith bought it for their home and business in 2017. They reroofed the main house, carriage house and guest quarters, repaired damaged masonry, and banished raccoons living in the box gutters. After buttoning up the outside, they began restoring the 8,400-square-foot, 24-room interior scarred by neglect, with termite damage, buckled floors, collapsed ceilings, broken and missing windows.

Because Mr. Smith plans to locate his auto parts logistics and distribution business in the house, he qualified for a matching grant for restoration from the Indiana Office of Community and Rural Affairs. While the grant will cover only a fraction of the cost, every bit helps achieve their goal of making the house a Whiskey Row showplace once again.

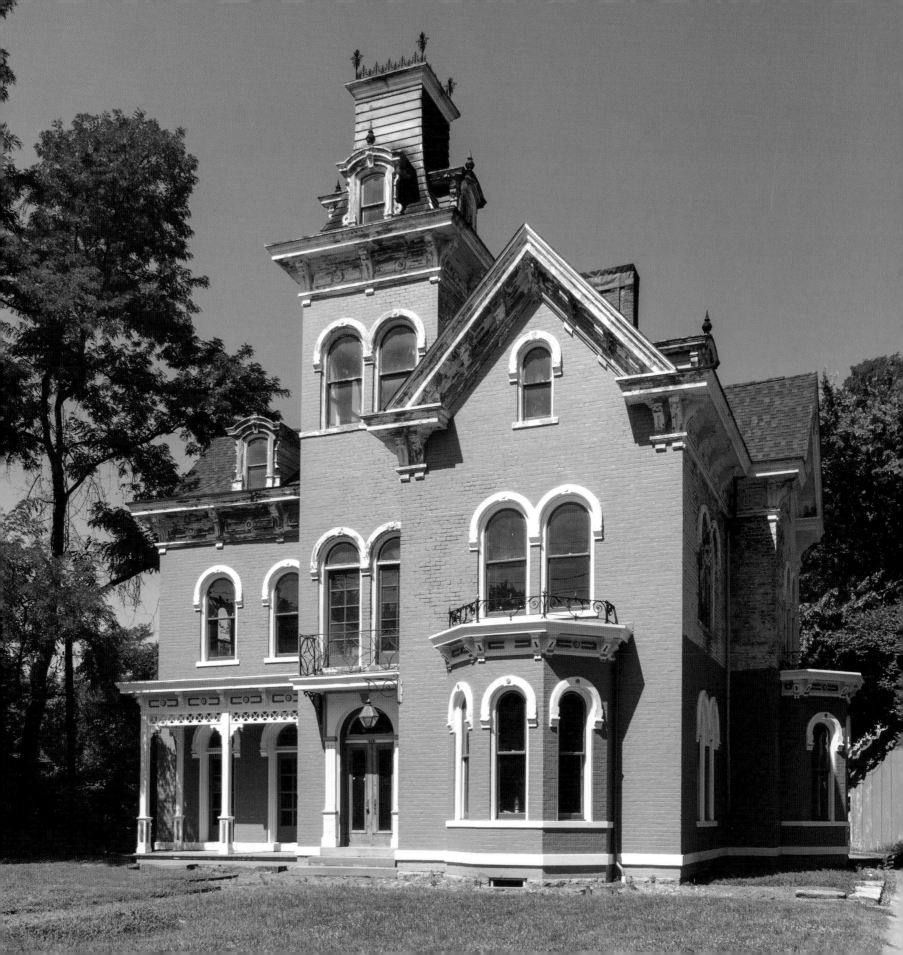

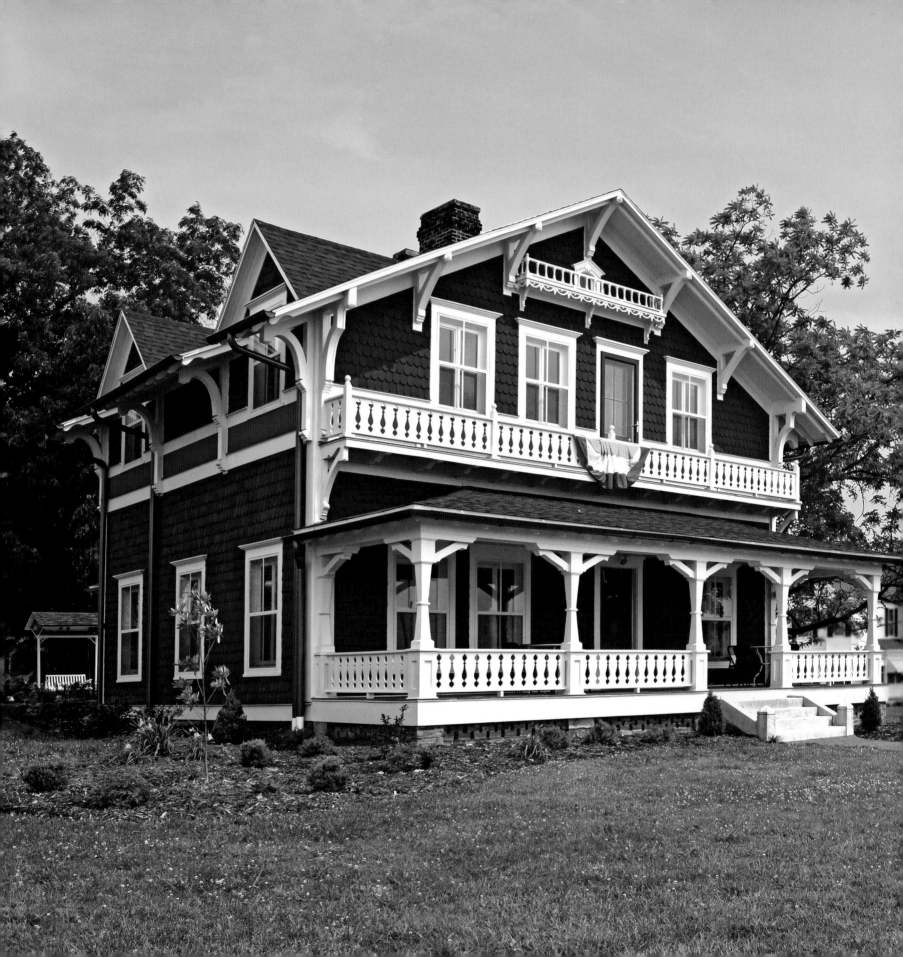

# Wollenmann House FERDINAND

The Germanic quality of the Wollenmann House—Craftsman style with Swiss chalet-like characteristics—reflects the dominant ethnic heritage of the area and Alois Wollenmann who commissioned the house in 1903. A German-trained Swiss physician, he came to Indiana to treat the monks of nearby Saint Meinrad Archabbey.

While doctoring was his main occupation, he also ran the local drug store and operated the post office and a watch repair shop. Bucking the early twentieth century's dominant customs, he treated Native Americans and employed and promoted African Americans.

Successive generations of Wollenmanns kept the house intact until 2007, when two elderly descendants listed the property—nearly a full city block—for sale. To maximize the selling price of the Main Street lot, they won a zoning change from residential to heavy commercial, which meant the house would likely be demolished for strip or franchise development. Indiana Landmarks declared it a 10 Most Endangered site the same year.

Seven Ferdinand residents banded together, bought the property, and donated it to the Ferdinand Historical Society, which raised the money for restoration. The Wollenmann House is not a museum, but you can visit and enjoy a meal: the society leases the house as a restaurant.

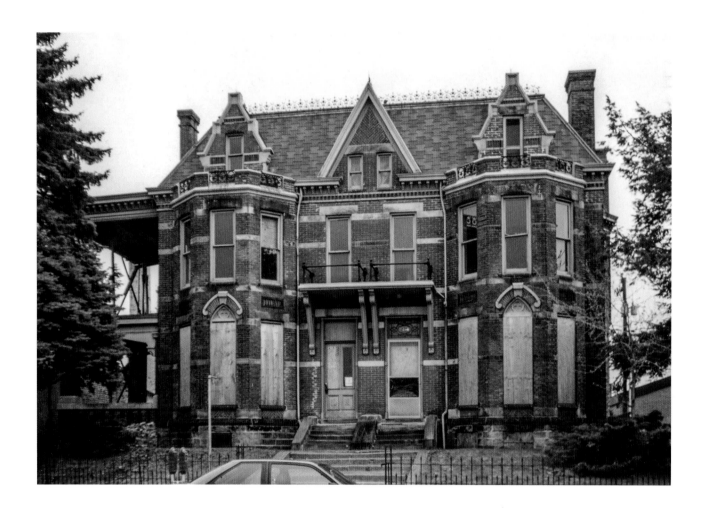

# McCulloch House FORT WAYNE

This is not your ordinary double. Charles McCulloch, an influential banker whose father was Secretary of the Treasury under Presidents Lincoln, Johnson, and Arthur, commissioned the Gothic Revival house in 1881. He passed it to his sons Ross and Frederick, who each occupied a side beginning about 1908.

Ross, an influential patron of the arts in Fort Wayne, lived in the house his entire adult life, joined for many years by Charles Weatherhogg, an English immigrant architect who put his own significant stamp on the city of Fort Wayne and the Midwest, designing downtown buildings, university structures, schools, and houses until his death in 1937.

In 2003, after decades of decline and fire damage—one side had been vacant 45 years—and appearances on the 10 Most Endangered list, the house was donated by its nonprofit owner to Indiana Landmarks. In partnership with ARCH, the local preservation group, and with support from the city, the state preservation office, the English-Bonter-Mitchell Foundation, and the Efroymson Family Fund, Indiana Landmarks restored the exteriors of the elegant duplex and carriage house.

Jerry Henry, an entrepreneur, philanthropist, and self-described landmark hoarder—in the best possible sense—bought the property in 2005 and restored the interiors for the headquarters of the United Way of Allen County. Still beautifying the city. Still connected to the community.

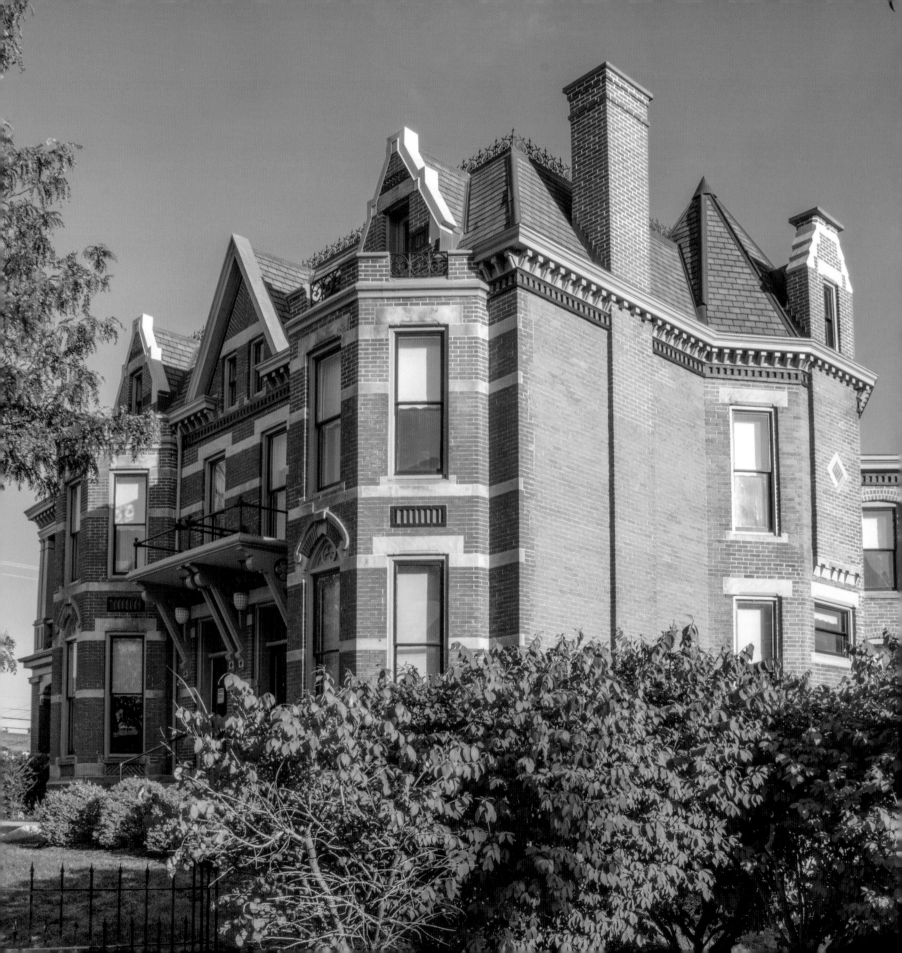

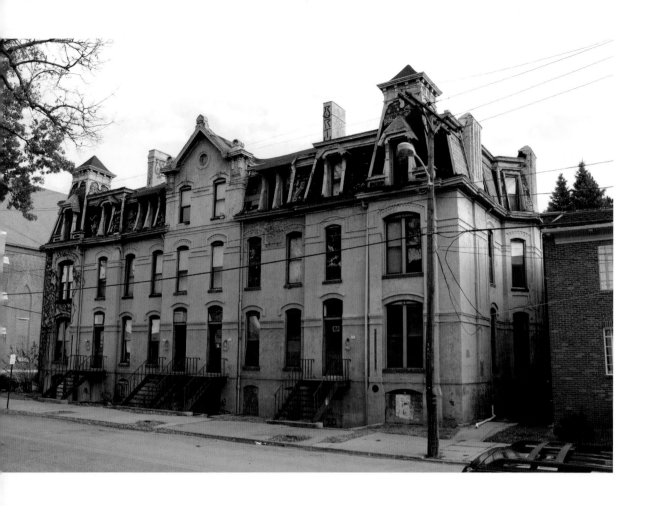

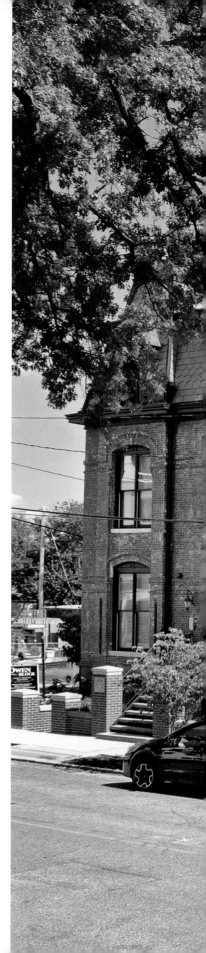

# Owen Block EVANSVILLE

**B**uilt for affluent tenants in 1882, the rare Second Empire-style townhouse row reached the twenty-first century a gutted mess, plagued with leaks, code violations, and a Smurf-blue paint job. Indiana Landmarks commissioned a building analysis that produced a blunt verdict: "Don't do it." The engineers judged the Owen Block too dilapidated and structurally unsound to save.

When the city condemned the property and erected a fence around it on New Year's Eve in 2014 to protect the public from falling brick, it looked like the end of the line. However, sometimes a place is just too important to let fall.

In three months, Indiana Landmarks raised $440,000 from donors and its own treasury—the amount of subsidy one brave developer said might make the project financially viable. The City of Evansville provided $50,000 and an equal amount for infrastructure improvements around the property. Jesika Ellis and the self-proclaimed Blockheads waged a clever Facebook campaign that generated local interest and support.

Michael Martin of Architectural Renovators took on the challenge, spending $1.25 million to restore the mansard roof, slated turrets, enormous windows, corbelled chimneys, and recapture the original elegant look, sans blue paint. Inside, the 15 open-plan apartments have a modern aesthetic. He calls it new wine in an old bottle.

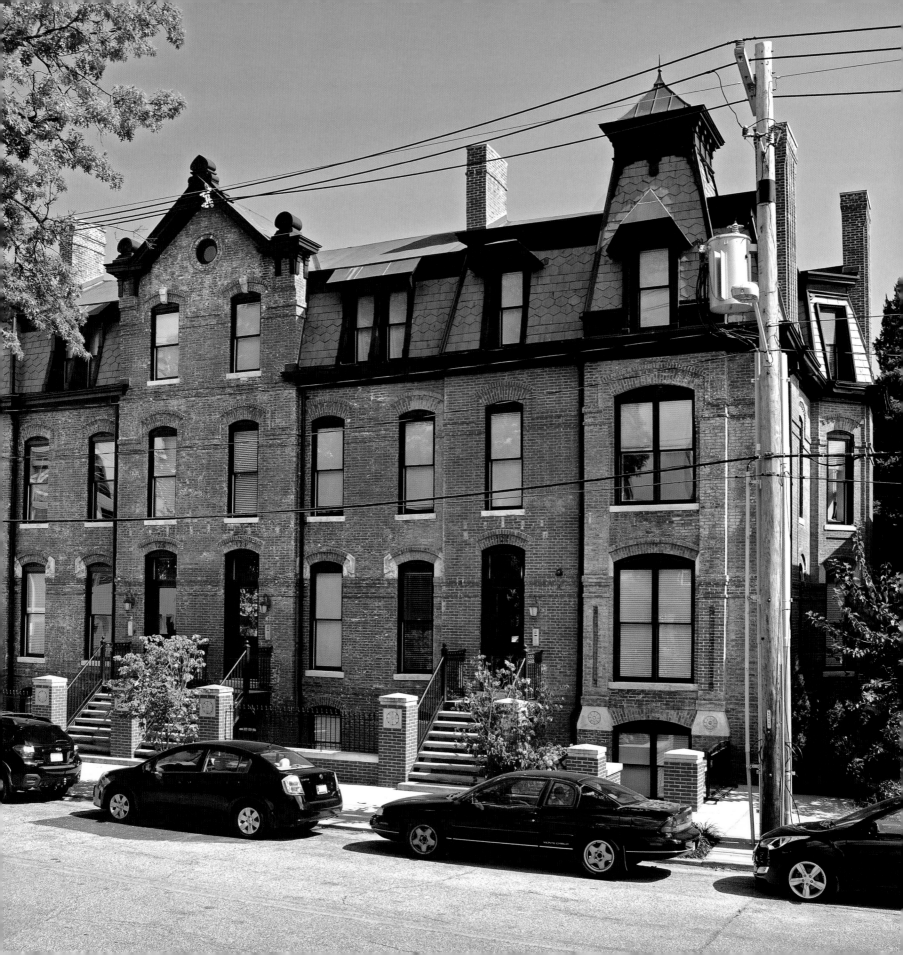

# Mills House SOUTH BEND

The federally funded Blight Elimination Program aims to rid cities of derelict houses that can shelter crime and contribute to neighborhood decline. To make sure historic houses with rehab potential don't end up in the landfill, Indiana Landmarks surveys the annual elimination targets.

In 2016, Indiana Landmarks petitioned the city of South Bend to pull 607 Leland Avenue from the demo list and, to spur revitalization in the area, enlisted Near Northwest Neighborhood, Inc. (NNN) and Habitat for Humanity to collaborate on the block. NNN rehabbed the house next door while Habitat built a house on an adjacent vacant lot.

Indiana Landmarks restored the small c.1900 cottage inside and out, giving it an open-plan living and dining area, a large kitchen, two bedrooms, and a bath and a half. The turn-key renovation caught the attention of Chad and Krissy Campbell, a young couple with an appreciation for the historic character of the house and neighborhood.

The couple liked the up-and-coming area but found most of the homes either didn't fit their budget or required more hands-on work than they felt able to undertake—until they saw the Mills House in 2018. They bought a completely rehabbed historic home they could afford—a win for them, the neighborhood, the environment, and heritage preservation.

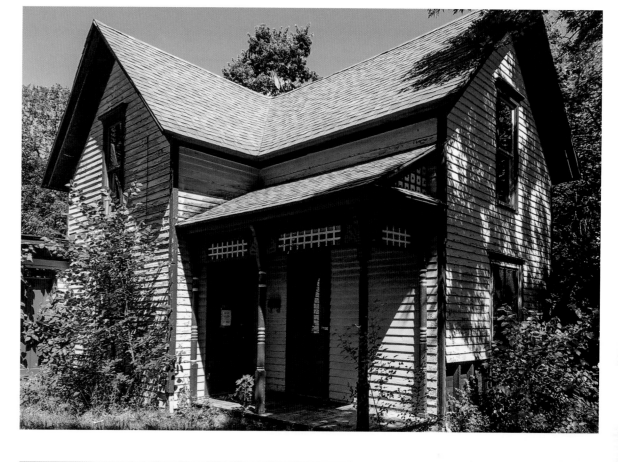

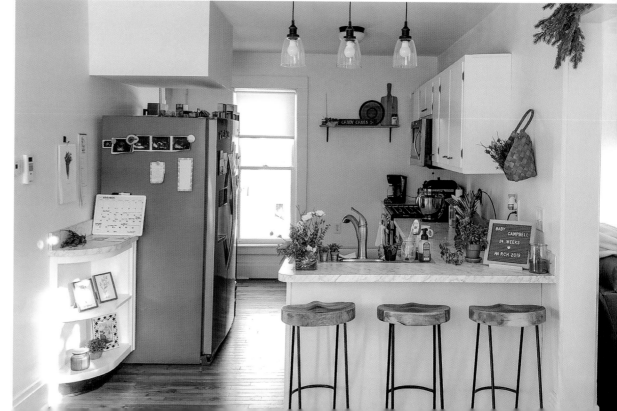

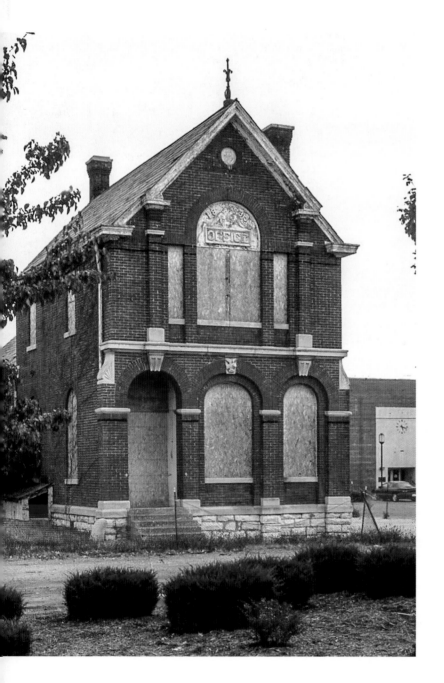

# Hack & Simon
# Brewery Office VINCENNES

The keystone on the façade offers a clue to the building's 1885 origin: a carved limestone eagle with a beer barrel in its talons. The Victorian Romanesque structure housed the administrative office of the Hack and Simon Eagle Brewery.

In 2002, Vincennes University sued the Vincennes Historic Review Board for denying it permission to replace the landmark with a parking lot in the locally designated Vincennes Historic District. Court-ordered mediation produced a compromise that gave local preservation advocates a shot at saving the deteriorating structure. The university kept the building. Vincennes/Knox Preservation Foundation had to cover the rehabilitation by raising $260,000 according to a phased schedule.

If the group missed a deadline, the university could let the wrecking ball swing. Indiana Landmarks helped cover the group's legal costs and supplied a loan that allowed it to meet one fundraising deadline. The group achieved the rest thanks to significant contributions from the community and grants from the Bierhaus Foundation, Indiana Division of Historic Preservation and Archaeology, and the Efroymson Family Fund.

In the down-to-the-wire campaign, Vincennes/Knox Preservation raised $275,000—Vincennes University chipped in $25,000—and oversaw the $300,000 rehab. The university leases the building to a commercial tenant.

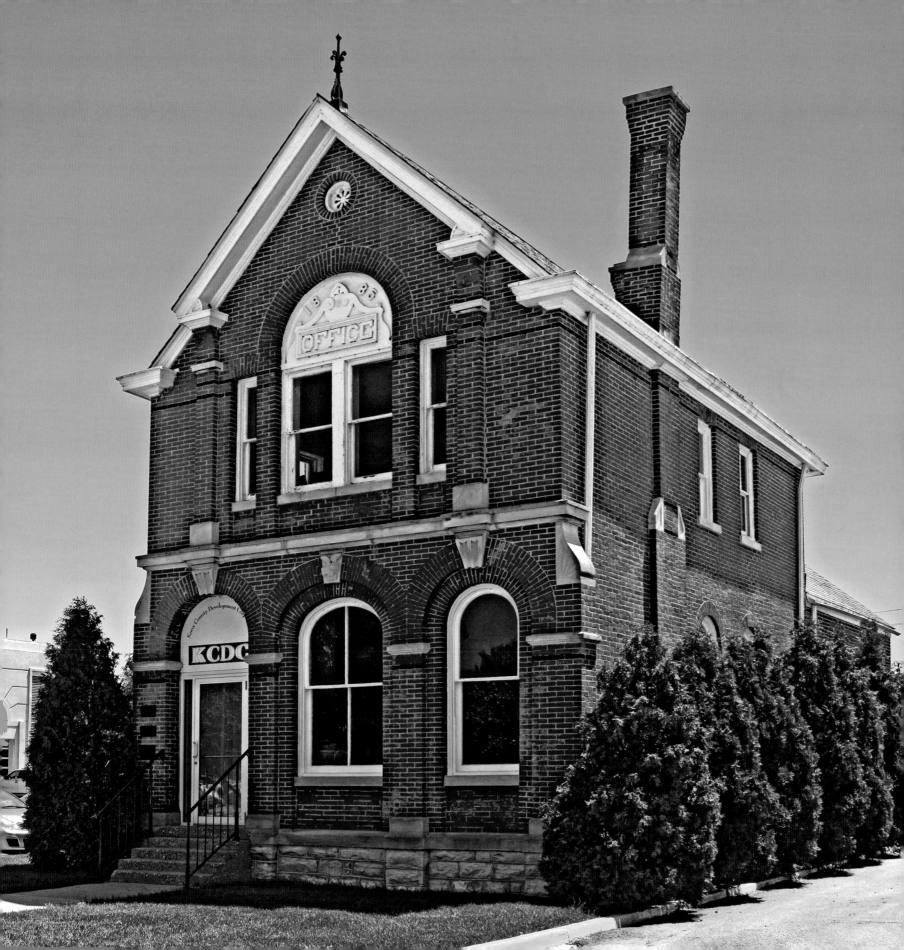

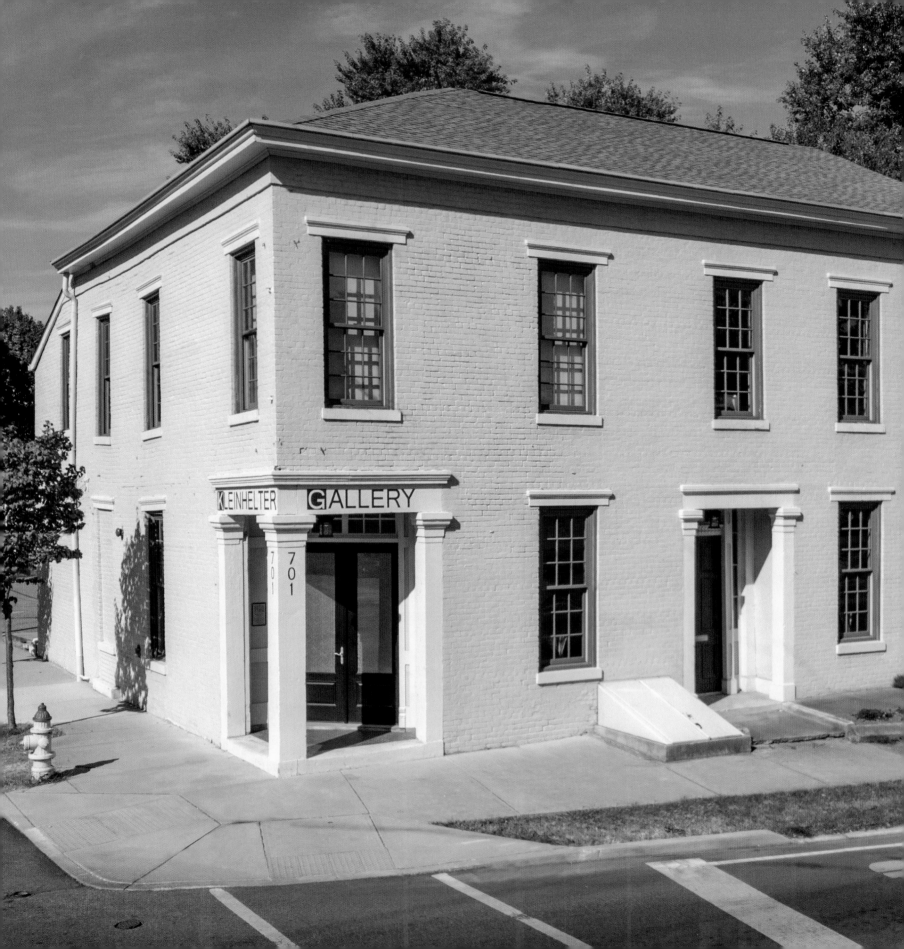

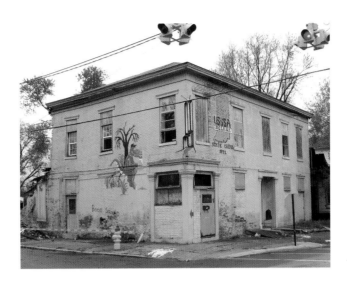

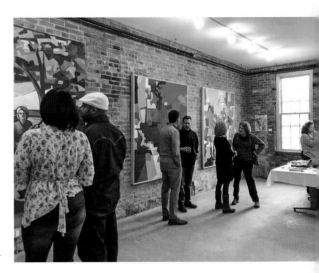

# Weinmann Building

## NEW ALBANY

Many didn't consider the c.1858 building at Eighth and Culbertson worth saving. The graffiti and peeling turquoise and pink paint were bad enough. When a 2011 storm collapsed a rear wall, the owner planned to demolish the place. But when a neighborhood loses a historic corner building, it creates an outsized hole in the streetscape.

Viewing the loss as damaging to Midtown and seeing potential beyond the crazy paint scheme, Indiana Landmarks intervened, teaming up with the city and the New Albany Urban Enterprise Association. With additional support from Horseshoe Foundation of Floyd County and Develop New Albany, Indiana Landmarks

rebuilt the collapsed corner and restored the Greek Revival exterior.

Artists Ray and Gina Kleinhelter also saw potential in the rough interior. They bought the place for its open spaces flooded with natural light from large windows, ideal for an art gallery and studios. Historic features—staircase, pocket doors, and wide-board pine flooring upstairs—added to the appeal.

Two years of sweat equity later, the couple and their adult children opened a main-floor gallery that exhibits local artists' work, with studios and apartments upstairs. Call it a corner catalyst: nearby you'll find a rehabbed shotgun house and a few newly built homes.

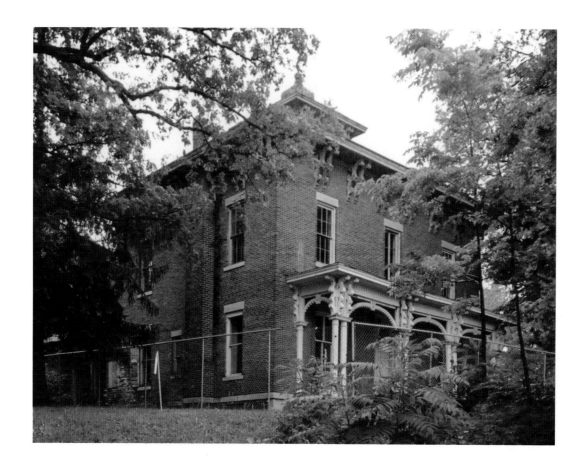

# Old Republic NEW CARLISLE

In the late 1990s, Historic New Carlisle, Inc., tackled the town's biggest eyesore—the condemned Jeremiah Service House. Built in 1860 and known as Old Republic, the Italianate-style house suffered under owners who installed a used car lot in the front yard, then left the place vacant for 30 years.

To protect the curious public, the city erected a tall chain link fence around the property and planned on demolition. The vandalized house had holes in the roof, falling plaster, and broken windows.

Indiana Landmarks included Old Republic on the 10 Most Endangered list in 1998 and funded legal work to help Historic New Carlisle become the court-appointed receiver of the property. A loan from Indiana Landmarks allowed the group to buy the 5,000-square-foot house.

Years of fundraising and countless hours of volunteer labor later, the restored Old Republic opened as a B&B and community meeting place with a small history museum. Happy end of story?

Yes, with a twist. Historic New Carlisle decided its mission to preserve and educate meant it shouldn't remain so focused on one building. The group sold Old Republic in 2019 so it could restore a downtown building and expand the museum. The new owners returned the property to its original use as a single-family home, protected in perpetuity by Indiana Landmarks' preservation covenant.

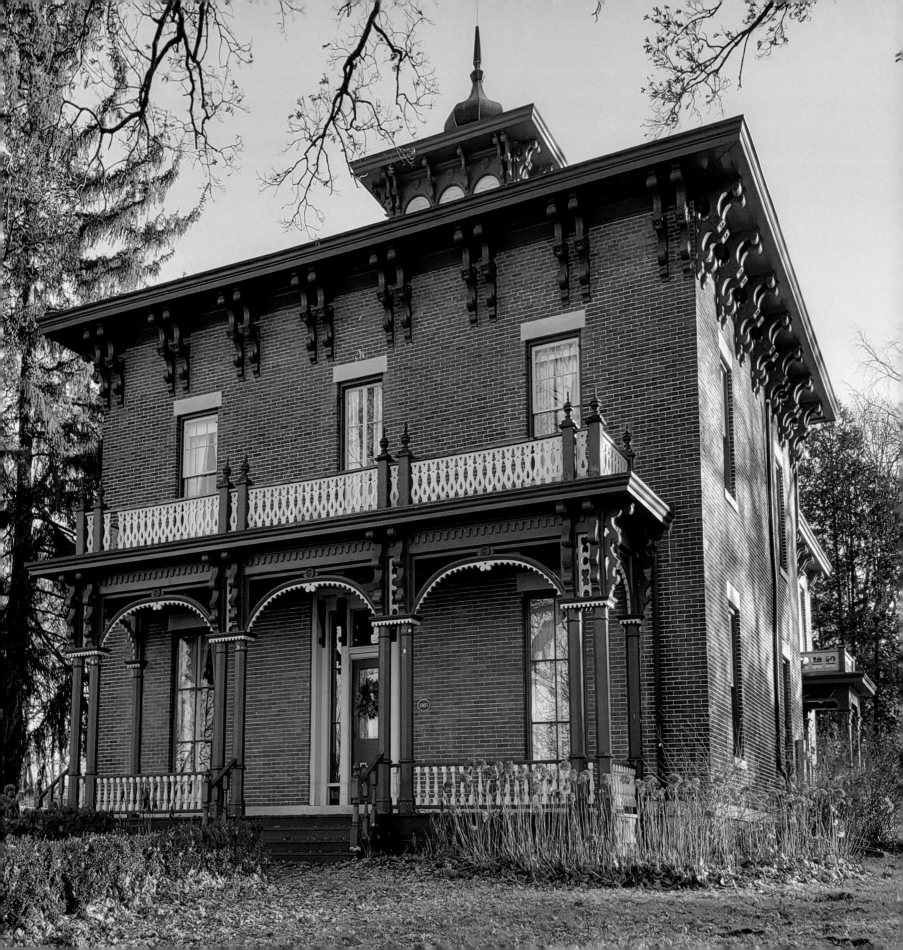

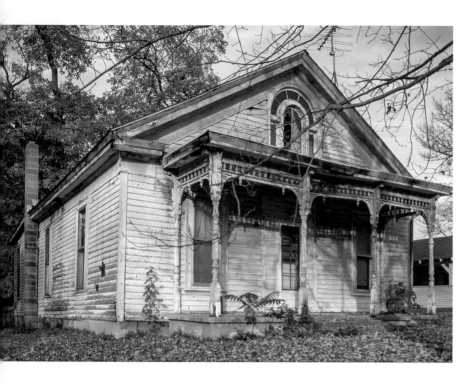

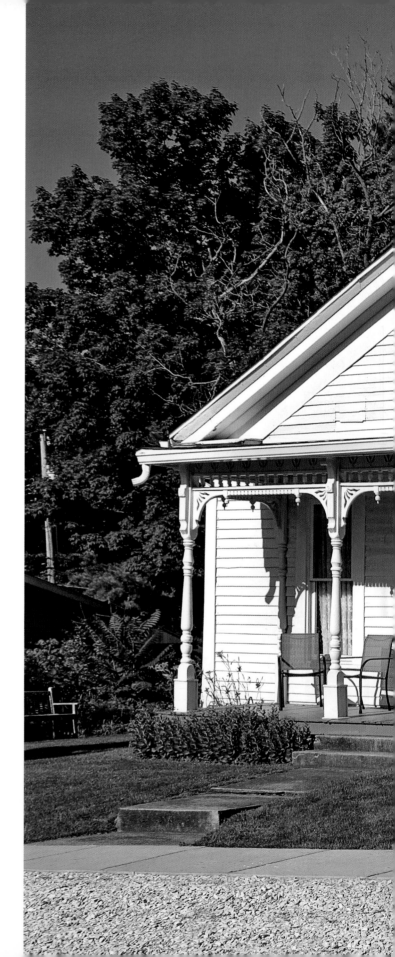

# T.C. Steele
# Boyhood Home WAVELAND

One of Indiana's most important artists, Theodore Clement Steele (1847-1926) started painting at age five, thanks to an uncle's gift of a paint set. He grew up perfecting his craft in the Greek Revival-style cottage where he lived with his family from 1852 to 1870.

After spending five years studying in Europe, he rose to prominence in the art world. His portraits of President Harrison, Vice President Fairbanks, governors, and prominent citizens supported his family and allowed him to indulge his passion for painting impressionistic urban and rural landscapes. Steele's Brown County house and studio is a state-owned historic site.

The setting that first inspired Steele's art, his 1850 boyhood home, fared less well. Vacancy, deterioration and a proposed highway project threatened the cottage and landed it on Indiana Landmarks' 10 Most Endangered list in 2001. When a local preservation group's effort to save the house foundered, Indiana Landmarks took over, stabilizing the exterior while hunting for a buyer.

After several years passed without offers, Indiana Landmarks' then board chair, Elkhart attorney Tim Shelly—a distant Steele relative—and his wife Meg, a teacher, made a compelling proposal in 2013. They bought and restored the house as a retreat for artists and art teachers, continuing the home's role in cultivating Indiana's creative community.

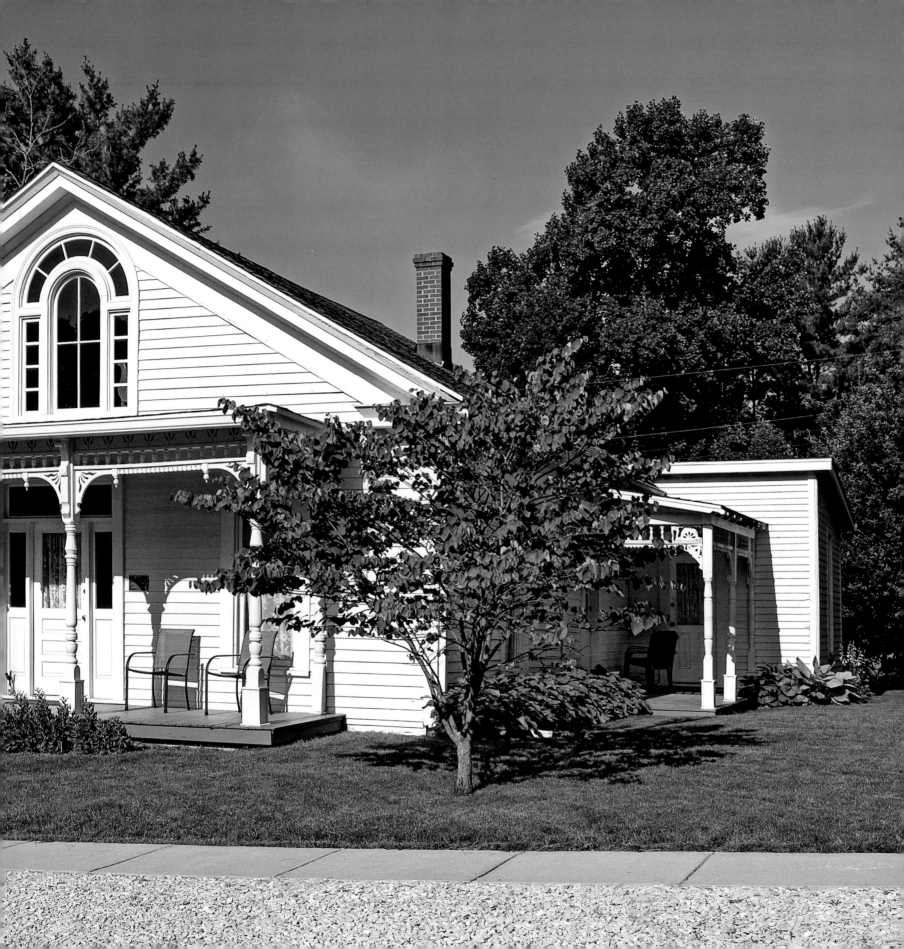

# PHOTOGRAPHY

*Photography credits are listed for each page, left to right, top to bottom*